POPARTPORTRAITS

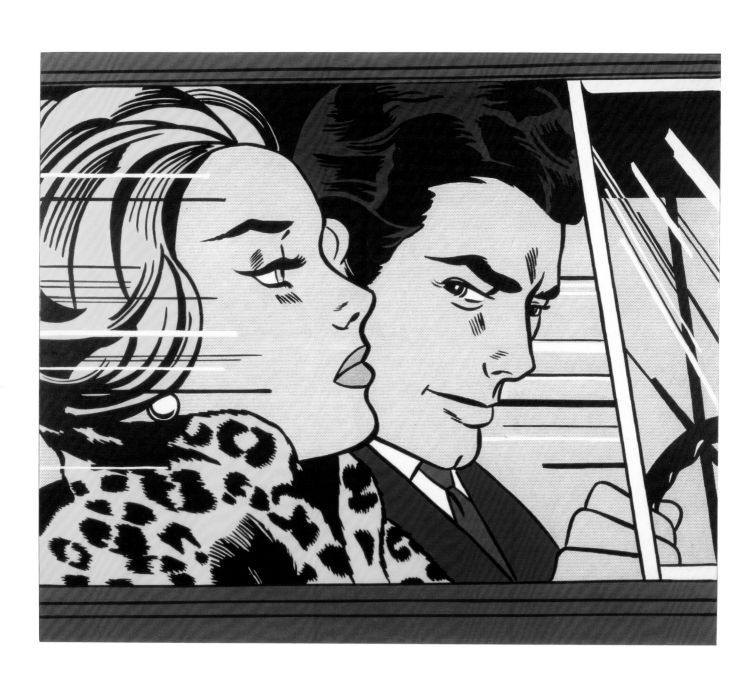

POPARTPORTRAITS

PAUL MOORHOUSE

With an essay by Dominic Sandbrook

YALE UNIVERSITY PRESS

Published in North America by Yale University Press
P.O. Box 209040, 302 Temple Street, New Haven, CT 06520-9040
www.yalebooks.com

Published in Great Britain by National Portrait Gallery Publications,
National Portrait Gallery, St Martin's Place, London WC2H 0HE

Published to accompany the exhibition *Pop Art Portraits* at the
National Portrait Gallery, London from 11 October 2007 to 20 January 2008,
and Staatsgalerie Stuttgart from 23 February to 8 June 2008

ISBN 978-0-300-13588-6

Library of Congress Control Number: 2007931348

Publishing Manager: Celia Joicey
Editor: Caroline Brooke Johnson
Copy Editor: Denny Hemming
Design: Rose-Innes Associates, London
Production Managers: Ruth Müller-Wirth and Tim Holton
Picture Research Assistants: Claudia Bloch and Susanna Brown
Printed and bound in Italy

Frontispiece
In the Car 1963, Roy Lichtenstein

CONTENTS

'I don't know where the artificial stops and the real starts.'

ANDY WARHOL

'Divine ambiguity
is possible.'

EDUARDO PAOLOZZI

PREFACE

Pop Art Portraits is the first book and exhibition to examine the role and significance of portraiture within Pop Art. As such, it addresses one of the major art movements of the late twentieth century, whose subject matter, imagery, themes and principal protagonists have all become instantly familiar through numerous exhibitions, catalogues, books and articles. This familiarity has resulted in the widespread assumption that the essence of Pop Art is known, the historical perspective formed and 'set'. Viewed in the context of the consumer society from which Pop Art emerged, the received wisdom is that Pop is an art about objects. This book and accompanying exhibition contest that view, proposing nothing less than a fundamental reassessment.

In the last forty-five years, the dominant tendency has been to see Pop Art as a visual response to a materialist culture that reached new heights in the 1960s, its imagery taken from the mass-media world of advertising, magazines, television and film. With the advent of exciting technological and cultural innovations, expressed through fashion, food, design, pop music, cars and space travel, the 1960s promised a progressive vision for the future rooted in material values. Pop Art, it is said, became synonymous with the fabric of this new society, a world dominated by standardization, repetition and predictability.

These ideas certainly played an essential part in the way Pop developed and in his essay (pp.14–30), Dominic Sandbrook illuminates the conditions and changes that shaped the social context in Britain and America. As Sandbrook shows, growing affluence in both countries went hand-in-hand with mass production and mass consumption. Pop Art is inextricably linked with such phenomena and it is telling that the epitome of Pop, Andy Warhol, has become identified in the public mind with images of Campbell's soup cans. But the real significance of Pop Art is more complex than this identification with objects would imply. Seeing Pop solely in terms of the material fabric of the society that nurtured it places an undue emphasis on things rather than people. Critics such as David Sylvester, who have argued that Pop was 'more often a form of still-life painting than of figurative painting', have powerfully influenced the way Pop has come to be viewed.

I have long felt that this perception of Pop Art is accurate but unbalanced and so, when I joined the National Portrait Gallery in 2005, I set out to take a fresh look at Pop, in terms of portraiture. Pop, it seemed to me, while closely linked with the depiction of things, was pre-eminently a figure-based art. Wherever one looks, the iconography of Pop is replete with portraits of many different kinds, with figures shown either as consumers interacting with their enhanced world of objects, or seen in isolation so that people become the main focus of attention. This is true of Pop's earliest manifestations from the 1950s: Eduardo Paolozzi's seminal *BUNK!* collage depicting the strongman, Charles Atlas (p.54); Richard Hamilton's iconic Pop image *Just what is it that makes today's homes*

so different, so appealing? (p.42), which teems with portraits; and Jasper Johns's plaster assemblages containing casts from life (pp.64–5). The subsequent development of Pop Art reveals an obvious, growing fascination with portraits, from those of media celebrities such as film stars, pop musicians, entertainers, models, politicians, astronauts and comic-strip characters, to images of anonymous people, all taken from mass-media sources. By the 1960s, in classic Pop Art images by leading figures such as Hamilton and Warhol, portraits have attained an iconic presence. My central argument is that people and objects are the two inseparable halves of the brave new world addressed by Pop Art. If Pop can be said to have a subject, then it is mankind's changing condition in a consumer society. But it is only by acknowledging the presence of portraits in the iconography of Pop that this subject makes any sense.

The aim of *Pop Art Portraits* is therefore to redress this imbalance by examining in detail the complex and subtle relationship between portraiture and Pop Art. In both America and Britain, Pop Art evinced a fascination with images of famous people. For that reason, portraits of the famous are in evidence throughout this exhibition. But it would be over-simplistic to claim that Pop's engagement with portraiture was simply a matter of appropriating images of famous individuals and then infiltrating them into a context inspired by the mass media. For example, in America the progressive infiltration of portraiture had a singular importance in challenging the dominant legacy of Abstract Expressionism. Rather, the subject goes way beyond the straightforward depiction of recognizable people in a modern setting, and Pop Art portraits are rarely simply a matter of hero worship or of direct quotation. In the hands of such artists as Warhol, James Rosenquist, Hamilton and Robert Indiana, portraiture reflects an interaction with the visual language of their mass-media sources. Several of these artists' responses also reveal an intense interest in the mechanisms of fame, the processes that transform an unknown person into a celebrity, and the consequences of that transformation.

The story is made still more complex by the way in which, alongside overt representations of familiar figures, portraits of a quite different kind can also be found. The figures depicted by Mel Ramos and Tom Wesselmann have, in the past, been taken to be mere 'types', not recognizable as portraits in the conventional sense at all. Such images exemplify another theme of Pop Art portraiture – that of the covert or hidden portrait, in which the identity of the sitter is concealed or not made obvious, even though such images are derived from real people. In some instances, for example early works by Jim Dine, David Hockney and Allen Jones, the images appear anonymous but actually represent the artists themselves. Alternatively, artists such as Paolozzi, Robert Rauschenberg and Hamilton appropriated images of anonymous figures from mass-media sources, taking whatever seemed to have a stimulating vitality, interest or relevance to their needs. Although unidentified, such figures are real people whose identities have been obscured by the process of recontextualization. These threads,

too, run through this selection of works, manifesting an interest in the way in which commercial advertising, and also the creation of portraits in a fine-art context, can mask and even obliterate an individual's personal identity.

A further, fascinating aspect of Pop's engagement with portraiture was the singular way in which it extended the genre through the creation of fantasy or imaginary subjects. In this respect, Paolozzi's early collages based on *Time* magazine covers, made in the early 1950s, are of primary importance. By dismembering recognizable portraits and then reassembling the fragments in new combinations, Paolozzi shattered the boundaries of portraiture. The image of an actual individual is replaced with one that reads as a newly fabricated, invented, portrait. Other artists such as Nigel Henderson, Derek Boshier and Colin Self developed the process further, creating compelling, highly particular portraits of imaginary sitters. Rauschenberg, Richard Smith, Jones, Hamilton, Claes Oldenburg and Allan D'Arcangelo took a related but different direction, creating portraits of identifiable sitters in which the means of representation is non-literal or the appearance of the sitter has been modified radically. In some instances, notably Rauschenberg's *Trophy V* (p.67) and Smith's *MM* (p.85), such works initially appear completely abstract, not reading as portraits at all in any usual sense.

In shifting the focus from objects to people, *Pop Art Portraits* aims to give a truer assessment of the full significance of this influential art movement. Its contention is that through portraiture Pop Art addressed the changing status of the individual in a consumer-driven, celebrity-obsessed society in which human values were being rewritten. It reflected the way in which the mass media could transform an individual by conferring instant fame but how, in the process, personal identity could be lost. This was a world in which replication was valued above uniqueness, objects were accorded a growing importance, and the individuality of the person was qualified. In a sense, objects were charged with the significance of people, and people became more like things. This book and exhibition trace the way in which Pop Art embraced and transformed the portrait, supplanting the religious icons of the past and creating new gods – part real and part fantasy – as secular idols for a material world.

Paul Moorhouse
Curator of Twentieth-Century Portraits
National Portrait Gallery, London

THECONTEXTFORPOPART

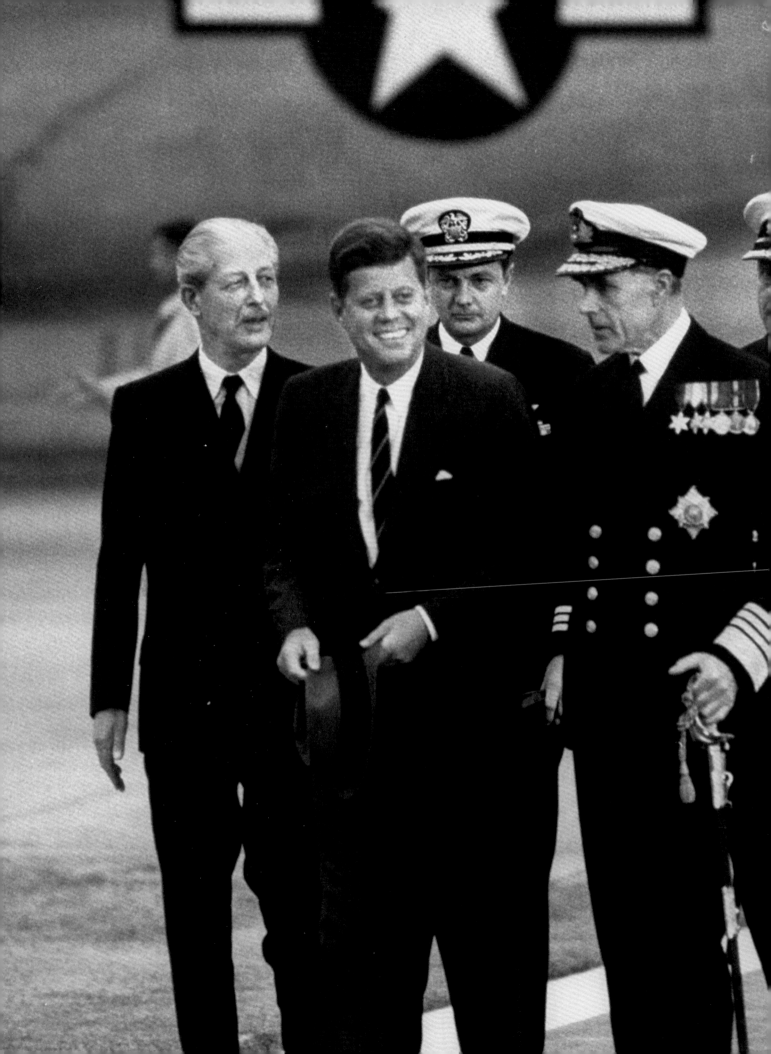

'The Age of Boom': Britain and the United States in the 1950s–1960s

DOMINIC SANDBROOK

President John F. Kennedy with Prime Minister Harold Macmillan in Britain 1 June 1961

Although millions saw John F. Kennedy as a champion of freedom and change, his presidency was dominated by the Cold War and Vietnam. Britain's prime minister Harold Macmillan urged caution, but Kennedy was determined to roll back international Communism.

Bright, bold, optimistic and self-consciously modern, Pop Art was unmistakeably rooted in a distinctive era in British and American twentieth-century life: the swinging, turbulent, controversial Sixties. Although Pop Art's origins can be traced to the consumer boom of the mid-1950s, and even beyond that to the escapist fantasies of the austere late 1940s, the movement reached its popular peak during the years of Lennon and McCartney, Marilyn Monroe and Mary Quant, San Francisco's Haight-Ashbury and Swinging London. As its influence spilled over into everything from fashion to advertising posters, Pop became a kind of visual metaphor for the youthful spirit of the day. 'Pop Art: Way Out or Way IN?' asked the cover of the *Sunday Times* colour supplement – itself a symbol of consumerism and change – in the opening weeks of 1964. The answer, of course, was 'Way IN'.[1]

Although four decades have elapsed since the high point of the 1960s, the legacy of the period – on both sides of the Atlantic – is still hotly debated. Even its dates are contested, although most historians agree that as a distinctive era it ran from roughly the mid-1950s until some time between 1968 and 1973, spanning a period of increased social democracy, economic growth and consumer affluence throughout the Western world. For some commentators, the 1960s represented a pivotal moment of change and freedom, in which class boundaries dissolved and young people enjoyed previously unimagined opportunities to widen their cultural horizons. This is the 1960s of media clichés, all long hair and miniskirts, as lampooned in innumerable television film comedies, above all the *Austin Powers*

The 1950s and 1960s were boom years for the American city. Lit up by thousands of neon advertisements promising new horizons of excitement, the city played a crucial role in the new visual language of American Pop Art.

comedies. But to more conservative observers the picture looked very different. In the words of the British moral campaigner Mary Whitehouse, the Western world had sunk into an abyss of state-sponsored depravity, from 'pre-marital sex, abortion on demand [and] homosexuality' to 'abuse of the monarchy, moral values, law and order and religion'.[2] Consensus seems impossible, and forty years on, the argument continues.

Putting aside the passionate rhetoric that usually surrounds the 1960s, however, the principal elements of their historical legacy seem clear. First, in both the United States and Britain, there was the invigorating shock of new-found, postwar affluence. For many, the privations of the 1930s and 1940s were an all too recent memory – the hardships of the American Dust Bowl, the restrictions and ration books of wartime Britain, and the dole queues and shortages of postwar austerity. Indeed, as late as the mid-1950s, millions of homes on both sides of the Atlantic lacked modern sanitation, with many working-class families in Britain still relying on a sink for their daily ablutions and bathing once a week in a tin bath. Even ten years later, everyday life in many areas was still a struggle against darkness, cold and dirt. For the poor, the disabled, the homeless and the elderly, life in the 1960s was rather less than swinging.

Change, however, was already in the air. In Britain, the turning point had come around 1954, when Churchill's Conservative government lifted the last of the food rations and relaxed controls on hire purchase. To use the analogy of the athletics track, if the average worker had been a sprinter, it was as though – after hours delayed on the blocks – he had suddenly been released and was racing towards prosperity. Wages boomed, consumer spending soared, and even working-class families could aspire to own their own houses, cars, televisions and other attributes of modern consumer society. 'Have you woken up?' asked the magazine *Queen* at the end of the 1950s. 'Don't you know you are living in a new world? … Britain has launched into an age of unparalleled lavish living … Don't wait until years after to realise you have lived in a remarkable age – the age of BOOM.'[3]

In the United States, where the rigours of wartime had been less exacting, the boom had started earlier, around 1945, and was even more pronounced. Foreign visitors in the early 1950s were often struck by the wealth and comfort of middle-income American families. This 'new world' was nicknamed the 'affluent society', after the liberal economist John Kenneth Galbraith's popular bestseller. British commentators, meanwhile, borrowed a phrase from the new Conservative prime minister, Harold Macmillan, who openly revelled in the new consumerism and used it to win re-election in 1959. 'Most of our people,' he famously declared, 'have never had it so good.'[4]

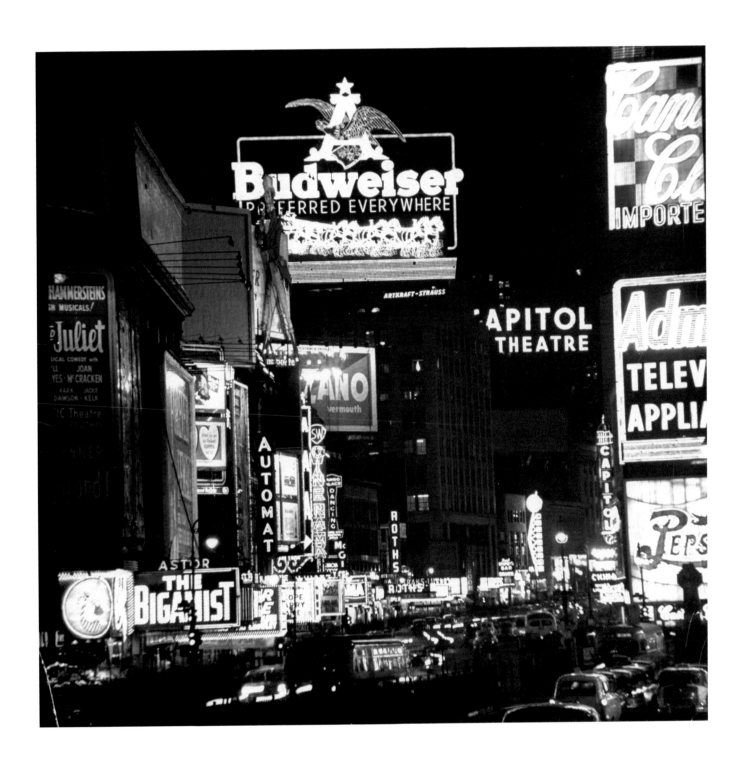

Advertisement in *Picture Post*

27 March 1954

Nowhere was the domestication of science and technology more apparent than in the suburban household, and no aspiring 'kitchen goddess' could be content without her own gleaming Formica worktops, which symbolized affluence and status.

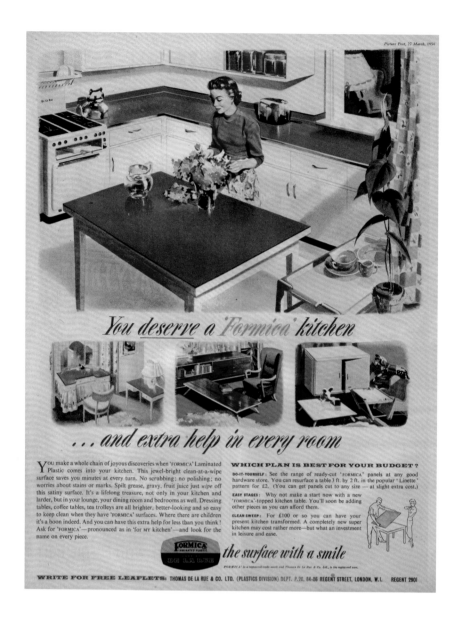

But behind the political rhetoric there were hard facts: rapid and steady economic growth, technological innovation, and unprecedented consumer demand. From Minneapolis to Manchester, millions of ordinary people found their lives transformed. Electric ovens and washing machines liberated housewives from hours of backbreaking drudgery, supermarkets offered an unrivalled choice of cheap foods, and new cars and fast highways opened the way to day-trips and family holidays by the seaside or in national parks. Instead of spending their evenings in pubs and bars, many men preferred to stay at home and watch television with their families. Whether British or American, youngsters found their horizons broadened by cheap paperbacks and a steady supply of comics, colourful toys and educational television programmes. And suburban housing estates, famously pioneered in Levittown, New York and then copied in the likes

of Telford and Milton Keynes, delivered cleanliness and comfort to families from the old inner cities. 'At the gates of the new decade,' said *The Economist*, looking forward to the 1960s, 'the main peril, blinding our eyes to what we could achieve, seems almost to be smugness.'[5]

Technological innovations were not confined solely to the domestic arena, and not for nothing did the 1960s become widely known as the Space Age. For many Americans and Britons, the most glamorous and exciting scientific developments of the postwar years were taking place in space. The race was on between Soviet and American scientists to build bigger and better rockets in which to explore the vast expanses of the universe. When *Sputnik*, the first satellite, was sent into orbit in 1957, the *Daily Express* ran the enormous banner headline 'SPACE AGE IS HERE' above the news that a Soviet 'man-made moon' was circling the earth.[6] With the launch of the NASA space programme in 1958, popular enthusiasm for rocketry, air power and space travel reached a peak never matched before or since. Words like 'astronaut', 'cosmonaut', 'countdown' and 'blast-off' found their way into everyday conversation, while a revealing cliché of the era held that every boy wanted to be an astronaut and every girl wanted to marry one. American toy

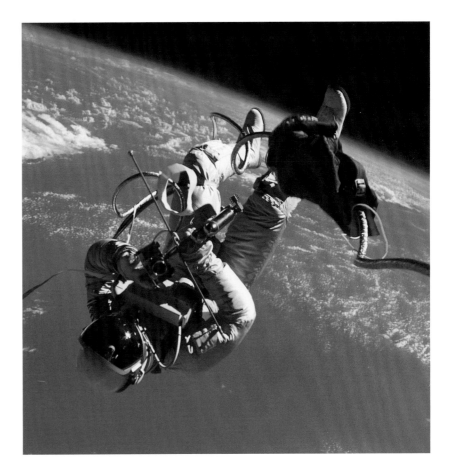

America's first space walk
3 June 1965

The space race captured imaginations across the world, especially in the United States and Soviet Union. Millions were entranced by the feats of astronauts such as NASA's Edward White, seen here floating in space with only a slender cord attaching him to his Gemini 4 capsule.

companies manufactured rockets, ray guns and spacesuits in their thousands, and children everywhere looked forward to a bright new future of intergalactic colonies, space walking and day trips to Jupiter. Indeed, it was supremely fitting that in the final year of the 1960s, Neil Armstrong became the first man to step onto the surface of the moon, providing one of the seminal images not merely of the decade, but of the century.

If one figure stood as the symbol of modern consumerism and luxury, the world so boldly captured by Pop Art, it was the teenager. The label had been coined by an American advertising agency in the 1930s, but teenagers really came to the fore in the mid-1950s, when their cultural horizons and economic independence set them apart as a distinctive social group. Much press attention focused on specific, often alarming subcultures, often heightened by class distinctions – the Teddy Boys of the early 1950s, the Mods and Rockers of the early 1960s, or the hippies and skinheads later in the decade – but in both Britain and the United States, most teenagers remained surprisingly conservative, preferring to earn a little extra money for clothes and records rather than knifing their neighbours or fomenting world revolution. Yet as a representative of modernity, energy, sexuality and ambition, the teenager was a striking emblem of what had changed since the days of austerity.

Teenage consumerism made its greatest impact in the fashion and music industries. In Britain, teenagers at the beginning of the 1960s spent more than £800 million a year on clothes and entertainment, chiefly pop records.[7] Popular music was not in itself anything new, but record companies recognized that teenagers were their most loyal and enthusiastic consumers and therefore tailored their output accordingly, as did the newly emergent radio stations. Contrary to legend, rock and roll music was only one among several musical genres, from romantic ballads, folk music and British R&B to skiffle and trad jazz, which were all jostling for commercial success during the late 1950s and early 1960s. In the United States, country musicians like Merle Haggard continued to appeal to millions of listeners, defying the snobbery of urban elites who looked down on 'hillbilly' music. By the middle of 1964, however, the extraordinary success of the Beatles had transformed the music scene on both sides of the Atlantic, and pop music became the defining element of the youth culture of the day, providing a common reference point for teenagers from wildly different backgrounds. Even the politicians had been converted: in 1964, the new Tory prime minister Sir Alec Douglas-Home inserted Beatles references into his speeches, while a year later Harold Wilson even awarded them the MBE. 'We may be regarded as a second-class power in politics,' the New Musical Express reminded its readers, 'but at any rate we now lead the world in pop music!'[8]

Nobody embodied the new spirit of the Swinging Sixties better than the Beatles, who were equally popular in Britain and the United States. Youngsters were delighted with the award; older generations, however, were horrified, and some war veterans even returned their medals.

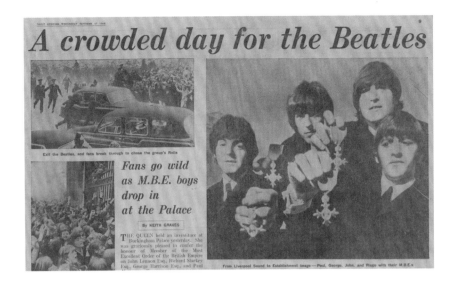

A crowded day for the Beatles

Exit the Beatles, and fans break through to chase the group's Rolls

Fans go wild as M.B.E. boys drop in at the Palace

By KEITH GRAVES

THE QUEEN held an investiture at Buckingham Palace yesterday. She was graciously pleased to confer the honour of Member of the Most Excellent Order of the British Empire on John Lennon Esq., Richard Starkey Esq., George Harrison Esq., and Paul

From Liverpool Sound to Establishment image — Paul, George, John, and Ringo with their M.B.E.s

Popular, transient, mass-produced, the emblematic music of the era fits squarely into the artist Richard Hamilton's famous definition of pop culture of 1957:

> Popular (designed for a mass audience)
>
> Transient (short term solution)
>
> Expendable (easily forgotten)
>
> Low cost
>
> Mass produced
>
> Young (aimed at youth)
>
> Witty
>
> Sexy
>
> Gimmicky
>
> Glamorous
>
> Big Business.[9]

Like so many of Pop Art's leading lights, Hamilton was fascinated by the expendability, glitter and sheer modernity of consumer culture, which reached a peak, as far as the British media was concerned, between about 1964 and 1966, the years of Harold Wilson's first Labour government. Breathless press features identified London as 'the swinging city', where 'ancient opulence and new elegance are all tangled up in a dazzling blur of Op and Pop'.[10] With a younger, more cosmopolitan population than at any time in living memory, thanks to immigration and an influx of affluent young couples, London had rediscovered its cultural self-confidence. Celebrities such as Mick Jagger, Michael Caine, Mary Quant and Jean Shrimpton were hailed as the new aristocracy, supposedly spearheading a great social breakthrough that would tear down the walls of tradition. 'People like me, we're the moderns', the actor Terence Stamp modestly

Mary Quant fashion
1 August 1967

Emphasizing youth, colour, vigour and fantasy, Mary Quant's clothes proved an international commercial sensation. Contrary to popular belief, however, their high prices meant that only wealthier shoppers could afford them.

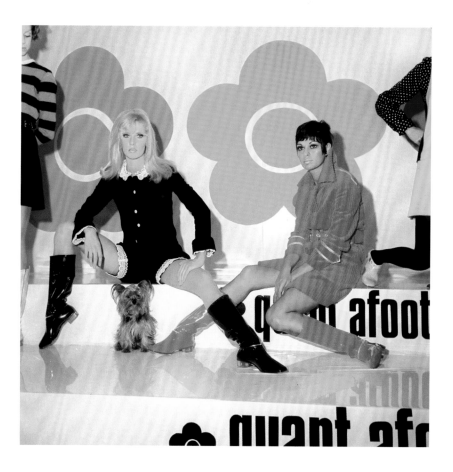

told an interviewer. 'We're the new swinging Englishmen. And it's people like me that are spreading the word.'[11]

Of course much of this was nonsense. Most people's lives, even in the capital itself, remained entirely untouched by Swinging London. But beneath the froth lay some solid foundations. British design and technology, epitomized in Alec Issigonis's Mini, Kenneth Grange's Kenwood Chef and Terence Conran's Habitat stores, were enjoying international acclaim. British fashion was also winning plaudits around the world, largely thanks to the wit and irreverence of Mary Quant, John Bates and Ossie Clark. And it was more democratic than ever before, too; with the advent of cheaper fabrics, more efficient distribution and, above all, mass production the very latest styles were available to all.

This bright new world of ceaseless innovation and conspicuous consumption, however, was not without its critics. Perhaps the most common indictment was that as Britain's empire fell away and its citizens devoted themselves to the pursuit of pleasure, they were steadily becoming 'Americanized'. The United States occupied a curious place in British affections during the 1950s and 1960s. On one level, it was a trusted and valued ally, a partner in the Cold War and a collaborator

in NATO. But on another level, however much it was idolized by those on the moderate left as a beacon of egalitarianism and democracy, America was deeply distrusted by older and more conservative observers as materialistic, selfish and suburban. In his book *The American Invasion* (1962), Francis Williams even argued that 'what too often moves across the world in the wake of American money and American know-how is what is most brash and superficial'.[12]

Yet in younger circles, especially among those who disliked the air of genteel decline that hung over British institutions, all things American seemed positively seductive. American culture appeared to offer something for everyone: pulp paperback bestsellers for the weary commuter; Beat poetry for the bohemian student; Disney cartoons for the enthusiastic youngster; even big-budget epics like *Ben Hur* or *Cleopatra* to divert the bored housewife. From television comedies like *I Love Lucy* to the paintings of Andy Warhol, the poetry of Allen Ginsberg and the novels of young Turks like Philip Roth and John Updike, American culture seemed to be sparkling with energy and excitement. 'The very air of America,' wrote the critic Bernard Bergonzi, 'seems more highly charged, more oxygenated, than the atmosphere in England.'[13]

Enthusiasm for America threw together a strange assortment of bedfellows, from Harold Wilson to David Hockney and from Kingsley Amis to Keith Richards. Opinion polls, however, consistently found that most British people regarded Americans with a strange mixture of envy and contempt, and far from tossing

Advertising in London
24 September 1968

By the late 1960s American-style advertising had reached Britain; from supermarket aisles to radio jingles, a new spirit of carefree materialism seemed to have taken hold.

**Civil rights riot,
Birmingham, Alabama**
3 May 1963

Civil rights marchers hoped to reverse
decades of segregation and suffering
in the American South, where racial
prejudice still held sway. International
audiences watched in awe the courage
of the civil rights activists, such as
this 17-year-old demonstrator, who is
defying an anti-parade ordinance. No
movement left a more inspiring legacy.

aside their local traditions in the rush to embrace Americanized affluence, most
clung to the reassurance of the familiar. But there is no doubt that thanks largely
to the influence of Hollywood films, transatlantic habits and fashions had more
impact in Britain than ever before – as exemplified by the ubiquity of American
stars, from Elvis Presley to Marilyn Monroe, in contemporary British culture.
(For more on this new fascination with fame, see Paul Moorhouse's essay later
in this book.) Even British cuisine showed signs of being 'Americanized', not least
through the appearance of steakhouses and burger bars.

The process of cultural exchange, however, was a complex one, as illustrated by
that most iconic example of American culture, rock and roll, which was exported
across the Atlantic in the late 1950s. Although British youngsters certainly loved
rock and roll, it had fallen from grace with American audiences by 1962 or so,
and it took the success of the Beatles – who drew on their own native musical
traditions as much as on American models – to convert Middle America to the
new musical genre. In later years, some American critics would moan that the
Beatles were merely imitating American originals like the adenoidal Bob Dylan;
but this merely overlooked the indigenous cultural heritage, from music hall to
nursery rhymes, which provided such a crucial element in their success.

Life on both sides of the Atlantic was characterized by economic growth,
affluence and consumerism, and there were plenty of overlaps between British
and American culture, not least in the field of pop music. But while Britain's
international position and self-esteem were in steady decline, most Americans
entered the decade in buoyant, self-confident mood. Despite the shadow of
the Cold War, which always loomed larger in American households than their
British equivalents, the 1950s had been generally good years. The newly elected
president, John F. Kennedy, who took office in January 1961, seemed a fitting
representative of the fresh spirit of vigour and enterprise; indeed, his promises to
'get America moving again' and to explore a 'new frontier' of opportunity captured
the optimistic mood of the day.

Although Kennedy in office proved to be a more cautious and conservative
president than is generally remembered, his youthful good looks, glamorous family
and skilful use of television meant that he became recognized across the world
as an icon of progressive promise. Even Kennedy's aggressive handling of the
Cold War, which risked nuclear confrontation during the Cuban Missile Crisis and
caused him to send some 18,000 American troops to South Vietnam, failed to
dent his popularity. By contrast, British politicians like Harold Macmillan and Alec
Douglas-Home looked positively antediluvian, and even though Harold Wilson,
then Britain's youngest prime minister, tried to affect various Kennedyesque

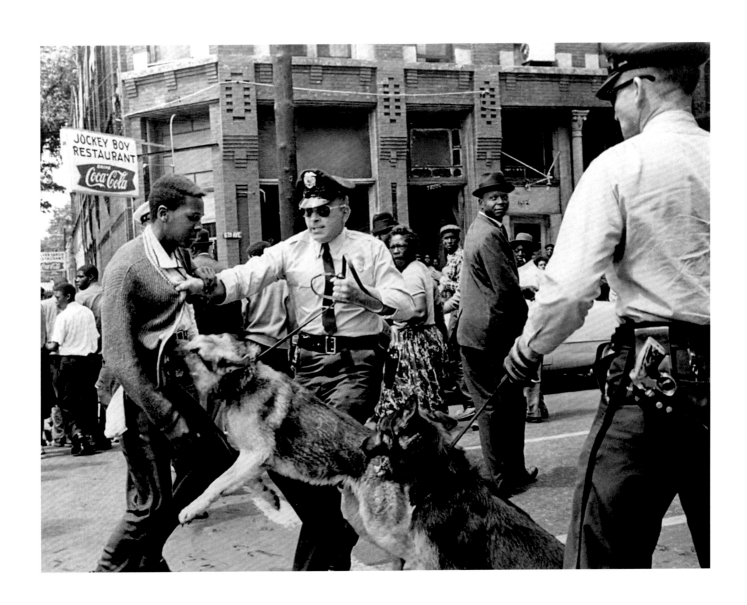

mannerisms, the spectacle of him puffing his pipe in a plastic raincoat did not inspire the same kind of adoration. Had Macmillan or Wilson been shot in November 1963, rather than Kennedy, it is hard to imagine a similar cult of the slain leader taking hold.

Ironically, it was Kennedy's successor, Lyndon Johnson, who proved a more effective legislative reformer. As an older, rather shop-worn wheeler-dealer from Texas, Johnson had none of his predecessor's telegenic charm and never became an icon of the era to the same extent. But it was Johnson, not Kennedy, who pushed through the laws that ended racial segregation in the American South, and it was Johnson who borrowed the slogan of the civil rights movement, telling Congress: 'We shall overcome.' Of course, this movement, rather like the anti-war campaign later in the decade, attracted enormous attention in Britain, not least because advances in communications technology meant that American events,

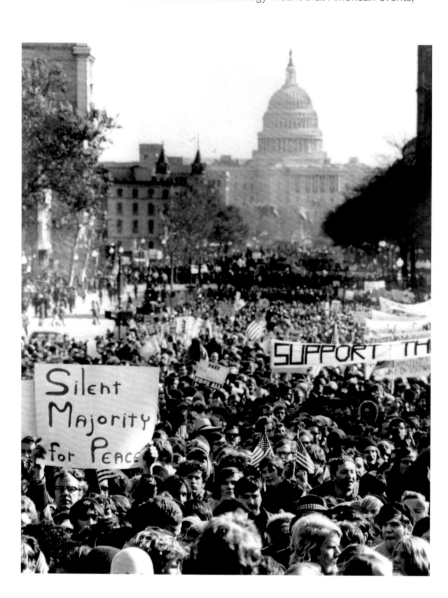

Moratorium Day peace rally, Washington, DC
15 November 1969

The movement against the Vietnam War galvanized millions of young people, students and radicals across the Western world, horrified at the terrible human cost. But for all the marches and demonstrations, the slaughter continued until 1975.

notably Kennedy's assassination, could be shown instantly in the living rooms of Huddersfield and Hull. Indeed, for many young observers on both sides of the Atlantic the civil rights movement became the emblematic struggle of the 1960s, though, looking back, what is really striking is how far it fell short of its goals.

While British commentators liked to talk about the 'rebellious' climate of American life, this was far from the truth. In most parts of the United States, especially in the heartland states far from New York and San Francisco, life went on much as before. Taking advantage of a continuing spirit of economic optimism, President Johnson pushed through a staggeringly ambitious programme of reforms known as the 'Great Society', designed to eradicate poverty and open opportunities for all. Harold Wilson's ambitions looked mundane by comparison. Wilson had come to power as the apostle of the technological age, promising a 'New Britain' born in 'the white heat of [the scientific] revolution'.[14] But Johnson's vision for the future was to turn sour, just as Wilson's dream of a New Britain failed to materialize.

In July 1966, when a crippling financial crisis wiped out Wilson's plans for a national renaissance, much of the economic optimism of the early 1960s evaporated. Swinging London was largely forgotten, while Wilson himself dropped all references to 'white heat' and was widely despised as the most unpopular prime minister since the 1930s. Johnson, having inherited Kennedy's commitment to defend the rump anti-Communist state of South Vietnam, deepened American involvement by sending hundreds of thousands of troops into the Indochinese jungle. The war went badly, becoming deeply unpopular with the left and among students, and in 1968 Johnson was forced to renounce his bid for re-election. Indeed, given the shock of the assassinations of Martin Luther King and Robert Kennedy, as well as the near-collapse of the American dollar and unprecedented scenes of protest and rioting in the streets, most Americans regarded 1968 as one of the most harrowing years in living memory – a useful reminder that there was much more to the 1960s than the youthful high jinks of popular memory.

The period ended rather differently for Britain, where the searing experiences of the civil rights movement and the Vietnam War in the United States had no parallel. There was simply no British equivalent to the experience of millions of black Americans in the Deep South, where it took a long campaign of sit-ins, demonstrations and boycotts to force the repeal of the repressive 'Jim Crow' segregation laws. And although the Vietnam War was deeply unpopular with the British public, it did not provoke anything like the anguish and introspection in the United States, largely because Harold Wilson had managed to keep British troops out. As the historian and activist Robin Blackburn put it, 'the Vietnam War, however much one might demonstrate against it here, was theirs'.[15] Despite

the attention given to the two marches to the American Embassy in Grosvenor Square in 1968, just a year later the British peace movement seemed to have disappeared without a trace – as did its American equivalent three years later.[16]

Unlike many of its neighbours, Britain did not have a particularly traumatic experience during 1968. While student protests paralysed Paris, Rome and West Berlin, the strikes and sit-ins at the London School of Economics and other institutions looked small-scale by comparison, and soon fizzled out leaving no major legacy. British students, in truth, were extremely well funded and treated by comparison with their European counterparts, and had far less to complain about.

American historians often treat the Vietnam War as a watershed, marking the point at which the technological, Technicolor optimism of the 1960s curdled into the grim, monochrome malaise of the 1970s. In fact, beneath the superficial self-confidence, a deep undercurrent of pessimism and angst ran directly from the 1950s to the 1970s. American commentators often spent more time arguing about racism, anti-Communism, the dangers of nuclear annihilation and the intractable problem of poverty than they did celebrating the consumerism of the day. In Britain the sense of unease was even more pronounced. The loss of Empire, the decline of Britain's international economic supremacy, the growing problem of industrial unrest and the outbreak of civil strife in Northern Ireland all provoked great bursts of soul-searching that undermined the common view of the 1960s as utopian years. Indeed, although the middle part of the decade did see a temporary enthusiasm for all things scientific, the 1960s began and ended with commentators asking 'What's Wrong With Britain?'

This loss of confidence was deeply rooted in popular suspicion of the social and cultural changes of the period. Contemporary surveys show that instead of throwing off their old habits, slipping into the latest fashions and dashing off to the nearest space-age orgy, most people stubbornly held fast to what they knew and trusted. In Britain, far from being swept away by the innovations of affluence, such apparently mundane pastimes as gardening, angling, working men's clubs and Crown Green bowls still enjoyed enormous popularity. In fact, the more controversial or innovative the developments, the more most people disliked them. There was no 'permissive' consensus: asked to nominate the change they hated most for a British survey in November 1969, the majority chose 'easier laws for homosexuality, divorce, abortion etc.', followed by immigration and student protest.[17]

The gradual liberalization of laws governing sexual behaviour was not, of course, confined to Britain. It was a general Western phenomenon, but in the United

States, too, developments like the legalisation of abortion were met with a combustible mixture of approval and horror. And by the beginning of the 1970s, talk in the United States of a 'silent majority' had become so popular that it was in danger of becoming a cliché. Indeed, it remains extremely doubtful whether there was a genuine 'sexual revolution' at all, and Philip Larkin deserves better than to be remembered for his misleading claim that sexual intercourse began in 1963. For one thing, sexual attitudes and behaviour had been changing since at least the turn of the twentieth century, so even if they became much more newsworthy in the 1960s, it makes more sense to talk of evolution than revolution. Contemporary surveys found that in both countries, most teenagers still led relatively chaste lives, with only a mild liberalization since the early 1950s, and for most people any revolution took place in the newspapers, not the bedroom.[18] And the Pill, which is often credited with (or blamed for) having revolutionized sexual behaviour overnight, was simply not a factor in the lives of many women, British or American, until the 1970s, as most family planning clinics would not issue it to unmarried women. In this respect, as in so many others, conservatism died hard.[19]

What was more striking was the changing role and expectations of women. Women's liberation also reflected a long history of progress going back to the Victorian period, but it nevertheless represented perhaps the one genuine social 'revolution' – and legacy – of the 1960s. In the mid-1950s, no more than one in four married women, whether British or American, had gone out to work. But the years that followed were to see an enormous transformation. On both sides of the Atlantic women poured into the workforce to meet the needs of the booming economy, so that by 1972 almost one in two married women went out to work. And whereas in 1950 most girls had been treated like housewives-in-waiting, by the end of the 1960s they were encouraged to nurture their own ambitions and follow their own careers. Of course there was still some way to go. Despite the rise of female politicians such as Barbara Castle, Margaret Thatcher and Shirley Williams, there were still very few women in British politics, and even fewer in Washington, DC. Even the art world was still overwhelmingly a male domain. With the notable exception of Bridget Riley, the best-known figures of the 1960s art scene were men.

As we have seen, for all the innovations of the decade, the 1960s ended on a strikingly downbeat note. Western economies were in deep trouble even before the decade ended, but it was the 1973 OPEC oil crisis, and the unexpected hike in petroleum prices, which finally signalled the end of the good times and the arrival of crippling inflation and industrial strife. Ultimately optimism gave way to disillusion. In both Britain and the United States, the economy had begun to

NOTES

1 *Sunday Times* colour supplement, 26 January 1964.

2 Mary Whitehouse, *Whatever Happened to Sex?* (Hove, 1977), pp.8–9.

3 *Queen*, 15 September 1959.

4 See Dominic Sandbrook, *Never Had It So Good: A History of Britain from Suez to the Beatles* (London, 2005), p.80.

5 *The Economist*, 26 December 1959.

6 *Daily Express*, 5 October 1957.

7 Mark Abrams, *The Teenage Consumer* (London, 1959), pp.13–14.

8 *New Musical Express*, 25 June 1965.

9 Letter dated 16 January 1957, reprinted in Richard Hamilton, *Collected Words: 1953–1982* (London, 1982), p.28.

10 *Time*, 15 April 1966.

11 Shawn Levy, *Ready, Steady Go! Swinging London and the Invention of Cool* (London, 2002), p.66.

12 Francis Williams, *The American Invasion* (London, 1962), p.12.

13 Bernard Bergonzi, *The Situation of the Novel* (London, 1970), p.62.

14 See Dominic Sandbrook, *White Heat: A History of Britain in the Swinging Sixties* (London, 2006), pp.3–7.

15 Quoted in Jonathon Green, *Days in the Life: Voices from the English Underground, 1961–1971* (London, 1998), pp.61–2.

16 See Melvin Small, *Johnson, Nixon and the Doves* (New Brunswick, 1988).

17 *New Society*, 27 November 1969.

18 See Michael Schofield, *The Sexual Behaviour of Young People* (London, 1965) and Geoffrey Gorer, *Sex and Marriage in England Today* (London, 1971).

19 See, for example Hera Cook, *The Long Sexual Revolution: English Women, Sex and Contraception, 1800–1975* (Oxford, 2004).

20 Ben Pimlott, *Harold Wilson* (London, 1992), p.558.

stutter badly as early as 1966, as both governments grappled with labour unrest, overvalued currencies and rising inflation. By 1968, British workers found that they were no longer enjoying fatter wage packets and improved living standards year after year, and as they struck for higher pay, inflation climbed still higher. At the same time, the backlash against the ambitions of liberalism was already underway. Crime, drug addiction, homelessness and other social ills had all risen steeply during the 1960s, and while American politicians like Richard Nixon and Ronald Reagan built new conservative alliances on the back of popular discontent, British critics of liberalism from Mary Whitehouse to Kingsley Amis mounted a fierce attack on the values of affluence. With the Beatles breaking up, the Rolling Stones losing their innocence and even Sean Connery losing his hair, there was a palpable sense that an era had passed. And when Harold Wilson lost the British general election in June 1970, his sons cleared his things out of Downing Street while listening to the Seekers' hit *The Carnival Is Over* – a fitting conclusion to the gaudiest of postwar decades.[20]

In a sense, however, the 1960s are with us still. The twenty-first century may look nothing like the stark white utopia portrayed in Stanley Kubrick's film *2001: A Space Odyssey* (1968), but we nevertheless grapple with issues that came to the fore during that period, from mass consumerism and technological change to sexual morality and gender equality. And in many ways Pop Art, too, is with us still, its bold, bright colours, celebration of celebrity and fascination with consumerism having seeped into the cultural mainstream. Fads and fashions come and go, but it is remarkable that the legacies of the Swinging Sixties – political, musical, artistic – remain as controversial as ever. 'Pop Art: Way Out or Way IN?' asked the *Sunday Times* in 1964. Four decades on, the answer is still 'Way IN'.

UK

1952

The Independent Group is established at the Institute of Contemporary Arts (ICA), London to discuss topical issues connected with contemporary urban life. Eduardo Paolozzi gives the inaugural lecture, 'Bunk', a quick-fire presentation of images based on collages and magazine covers.

Identity cards, carried by all British citizens as a compulsory measure during wartime, are abolished by Winston Churchill's government.

The world's first commercial jet (a BOAC Comet 1) flies from London to Johannesburg, carrying 32 fare-paying passengers, in less than 24 hours.

1953

Eduardo Paolozzi, Nigel Henderson and Alison and Peter Smithson curate *Parallel of Life and Art* at the ICA, London, which contains over 100 black-and-white images from art and non-art sources.

Edmund Hillary and Tenzing Norgay conquer Mount Everest.

The coronation of Elizabeth II is one of the first major events to be televised – over 20 million people watch the BBC coverage.

English geneticist Francis Crick and Chicago-born genetic researcher James Watson discover the double-helix structure of DNA, which explains how genetic information is carried and reproduced by living organisms.

1954

The 1954 Television Act allows the creation of the first commercial television network and advertising-funded programmes (ITV begins broadcasting the following year).

Food rationing ends, almost nine years after the end of the Second World War.

The first Wimpy Bar opens in Coventry Street, London, established by J. Lyons and Co.

Athlete Roger Bannister breaks the record for the four-minute mile.

International

1952

Allied occupation of West Germany, after the Second World War, comes to an end.

The American rebuilding of European allied countries under the Marshall Plan is completed.

The USSR vetoes Japan's admission to the United Nations (UN).

In Paris, Irish playwright Samuel Beckett's radical play, *En attendant Godot* (Waiting for Godot), is first performed.

1953

Joseph Stalin, General Secretary of the Communist Party of the USSR's Central Committee, dies, having ruled the Soviet Union since 1928.

The Korean War, which began in 1950, is ended by the signing of an armistice.

Successful detonation of a Soviet hydrogen bomb is publicly acknowledged by the USSR.

Cuban lawyer Fidel Castro leads a rebel force to unseat the dictatorship of General Batista, but most of his men are killed and Castro himself is arrested and sentenced to a 15-year prison term.

1954

Vietnam is divided, with a communist regime under Ho Chi Minh in the north and a nationalist government in the south, after the defeat of the French at Dien Bien Phu.

The USSR's first nuclear power station becomes operational.

The portable transistor radio, designed by Texas Instruments, is marketed worldwide.

US

1952

Racial and ethnic restrictions in the application process to become a US citizen are abolished through the Immigration and Naturalization Act.

The National Security Agency is founded, responsible for the collection of foreign intelligence.

The US Atomic Energy Commission tests a hydrogen bomb at Bikini Atoll in the South Pacific that is over 500 times more powerful than the atom bomb dropped on Hiroshima in 1945.

1953

Willem de Kooning holds a solo exhibition at the Sidney Janis Gallery, New York.

Publisher Hugh Hefner launches *Playboy* magazine, with Marilyn Monroe as its cover girl.

CBS begins the first colour television broadcasts; 54 per cent of American homes now have television sets and *TV Guide*, a pocket-size weekly programme listing, has a circulation of 1.5 million by the year end; the US television industry now has a revenue of $538 million, thanks in part to support from cigarette advertisers.

IBM starts building commercial computers.

1954

The USS *Nautilus*, the world's first nuclear-powered submarine, is launched.

General Motors produces its 50 millionth car.

Racial segregation is ruled to be in violation of the Fourteenth Amendment by the US Supreme Court, beginning the long struggle for civil rights for African-Americans and other minority groups in the US that continues into the 1960s.

1955

The exhibition *Man, Machine and Motion* at the ICA, London is devised by Richard Hamilton.

Welsh fashion designer **Mary Quant** opens her first clothing boutique, *Bazaar*, on the King's Road, London and attracts a following among Chelsea's writers, artists, photographers and models.

Ruth Ellis is the last woman to be executed in Britain.

West Germany joins the North Atlantic Treaty Organization (NATO); as a consequence, the Soviet Union establishes its own military alliance, the Warsaw Pact.

The first shanty towns appear outside Johannesburg, South Africa as black citizens are forcibly removed from the city.

Dictator and president of Argentina, Juan Perón, is deposed by the military junta.

Rosa Parks refuses to give up her bus seat to a white American passenger in Alabama; following her arrest, African-Americans campaign for the desegregation of public transport.

Popular icon James Dean dies in a car accident shortly after the release of the film *Rebel without a Cause*, directed by film-maker Nicholas Ray.

US automobile sales reach an unprecedented 7,169,908, of which fewer than 52,000 are imported.

1956

The exhibition *This is Tomorrow* opens at the Whitechapel Art Gallery, London, and includes installations by Independent Group members Eduardo Paolozzi, Richard Hamilton and others. Hamilton is commissioned to make an illustration for the catalogue and exhibition poster; the collage he produces, *Just What is it that makes today's homes so different, so appealing?*, is later recognized as a seminal Pop Art image.

Important works by Abstract Expressionist painters Jackson Pollock, Willem de Kooning and others are included in the exhibition *Modern Art in the United States*, at the Tate Gallery, London.

Newly elected president of Egypt, Colonel Gamal Nasser, nationalizes the Suez Canal and the Suez crisis begins, which involves the abortive invasion of Egypt by Israel, Britain and France.

Popular Hungarian uprising against Communist rule suppressed by Soviet troops.

Fidel Castro leaves Mexico (his chosen domicile under an amnesty in 1955) and lands on the coast of Cuba; the Cuban revolution begins.

Jackson Pollock dies in a car crash and the Museum of Modern Art, New York holds a memorial exhibition of his work.

Construction work starts on the Interstate Highway.

Elvis Presley releases his first No. 1 hit, *Heartbreak Hotel*, and becomes known as the King of Rock and Roll.

The first transatlantic cable telephone service becomes operational.

1957

Richard Hamilton begins teaching at the RCA, London and meets Richard Smith and Peter Blake.

The Gold Coast is the first of Britain's African colonies to become independent, followed in 1960 by Nigeria, in 1962 by Uganda, in 1963 by Kenya, and in 1964 by North Rhodesia; Malaya also becomes independent of Britain.

The Wolfenden Report recommends the decriminalization of homosexuality.

France, West Germany, Italy, Belgium, the Netherlands and Luxemburg establish the European Economic Community (EEC) through the Treaty of Rome.

The International Atomic Energy Agency is set up to control the production of atomic weapons and promote peaceful use of nuclear power.

The USSR launches Sputnik I and II, the world's first man-made earth satellites, and triggers the space race.

Zabriskie Gallery, New York, holds the *Collage in America* exhibition.

Leo Castelli Gallery, New York opens with a group show that includes the work of Willem de Kooning and Jackson Pollock.

The first nuclear power plant generates electricity in Pennsylvania.

Jack Kerouac publishes *On the Road*, which makes him a cult hero of the Beat movement.

Leonard Bernstein's musical *West Side Story*, a popular retelling of the Romeo and Juliet story in the guise of contemporary New York gang culture, premieres on Broadway.

1958

Works by Peter Blake and Richard Smith are shown in the exhibition *Five Young Painters* at the ICA, London.

The exhibition *Jackson Pollock: 1912–1956* opens at the Whitechapel Art Gallery, London.

Gatwick Airport reopens after major renovation and is the first UK airport with a direct train link into central London.

The Campaign for Nuclear Disarmament (CND) is launched.

Racial attacks occur in Nottingham and in Notting Hill, London.

A new world record is set for a London to New York flight at just under eight hours.

The United Arab Republic is formed, with Syria and Egypt as founding members.

The British airline BOAC revolutionizes commercial transatlantic aviation with a new version of the de Havilland Comet passenger aircraft.

Mao Zedong (Mao Tse-tung) instigates the Great Leap Forward, which aims to speed up China's industrial development.

Jasper Johns and Robert Rauschenberg hold their first solo exhibitions at the Leo Castelli Gallery, New York.

Allan Kaprow mounts an installation of sound, light and smell at the Hansa Gallery, New York.

The US establishes the National Aeronautics and Space Administration (NASA) to run the national space programme.

The first US-built commercial jet, the Boeing 707, goes into service to challenge the De Havilland Comet for leadership in the jet aircraft industry.

1959

David Hockney, Derek Boshier, Peter Phillips and Allen Jones all enrol at the RCA, London and R. B. Kitaj transfers to the RCA from the Ruskin School of Drawing, Oxford.

The first British survey of Abstract Expressionism, *The New American Painting*, is held at the Tate Gallery, London.

Britain's quintessential small car, the Mini, designed by Alec Issigonis, goes on sale.

English engineer Christopher Cockerell demonstrates his hovercraft design by crossing the English Channel on a cushion of air; within six years hovercrafts are in daily use.

War breaks out in Vietnam; the US deploys military support to the Republic of Vietnam in the south while the USSR and People's Republic of China arm the communist Viet Cong in the north.

Fidel Castro overthrows the Batista government to become prime minister of Cuba.

Soviet space probe Lunik 3 takes the first photographs of the dark side of the moon.

The first public 'happening' is produced by Allan Kaprow at the Reuben Gallery, New York with Jasper Johns and Robert Rauschenberg among the performers.

The Barbie doll is introduced at a New York toy fair by Mattel Inc, and is allegedly based on dolls handed out to patrons of a West Berlin brothel.

Xerox manufactures a plain paper copier.

The microchip is invented by Texas Instruments engineer Jack Kilby; its legacy is the computer revolution.

1960	**1961**	**1962**	**1963**	**1964**

Eduardo Paolozzi represents Britain at the 30th Venice Biennale, Italy.

Jasper Johns exhibits *White Numbers* (1958) as part of the *Mysterious Sign* exhibition at the ICA, London, his first work to be shown in the UK.

One of the first menswear boutiques, Domino Male, opens in Carnaby Street, London.

The ban on *Lady Chatterley's Lover*, D.H. Lawrence's 1928 novel, is lifted and Penguin Books is acquitted of obscenity.

Young Contemporaries exhibition is held at the RBA Galleries, London and includes work by Derek Boshier, Patrick Caulfield, David Hockney, Allen Jones, R. B. Kitaj and Peter Phillips.

The National Health Service announces that contraceptive pills are to be made available to women.

South Africa becomes a republic, outside the Commonwealth.

Pop! Goes the Easel, a documentary film on Pop Art in the UK by Ken Russell, is screened on BBC's weekly cultural show *Monitor*; this introduces the British public to Peter Blake, Pauline Boty, Peter Phillips and Derek Boshier.

Image in Progress at the Grabowski Gallery, London includes the work of David Hockney, Derek Boshier, Allen Jones and Peter Phillips.

The Commonwealth Immigration Act removes the right to free entry to Britain for all Commonwealth citizens.

The Popular Image opens at the ICA, London, with work by Lichtenstein, D'Arcangelo, Dine, Johns, Oldenburg, Rauschenberg, Ramos, Rosenquist, Warhol and Wesselmann.

Richard Hamilton, Richard Smith and Peter Blake give talks to students at the RCA on the 'Nature of Pop Art'.

John Profumo, secretary of state for war, resigns from the government, admitting that he had misled the House of Commons by denying his affair with Christine Keeler, who had also been the lover of Soviet naval attaché Captain Evgeny Ivanov, a known spy.

The miniskirt appears, designed by Mary Quant.

The *Sunday Times* **colour magazine** reproduces Roy Lichtenstein's *Hopeless* on the cover, to illustrate the feature 'Pop Art: Way Out or Way IN?'

The exhibition *The New Generation: 1964* is held at the Whitechapel Art Gallery and features the work of Derek Boshier, Patrick Caulfield, David Hockney, Allen Jones and Peter Phillips.

The Labour Party wins the British general election and Harold Wilson takes over from Sir Alec Douglas-Home as prime minister.

The Beatles star in their first film – *A Hard Day's Night* – and appear on *The Ed Sullivan Show* on US television.

The European Free Trade Association (EFTA) is formed as an alternative to the EEC by the UK, Austria, Denmark, Norway, Switzerland, Portugal and Sweden, enabling free trade between its members.

Outside Sharpeville police station, some 7,000 black South Africans, coordinated by the Pan African Congress (PAC), protest against the enforced carrying of Pass Books; the police open fire killing 69 protesters and injuring over 180.

Federico Fellini's decadent film *La dolce vita* is screened.

The Berlin Wall is built, designed to partition East and West Germany and to stop migration from the Communist Eastern bloc to democratic West Berlin.

The US provides military support to an army of some 1,500 Cuban exiles in a plan to overthrow Fidel Castro, but the coup is unsuccessful and the Bay of Pigs invasion, as it becomes known, ends in disaster for the US.

Soviet cosmonaut Yuri Gagarin becomes the first man in space and the first to orbit the earth, aboard the Vostok 1.

Launch of the first communications satellite, Telstar, which enables television, high-speed data and telephone transmissions from the UK to the US and vice versa.

The Berlin Wall claims its first fatality as an East German civilian is killed trying to cross it.

The Cuban Missile Crisis erupts when American aircraft spot a Soviet nuclear missile base being built in Cuba and the US declares a naval blockade; after ten days of an imminent threat of nuclear war, Soviet leader Nikita Khrushchev agrees to dismantle the Cuban missile sites, the blockade ends, and US missiles in Turkey are quietly removed.

President de Gaulle vetoes British entry to the EEC.

Soviet cosmonaut Valentina Tereshkova becomes the first woman in space.

The trial of Nelson Mandela – charged with sabotage and conspiracy to overthrow the government, under the Suppression of Communism Act – begins in South Africa (ends 1964).

The Nuclear Test-Ban Treaty, banning all above-ground nuclear testing, is signed in Moscow by the UK, the US and the Soviet Union.

NASA's Ranger VII photographs the moon's surface.

The People's Republic of China detonates its first atomic bomb.

Nelson Mandela and seven others are sentenced to life imprisonment on Robin Island in South Africa.

Japan's 'bullet' trains average 102 miles per hour and cut the 320-mile trip between Tokyo and Osaka from 390 minutes to 190 minutes.

Eduardo Paolozzi makes his debut in the US with a one-man touring show starting at Betty Parsons Gallery, New York.

The oral contraceptive pill becomes available to married women.

The Minimalist movement begins and maintains an important place in the art world for about a decade.

US registration figures record 74 million cars on US roads, one for every three Americans; and 15 per cent of families have more than one car, an increase from seven per cent in 1950.

Some 87 million US homes have television sets with access to more than 500 TV stations.

The Solomon R. Guggenheim Museum, New York recruits Lawrence Alloway as its new curator.

American astronaut Alan Shepard makes the first US manned space expedition, a 15-minute sub-orbital flight in Freedom 7.

John F. Kennedy is elected 35th president of the US against Richard Nixon, the first Catholic to hold the office; his presidency is known as the Camelot era.

The International Exhibition of the New Realists opens at the Sidney Janis Gallery, New York, featuring a mix of Pop artists from the UK and US.

British Art Today, curated by Lawrence Alloway, includes works by Peter Blake, Allen Jones, Eduardo Paolozzi, Peter Phillips and Joe Tilson; the exhibition starts its US tour at the San Francisco Museum of Art.

Andy Warhol paints *Campbell's Soup Cans*, a key work of the Pop Art movement using images from consumer culture, and, with other artists including Claes Oldenburg and Roy Lichtenstein, satirizes Americans' voracious consumption of manufactured products in the postwar period.

Marilyn Monroe is found dead.

Pop! Goes the Easel exhibition is held at the Contemporary Arts Museum, Houston and brings together Pop artists from the East and West coasts of America.

Andy Warhol opens the Factory, where he concentrates on mass-producing art works.

New York's Guggenheim Museum exhibits Pop Art works by Andy Warhol, Jasper Johns and Robert Rauschenberg.

Dr Martin Luther King leads 200,000 people on the 'March on Washington for Jobs and Freedom', at which he gives his famous 'I have a dream' speech.

President John F. Kennedy is assassinated in Dallas, Texas.

David Hockney has a highly successful first solo US show at the Charles Alan Gallery, New York.

The term 'optical art' is coined in *Time* magazine to describe painting and sculpture that makes use of optical effects to evoke physiological responses in the viewer; proponents of Op Art include Bridget Riley and Victor Vasarely.

The first Ford Mustang from Ford Motor Company is produced.

African-Americans are guaranteed the right to vote with the passage of the Twenty-Fourth Amendment to the US Constitution.

1965 | 1966 | 1967 | 1968 | 1969

1965

Pop as Art by Mario Amaya is published.

The Beatles receive the MBE for their services to pop music.

Winston Churchill dies and an estimated 350 million people worldwide watch his State funeral on television.

British Petroleum strikes oil in the North Sea.

John Schlesinger's *Darling*, starring Julie Christie, illustrates style-obsessed Sixties society.

1966

England wins the football World Cup at Wembley Stadium, the first victory for a home team since the tournament began in 1930.

A slagheap in the coal-mining village of Aberfan, South Wales, slides down Merthyr Mountain, destroying twenty houses, a farm and a school; 144 people are killed, including 116 children.

Ian Brady and Myra Hindley are sentenced to life imprisonment for the Moors Murders.

1967

Mick Jagger and the art dealer Robert Fraser are arrested on drugs charges.

The Abortion Act allows abortion under specified conditions.

The Beatles release *Sgt. Pepper's Lonely Hearts Club Band*.

The Sexual Offences Act decriminalizes homosexual acts between consenting males over 21.

Britain devalues the pound in an effort to check inflation and improve the nation's trade deficit.

1968

Roy Lichtenstein retrospective is held at London's Tate Gallery, the first show at the Tate devoted to a living American artist.

The UK now has over 19 million television sets.

Large demonstrations take place in London against US military action in Vietnam.

The Exchequer issues the nation's first decimal coins as Britain adopts the new currency.

1969

Pop Art opens at the Hayward Gallery, London.

After an attack by Protestants on a civil rights march in Northern Ireland, the Irish Republican Army (IRA) regroups with a view to retaliation; the British Army takes full responsibility for security in Northern Ireland.

Student protests shut down the London School of Economics.

The British version of the supersonic jet Concorde makes its first flight.

Prime Minister Ian Smith of Rhodesia issues a Unilateral Declaration of Independence (UDI) from Britain, and excludes blacks from participation in government.

Space walks by astronauts from the US and USSR.

US troops arrive in Vietnam and the ensuing war is the first to be televised.

Dominican Republic invaded and occupied by US Marines.

Heavy bombing of Hanoi, capital of North Vietnam, is carried out by US forces.

A power struggle within the Communist Party of China sparks the beginning of the Cultural Revolution by Mao Zedong (Mao Tse-tung), who publishes his *Little Red Book* with the aim of challenging the authority of party bureaucrats and restoring his own power, taking the People's Republic of China to the brink of civil war in the process.

The Soviet Luna 9 makes the first unmanned landing on the moon, soon followed by the United States' Surveyor 1.

The Six-Day Arab-Israeli War begins over the expulsion of the UN from the Gaza Strip, following months of conflict; Israel defeats Egypt, Jordan and Syria, afterwards occupying Arab land.

Argentinian/Cuban revolutionary Che Guevara is executed in Bolivia.

Dr Christiaan Barnard performs the first heart transplant in Cape Town, South Africa; the patient dies after 18 days.

The Boeing 737 makes its first flight.

In Czechoslovakia Alexander Dubcek becomes first secretary of the Czech Communist party and introduces liberal reforms, leading to the 'Prague Spring', which is brutally suppressed by Soviet tanks.

At My Lai, Vietnam, hundreds of unarmed civilians, many women and children, are killed by US soldiers.

French student protests escalate into a near revolution as workers strike and bring the country to a standstill; street protests also occur in other European cities, and the 'spirit of '68' becomes an inspiration for student radicals, revolutionaries and militants worldwide.

The first wave of US troops is withdrawn from Vietnam after the death of Ho Chi Minh.

Yasser Arafat is elected chairman of the Palestinian Liberation Organization (PLO).

Charles de Gaulle resigns as president of France after a referendum narrowly rejects constitutional reforms.

London: The New Scene starts its US tour at the Walker Art Center, Minneapolis; highlights include works by David Hockney, Allen Jones, Richard Smith, Joe Tilson and Peter Blake.

Black militant Malcolm X is shot dead in Harlem.

Students demonstrate in Washington, DC against the US bombing of North Vietnam and the peace movement gathers momentum through the 1960s as US involvement escalates.

Race riots erupt in the Los Angeles neighbourhood of Watts.

Pop and the American Tradition opens at the Milwaukee Art Center, Milwaukee.

Patrick Caulfield has his first solo exhibition in New York at the Robert Elkon Gallery.

Human Sexual Response by physician William H. Masters and psychologist Virginia Johnson at Washington University is thought to be the first comprehensive study of the physiology of human sexual activity.

The exhibition *Homage to Marilyn Monroe* held at the Sidney Janis Gallery, New York, exhibits 50 works by various artists.

There are now 74 nuclear-powered submarines in operation in the US Navy.

Some 100,000 people protest against the Vietnam War in San Francisco, the centre of the Free Love movement during the 'Summer of Love'.

Richard Hamilton holds his first solo exhibition at the Alexander Iolas Gallery, New York.

NASA launches Apollo 7, the first manned Apollo mission.

Dr Martin Luther King is assassinated in Memphis, Tennessee; a week of rioting and looting in American cities follows.

Senator Robert Kennedy, brother of President John F. Kennedy and front-runner for the Democratic presidential nomination, is assassinated in Los Angeles after winning the California primary.

Richard Nixon is elected 37th president of the United States against Hubert Humphrey.

The Woodstock music festival is held in upstate New York, attended by over 500,000 people; it becomes associated in the popular imagination with the youth culture of the late 1960s.

The Stonewall riot in New York begins the campaign for Gay Liberation, a movement that becomes part of a larger struggle for equal rights for oppressed groups, including racial minorities and women.

Apollo 11 is launched from Cape Kennedy in Florida; astronaut Neil Armstrong becomes the first man to set foot on the surface of the moon.

OVERTCOVERTANDIMAGINARY THEICONOGRAPHY OFTHEPOPARTPORTRAIT

PAUL MOORHOUSE

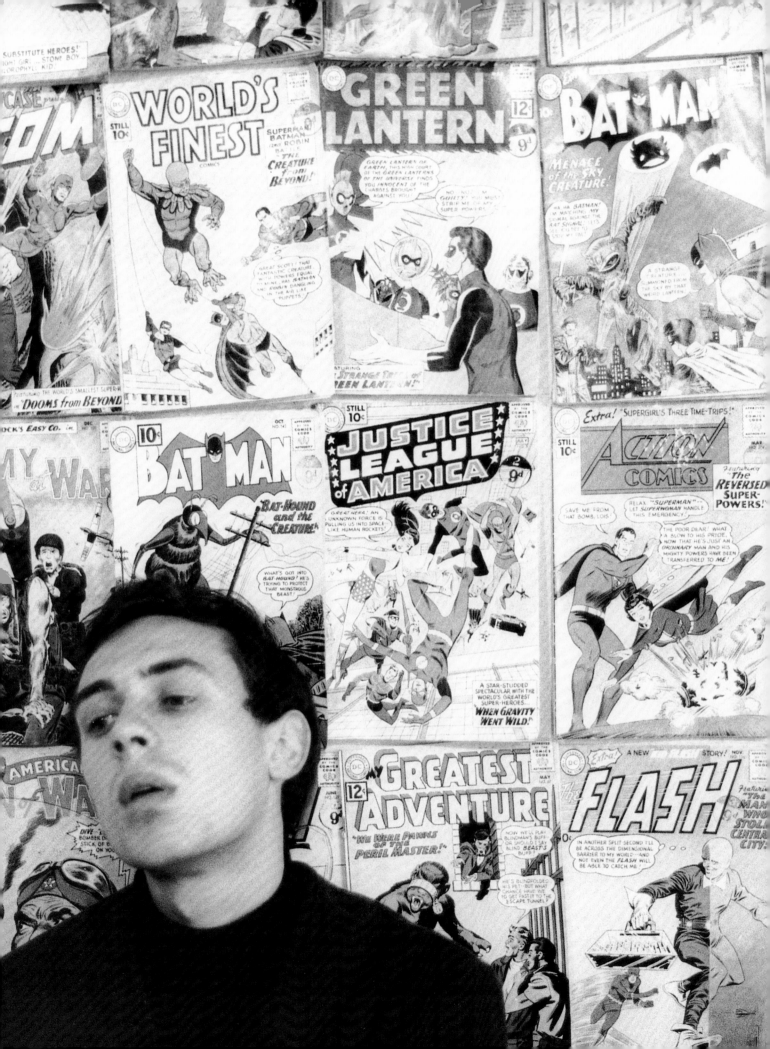

A New Image of Art

Pop Art defined the ideals and aspirations of a generation. While its origins in Britain and America are rooted in the 1950s, by 1965 Pop was firmly established, attracting international critical recognition and exciting the attention of the public in equal measure. In both countries a growing affluence promised a break with the privations of the past, generating fresh values and giving rise to unprecedented material expectations. The imagery and style of Pop Art seemed an inseparable part of the new consumer culture, sharing and expressing the widespread fascination with technological innovation and mass production. It was with some justification that in 1963 Andy Warhol described Pop Art as 'liking things'.[1]

Warhol's observation neatly encapsulates the slightly detached, somewhat uncritical treatment of its subject matter that characterizes American Pop Art. This tendency contrasts with the rather more probing approach of its British counterpart, as epitomized by Richard Hamilton:

> There was a mood of the late 1950s, felt both in London and New York, which made some painters strive for the unique attributes of our epoch – the particular character of our community as it is to register its identity on social history. Those affected by such recurring pressures seek to fabricate a new image of art to signify an understanding of man's changing state and the continually modifying channels through which his perception of the world is attained.[2]

Peter Phillips August 1963
Tony Evans

The difference between these two perspectives not only suggests striking variations in emphasis between British and American Pop. It also reveals, at a fundamental level, the diversity of Pop Art's motives and manifestations. Even a cursory comparison of the work of the leading figures associated with Pop throws up marked dissimilarities in terms of sensibility and subject. These disparities range, for example, from the machine-like nature of Warhol's screenprinting processes to the emphatic hand-made quality of Peter Blake's art; and they encompass Roy Lichtenstein's sophisticated manipulations of appropriated comic-strip imagery as well as the automatic drawing procedures favoured in Allen Jones's early Pop images.

The term 'Pop Art' is an art historical convenience and, inevitably, a generalization. Invented by the art critic Lawrence Alloway in 1954 to describe the material fabric of popular culture in general, it did not gain currency as a description of a particular kind of art until 1962, when Pop began to gain an international profile. As with most art categories, it serves as shorthand for a complex breadth of expression. The term is also used to refer to certain artists, notably Patrick Caulfield and David Hockney, whose work seems only tangentially or briefly to connect with the consumer culture that is taken to be one of Pop's defining characteristics. Such artists tended therefore to resist their work being labelled in this way. While the territory defined by the term is diverse, the essential elements of Pop Art are nevertheless precise. In essence, Pop's engagement with the urban environment reflects a concern with a changing world, the pace of which had accelerated in the postwar period. Pop focused on and brought into view the nature of these changes, holding up for scrutiny and in some cases interrogating the visual language of the consumer culture.

Central to these developments was the transition towards a mass culture. The consumer-driven principle of mass production found its ideal counterpart and voice in the mass media. A new, diverse platform of communication addressed a huge, expanded audience – simultaneously and with instantaneous effect. Cinema, television, radio, newspapers, magazines and paperbacks were vehicles conveying fresh ideas and developments in a way that transcended local boundaries, transmitting and disseminating the values of a truly 'popular' culture. Its manifestations embraced everything that was reproducible, from comic strips and fashion, to automotive styling and pop music. The trademarks of the new culture were standardization (expressing a wish for sameness), repetition (satisfying the need for predictability) and technological innovation (stimulating an ideal of newness). At its heart, and driving the process forward, was advertising. This was the pulse of modern society, circulating the excitement of life and creating an insatiable desire for more.

An art of objects and people

The picture that emerges of a dialogue between Pop Art and a society driven by consumer impulses dominates art historical assessments. In 1963, the critic David Sylvester observed of Pop Art: 'It incorporates into "fine art" things that ordinary people are looking at, makes us look at them in a new way.'[3] Sylvester shed valuable light on the crucial fact that Pop artists recontextualized the imagery and objects of popular culture within fine art in order to create a framework for perceiving and understanding such phenomena. But Sylvester's reference to 'things' echoes Warhol's identification of Pop with 'liking things', sustaining the impression that Pop is an art about objects. The following year, Sylvester returned to this idea and drove the point home:

> The peculiar thing about Pop Art is that it is more often a form of still-ife painting than of figurative painting … it doesn't depict men drinking, but the can of beer; it doesn't depict families out for a Sunday drive, but the car they drive in. When Pop Art brings figures in, it doesn't depict stars as they appear in the flesh, but the posters announcing their appearance…. In general, Pop Art's preoccupation is not so much with cult heroes and cult objects as with the means by which they are popularised.[4]

This view is true and yet, at the same time, unbalanced. Sylvester was certainly right to draw attention to a preoccupation with the 'means' of representation, an allusion to the appropriation of existing images and styles that characterizes the work of many Pop artists. However, the identification of Pop with still life rather than with figures needs to be treated cautiously. While objects are undoubtedly a prime source of Pop imagery, it is a mistake to overlook the rich vein of images

Robert Rauschenberg and Jasper Johns 1954
Rachel Rosenthal

Rauschenberg and Johns each had loft space in the same building on Pearl Street in New York from the mid-1950s. Around this time, both artists responded to the prevailing Abstract Expressionist style by introducing familiar objects and recognizable images within an abstract context. Rachel Rosenthal, who took this photograph, lived in the same building. Her face was cast in plaster by Johns, and the resulting portrait was used in *Untitled* 1954 (p.64).

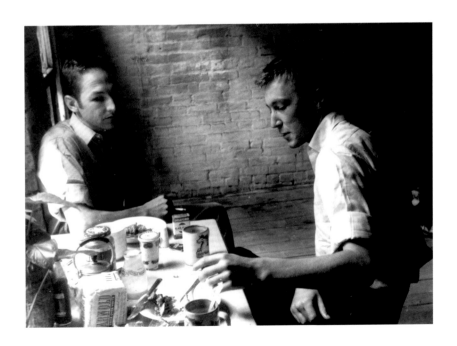

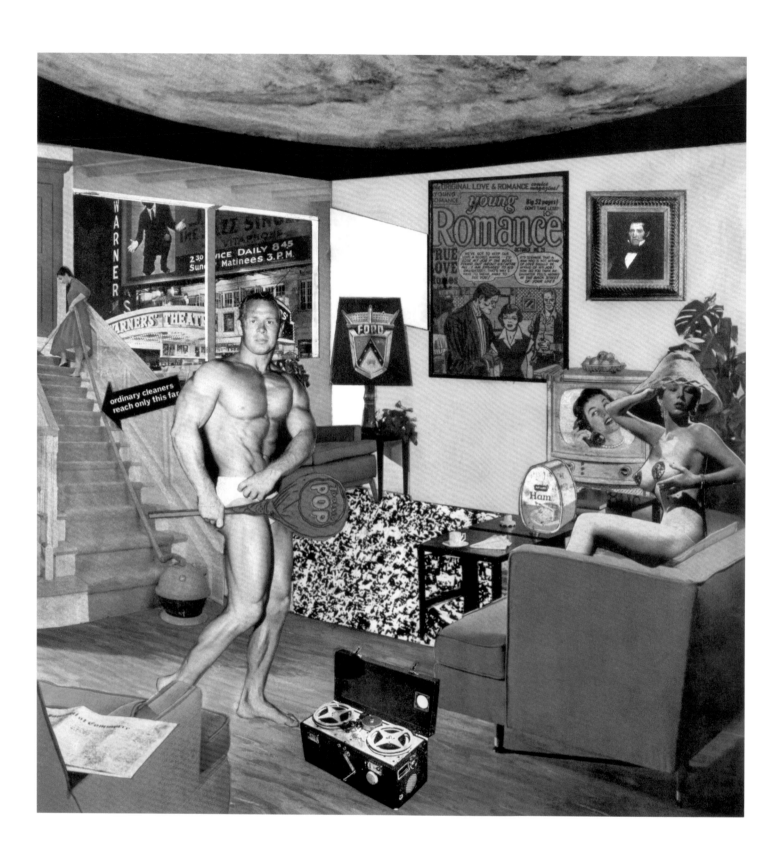

Just what is it that makes today's homes so different, so appealing? 1956 Richard Hamilton

of people, which Pop artists mined from the outset. Both in the context of a preoccupation with the 'means' of representation, and as subjects in themselves, figures and, in particular, portraits of various kinds, are key aspects of the iconography of Pop.

The figure is a dominant theme of early British Pop, as can be seen in Eduardo Paolozzi's *Time* magazine collages, in Richard Hamilton's seminal image *Just what is it that makes today's homes so different, so appealing?*, and in Peter Blake's works involving photographic pin-ups. Concurrent with these developments, in America Jasper Johns and Robert Rauschenberg were incorporating portrait casts and photographs of specific individuals within an abstract context. At the same time, Ray Johnson was making portraits of cult heroes such as Marilyn Monroe, James Dean and Elvis Presley the central preoccupation of his collages. The list can be extended indefinitely in considering the later history of Pop Art in Britain and America. The work of Hockney, Jones, Peter Phillips and other artists associated with the generation that emerged from the Royal College of Art in the early 1960s all contains a vital engagement with portraiture. The same is true of their American counterparts, notably Jim Dine, Lichtenstein, Mel Ramos and James Rosenquist and, not least, Andy Warhol. Ironically, given his reference to 'liking things', from the early 1960s Warhol emerged as an artist for whom portraiture was central.

Sylvester was not alone in identifying Pop as a form of still-life painting. Writing at the same time for an American audience, Alan Solomon, the Director of the Jewish Museum in New York, observed:

> The new art comes out of an intense need for deeper meanings than those provided
> by the art which preceded it, an art which had accepted the difference between art
> and life … the new art represents a search through the detritus of our culture for
> uncanny qualities which have somehow been produced in an unconscious way by
> the process of mass culture.[5]

Once again, this early view of Pop pinpoints some essential truths about the emerging movement while also introducing an element of distortion. As Solomon suggests, Pop represented a radical departure from the art of the preceding generation, Abstract Expressionism, in the way that it sought to abandon the insulated inner world of subjective experience and to reconnect with the external environment. However, the implication that the new realist art achieved this by sifting through the 'detritus' of contemporary culture places an undue emphasis on representing the world of things, as opposed to people. The 'detritus' that Solomon had in mind undoubtedly encompasses the material representation of

Look Mickey 1961 Roy Lichtenstein

human beings – for example, images in magazines, in advertising and on billboards – but the misleading impression conveyed was that Pop was primarily about objects.

This perspective dominates the literature on Pop and it obscures the critical presence of portraiture. Worse still, it fails to account for the rich complexity of images of people which characterizes the iconography of Pop. This is surprising, and also anomalous given that most critics recognize Pop's preoccupation with scrutinizing the nature and language of consumer culture, yet they ignore the fact that portraiture is a vital part of that scrutinizing process. Within Pop Art, there was, as Hamilton had pointed out, an imperative to reach 'an understanding of man's changing state', and it was only by examining the individual's relationship to the new world of mass-produced objects, and by addressing the way in which this relationship was represented, that such an understanding could be reached. For this reason, contrary to earlier assertions, Pop is replete with images of individuals interacting with the objects of popular culture – from Tom Wesselmann's *Great American Nude #27* 1962 (p.103), which depicts a reclining figure surveying an array of tempting drinks and ices, to Lichtenstein's *In the Car* 1963 (frontispiece), a close-up image derived from a comic strip.

The visual language of the Pop Art portrait

The boom in advertising, which by the early 1960s had reached unprecedented levels, stimulated a growing obsession with readily available consumer goods. But other manifestations of mass culture, notably cinema, fashion, television, magazines and pop music, propelled a parallel social revolution characterized by a fascination with media celebrities. Film stars, entertainers, astronauts, comic-strip characters and pop musicians all inhabited a popular collective consciousness. The glare of publicity illuminated this new infatuation with the phenomenon of fame. Such widely and instantly recognizable imagery was a primary source of material for Pop artists, the elements of glamour, excitement and affluence adding to its allure. Artists such as Rauschenberg, Warhol and Lichtenstein, in America, and Blake, Pauline Boty and Phillips in Britain, responded by positioning at the centre of their work images of the famous: the socialite Gloria Vanderbilt, Warhol himself, Donald Duck and Mickey Mouse, the Beatles, Marilyn Monroe and Brigitte Bardot. With its focus firmly fixed on the individual, a new popular portraiture was created.

These images have an overt subject. Indeed, depicting media celebrities in a fine art context depends for its impact on those depicted being recognizable. Even so, such portraits are rarely presented straightforwardly and without interpretation of the source image. In being recontextualized as art, the means of representation

and style of the original – whether photo-booth snapshot or newsclipping – were preserved and then subjected to manipulation. As Sylvester suggested, the language of the original – 'the means by which they are popularized' – was of great interest to the Pop artist. But to an extent perhaps not acknowledged sufficiently, Pop's focus on the style of representation underpinned a concern with the creation and status of a media 'image', and the relationship of that image to the individual depicted. In the case of Warhol's portraits of Marilyn Monroe, for example, it is this connection between the real person and their famous, mediated face that is the contested subject of these extraordinary images.

Pop's involvement with portraiture was not restricted to representations of icons, or overtly recognizable subjects. A great many Pop images have been mistakenly identified as depictions of anonymous 'types' with no real, individual identity. This view underestimates the rich complexity and subtlety that characterizes much figure-related imagery in Pop. Wesselmann, Hockney, Jones, Johns, Rauschenberg and even Lichtenstein are among many Pop artists whose work, in different ways, conceals the identity of the figures represented. Wesselmann's *Great American Nude* series (p.103), for example, drew on observation from life and, though not explicitly identified, the plaster casts from life in Johns's early assemblages are representations of known individuals. Such images are covert portraits, but portraits nonetheless, which also address the issue of the individual's relation to the modern world and its impact on personal identity.

Lastly, an important but also largely overlooked aspect of Pop Art is the way in which it developed the concept of portraiture way beyond the conventional representation of living people. Alongside portraits of overt and covert subjects, the work of such British Pop artists as Paolozzi, Hamilton and Colin Self is distinguished by strange but compelling images of invented individuals. Paolozzi's work, which is rooted in collage and assemblage, exemplifies this tendency. By taking disparate images and objects out of their original context, and then re-combining these elements in new configurations, Paolozzi's art spawned a new genre of fantasy portrait. The products of this process, of which his sculpture *St Sebastian No 1* 1957 (right) is a striking example, lift the image beyond the category of mere 'type'. In America, a variation of this approach is evident in the work of Claes Oldenburg and Allan D'Arcangelo. Unlike their British counterparts, these artists selected actual, named individuals, notably Marilyn Monroe. But such representations also embrace a degree of imaginative invention that transcends realistic description, testing and extending the boundaries of portraiture.

Whether depicting an overt, covert or imaginary subject, Pop portraiture developed in response to an epoch of unparalleled cultural change, a situation that inevitably

St Sebastian No 1 1957 Eduardo Paolozzi

48 **Eduardo Paolozzi** 1959 Ida Kar

Collage and assemblage were central to Paolozzi's art. Whether using found images on paper, or – as in this case – found objects cast in bronze, placing elements taken from different sources in new combinations permitted the creation of fantastic images and imaginary portraits. In this respect, Paolozzi cited Giuseppe Arcimboldo, the sixteenth-century Italian painter, as a progenitor.

raised questions about the status of the individual in a world that prized replication above uniqueness. Pop was the barometer of social flux, but its involvement in portraiture was the means by which issues such as the construction of fame and the transformation of personal identity could be addressed. As seen, Pop portraiture is complex in nature and varied in manifestation, and presenting a fuller picture now requires consideration of the particular stages and aspects of its development: from its beginnings in the early 1950s to its heyday between 1961 and 1965, and, finally, through the years leading to 1969, a period which saw the progressive darkening of the spirit of optimism that initially motivated Pop.

NOTES

1 Interview with G. R. Swenson, published in *Artnews*, November 1963, quoted in Marco Livingstone, 'Musings on women: Warhol and Lichtenstein', in *Pop Muses: Images of women by Roy Lichtenstein and Andy Warhol* (exh. cat., Tokyo, 1991).

2 Quoted in *Richard Hamilton: Paintings etc '56–64* (exh. cat., Hanover Gallery, London, October–November 1964).

3 David Sylvester, '"British Painting Now": Dark Sunlight', the *Sunday Times* colour magazine, 2 June 1963, pp.3–4, quoted in David E. Brauer, 'British Pop Art: 1956–1966 A Documentary Essay', in *US/UK Connections, 1956–1966* (exh. cat., The Menil Collection, Houston, January–May 2001), p.74.

4 David Sylvester, 'Art in a Coke Climate', the *Sunday Times* colour magazine, 26 January 1964, pp.14–23, quoted in Brauer, op. cit., p.76.

5 Alan Solomon, 'Introduction' in *the popular image* (exh. cat., ICA, London, 1963), unpaginated, quoted in Brauer, op. cit., p.75.

Precursors of Pop

The roots of Pop Art can be traced to a remarkable lecture entitled 'Bunk', given by Paolozzi in London in the winter of 1952. Paolozzi was addressing the first meeting of the Independent Group, a discussion group that would meet intermittently at the Institute of Contemporary Arts, Dover Street, during the next three years. Comprising artists, architects and writers, the group was consciously anti-elitist and anti-academic. The agenda that developed provided an opportunity for focusing on, and considering in an open way, contemporary urban life. Lawrence Alloway, who joined the group in 1953, observed that there was no dislike of commercial culture, as was the case in some intellectual circles. Movies, advertising, science fiction and pop music were accepted as facts of modern life. According to Paolozzi, some of the group members, including himself, were bound by a shared 'enthusiasm for the iconography of the New World'. At that time American culture was experienced from afar, through the imported American magazines that could be bought on the Charing Cross Road. The impression of an exotic and bountiful society conveyed by these lush magazine images would have contrasted with the situation in Britain, where food rationing continued until 1954.

The reaction to Paolozzi's lecture was one of 'shock' accompanied by 'disbelief and some hilarity'.[1] Using an epidiascope, Paolozzi projected, without commentary or logical sequence, a quick-fire succession of images. The audience saw, blown up to a large scale, an array of collages and pages torn from magazines that Paolozzi had been making and collecting since his final year at the Slade School of Fine Art in 1946. This activity had intensified during a stay in Paris between

**Meet the People from
Ten Collages from BUNK!** 1948
Eduardo Paolozzi

1947 and 1949, where he had immediate access to a rich fund of American magazines available from the GIs stationed there. The visual bombardment included covers of the magazine *Amazing Science Fiction*, advertisements for automobiles, sheets of American army insignia, and representations of robots performing a variety of tasks. Notwithstanding his audience's initial bewilderment, Paolozzi had made a serious point. Though much of the material might seem banal, it was held up as worthy of serious analysis and even as a source of aesthetic pleasure. The implication was that popular culture could be treated with the seriousness of art. 'To me,' Paolozzi later commented, 'this alternative culture had – and has – more energy and excitement than official culture.'[2]

The collages and tear sheets that Paolozzi had amassed comprised a highly visual mine of information about consumer culture, much of it reflecting America's leading role in harnessing technological development to the creation of an ideal future. In surveying this material, it is striking that so much of it contains imagery relating not simply to mass-produced objects, but to objects in new combinations and with a human dimension. The so-called *BUNK!* collages are complex images, comprising arrangements of disparate fragments.[3] They present a richly textured picture of individuals interacting with, or forming part of, a world of desirable consumer goods. In several instances, such images depict recognizable individuals. In *Meet the People* 1948 (p.50), for example, the American comedienne Lucille Ball and the comic-strip character Minnie Mouse are set against a multi-coloured backdrop of processed foods. Presenting both individuals in this way has a particular purpose, for the image as a whole seems to be saying that the American way of life is bountiful, convenient, glamorous and fun. Portraiture is again used to convey particular, if subliminal, messages in *BUNK! Evadne in Green Dimension* 1952 (p.54). The celebrity strongman Charles Atlas, complete with loincloth, is shown supporting above his head, and with one hand, a packed family saloon. The impression of consumer virility is compounded by a diagrammatic phallus containing an enticing female model in swimwear.

Empowered women are the subjects of *It's a Psychological Fact Pleasure Helps your Disposition* 1948 (p.55). Two collaged images depict smiling housewives enjoying themselves by cleaning an impressively glossy and technologically-boosted kitchen. Adorned with an ironic title, the image nevertheless succeeds neatly in directing attention to the visually slick, if psychologically patronizing language of advertising. Depicted photographically, both women are real individuals and in that sense the images are portraits. Yet the very nature of advertising strips them of their intended identity and renders them anonymous, an impression which sits uneasily with the sense of life enhancement. Recontextualized in this way, such covert portraiture – in which identity is not

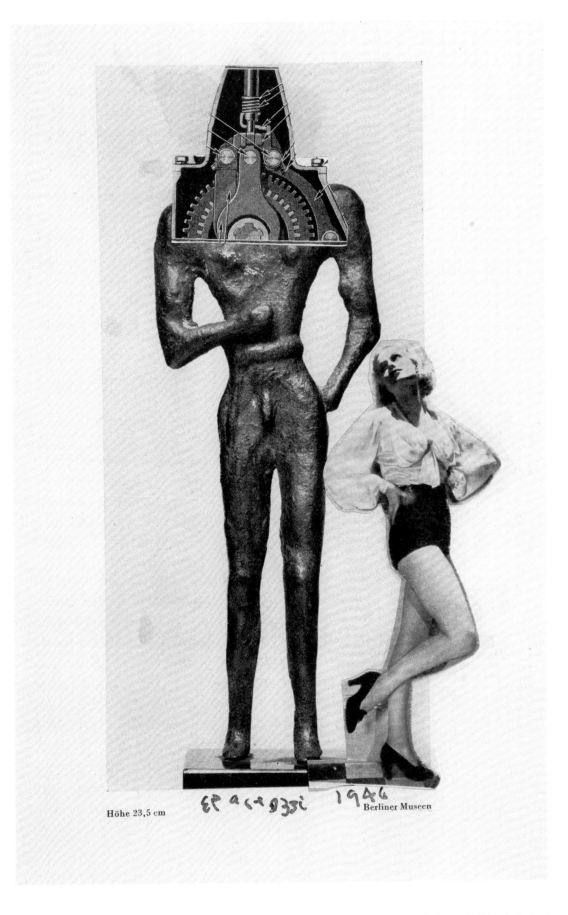

Höhe 23,5 cm

Berliner Museeen

Hi Hohe 1946 Eduardo Paolozzi

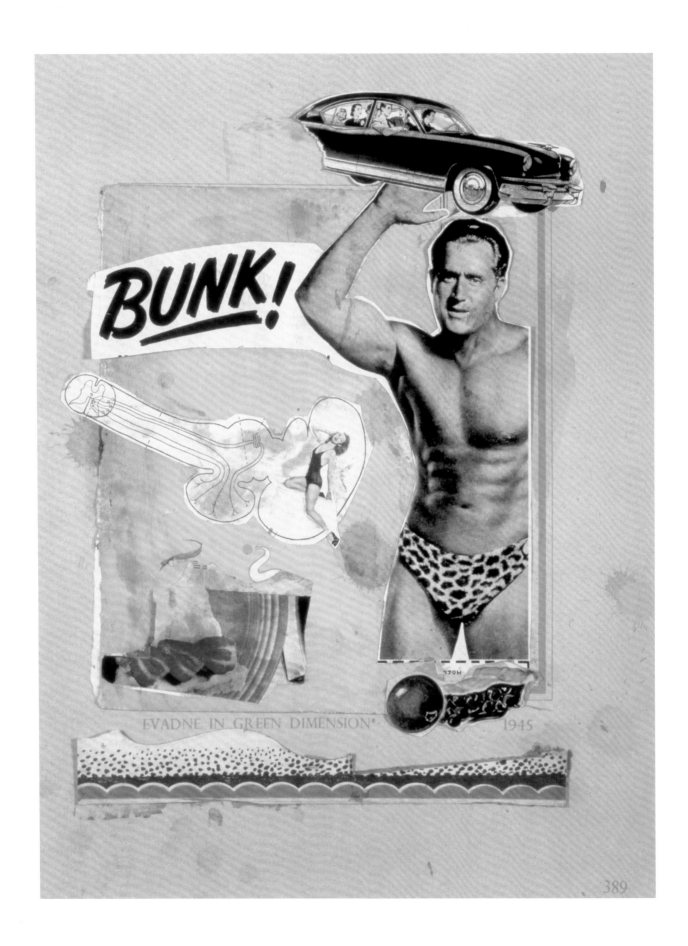

BUNK! Evadne in Green Dimension 1952 Eduardo Paolozzi

It's a Psychological Fact Pleasure Helps your Disposition from Ten Collages from BUNK! 1948 Eduardo Paolozzi

so much concealed as effaced – also has something to say about the relationship of the individual to a consumer world.

In the early 1950s, Paolozzi explored this idea further in a series of collages he made using the covers of *Time* magazine (right). In these images, Paolozzi dissected the portraits of real people and, by placing the parts in a different combination, created a new 'individual'. Created imaginatively, it is more difficult to categorize these images as portraits. Self-evidently that was their original status, yet the identity of each individual is now called into question. It is clear, however, that Paolozzi saw portraiture in a quite different light from conventional models. He later observed: 'Divine ambiguity is possible with collage – flesh marred by object or object masquerading as flesh. There is nothing astonishing in that – witness the great portraits of Arcimboldo.'[4] By relating the collage principle to the fantastic composite heads created by the sixteenth-century Italian painter, Paolozzi repositions his own images within the sphere of fantasy portraits: products of the artist's imagination. This kind of portrait raises questions about individuality, the implication being that personal identity is a fabrication.

These early collages had a personal significance for Paolozzi. The process of dissecting and recombining his archive of images, derived from the visual language of the mass media, facilitated his exploration of ideas. In sharing the *BUNK!* collages with fellow members of the Independent Group, he was to stimulate their interest in consumer culture, its complex layers of meaning and its potential for creating new structures with which to understand the modern world. In both respects, portraits and images of the human figure were central.

That said, the Independent Group did not act immediately on the ideas that Paolozzi had put forward in his 'Bunk' lecture. The programme of discussions in the winter of 1952–3 focused on technology. It was not until the winter of 1954–5 that the Group, reconvened by new members John McHale and Lawrence Alloway, set the agenda on the theme of popular culture. It was during the first meeting of these latter talks that the working theory of 'Pop Art' (referring then to the material manifestations of popular culture) was developed. Alloway recalled:

> We discovered that we had in common a vernacular culture that persisted beyond any special interest or skills in art, architecture, design or art criticism that any of us might possess. The area of contact was mass-produced urban culture: movies, advertising, science fiction, Pop music One result of our discussions was to take Pop culture out of the realm of 'escapism', 'sheer entertainment', 'relaxation', and to treat it with the seriousness of art. These interests put us in opposition both to the supporters of indigenous folk art and to anti-American feeling in Britain.[5]

Summer 1563
Giuseppe Arcimboldo

(Top left)
**From Mass Merchandising,
Profit for the Masses** c.1950

(Top right)
The Return 1951

(Bottom left)
North of the Border 1951

(Bottom right)
To Rule is to Take Orders 1952

Eduardo Paolozzi

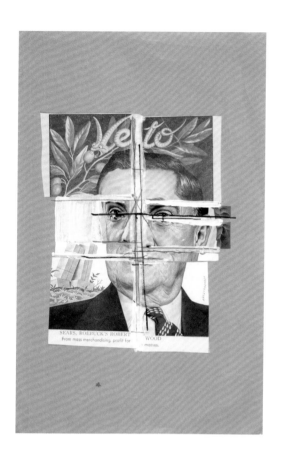

SEARS, ROEBUCK'S ROBERT ____ WOOD
From mass merchandising, profit for ____ ____ ties.

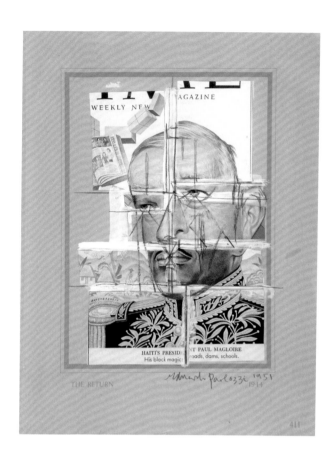

WEEKLY NEW ____ ____AGAZINE

HAITI'S PRESIDE ____ NT PAUL MAGLOIRE
His black magic: ____ roads, dams, schools.

THE RETURN

411

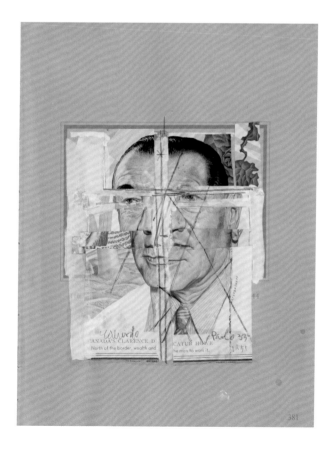

ANADA'S CLARENCE D ____ CATUR HO ____
North of the border, wealth and ____ ____ e man to work it.

381

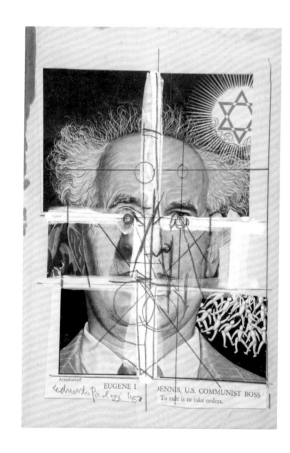

EUGENE ____ DENNIS, U.S. COMMUNIST BOSS
To rule is to take orders.

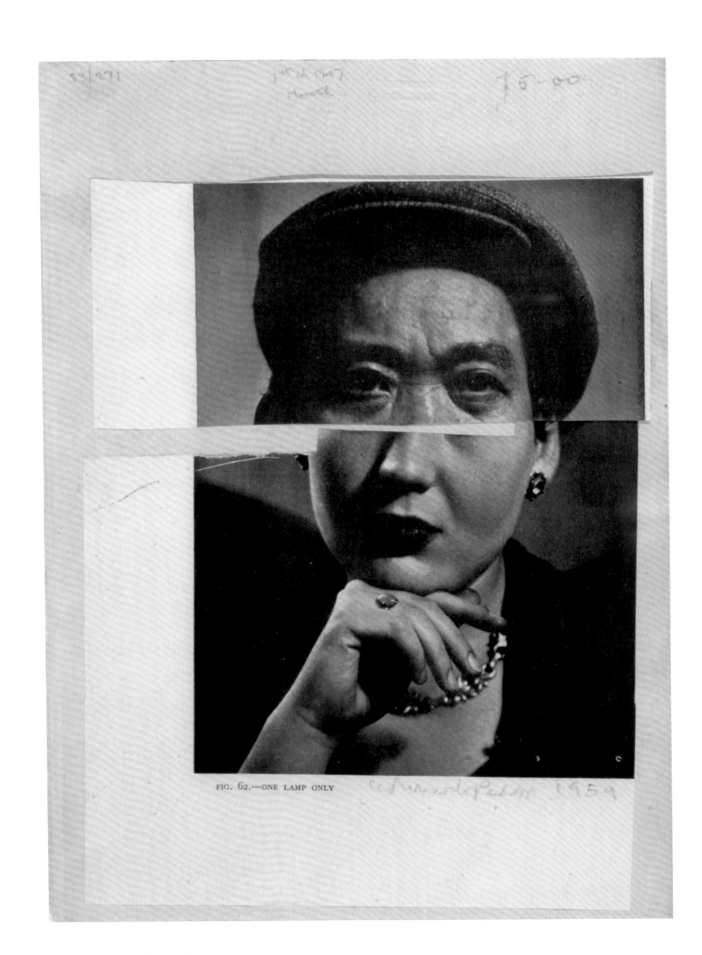

FIG. 62.—ONE LAMP ONLY

One Lamp Only 1959 Eduardo Paolozzi

Poster for *This is Tomorrow* at the Whitechapel Art Gallery 1956
Richard Hamilton

(Left)
In this collage, two half-fragments from a pair of unrelated photographs are combined, producing a new category of portraiture in which the subject is part-real and part-invented.

(Overleaf)
For the seminal exhibition *This is Tomorrow*, held at the Whitechapel Gallery in 1956, these artists and architects collaborated on the section entitled *Patio and Pavilion*, which included Henderson's *Head of a Man* (p.61).

Although treating Pop culture with the seriousness accorded to art, the Group had not yet conceived the notion of a continuum linking popular culture with the 'fine arts'. While that idea lay in the future, the focus of discussion was on popular culture itself. This process received much impetus from the large cache of American magazines, notably *Esquire*, *Mad* and *Playboy*, which John McHale had brought back to London following a trip to America. However, the Independent Group's subsequent involvement in two important London exhibitions – *Man, Machine and Motion* (1955) and *This is Tomorrow* (1956) – demonstrates the way popular culture, fine art and the role of the individual became progressively enmeshed. The first exhibition, *Man, Machine and Motion*, was organized by Hamilton, a founder member of the group, and used images of helicopters, automobiles and machinery to explore the relationship of men and machines. The second, *This is Tomorrow*, which was staged at the Whitechapel Gallery, comprised twelve installations, each assembled by a team of artists and architects, which explored the connection of art and modern life. Even so, for Hamilton the endeavour was 'not so much a question of finding art forms but an examination of values'.[6]

In terms of the evolution of Pop in Britain, *This is Tomorrow* was a landmark event and the role of people in the exhibition design is highly significant. The spectator was drawn into a succession of surrounding environments, each containing a plethora of material that evoked the profusion of modern life. As such, the exhibition underlined the relationship between the individual and the urban context, an impression reinforced by images of people as exhibits. The photographer Nigel Henderson participated in a section entitled *Patio and Pavilion*, designed by Paolozzi and the architects Alison and Peter Smithson. His exhibit, *Head of a Man* 1956 (p.61), which can be seen as an imaginative metaphorical portrait, takes the form of a large photographic collage in which images of a decaying city landscape are arranged in the form of a man's head and shoulders.

By general consent, the most arresting section was the final installation, organized by Hamilton, McHale and John Voelcker. The references to popular culture were direct and insistent: a fun-house structure, a giant collage of food, a sixteen-foot high figure of Robbie the Robot, an enormous bottle of Guinness, an image of Marilyn Monroe advertising the film *The Seven Year Itch*, as well as several projectors and a juke box. Hamilton was invited to make an illustration for the exhibition catalogue and a poster for the show (above). The remarkable collage he produced – *Just what is it that makes today's homes so different, so appealing?* 1956 (p.42) – is now seen as containing, in microcosm, the essential characteristics of Pop in terms both of spirit and imagery. While commentators

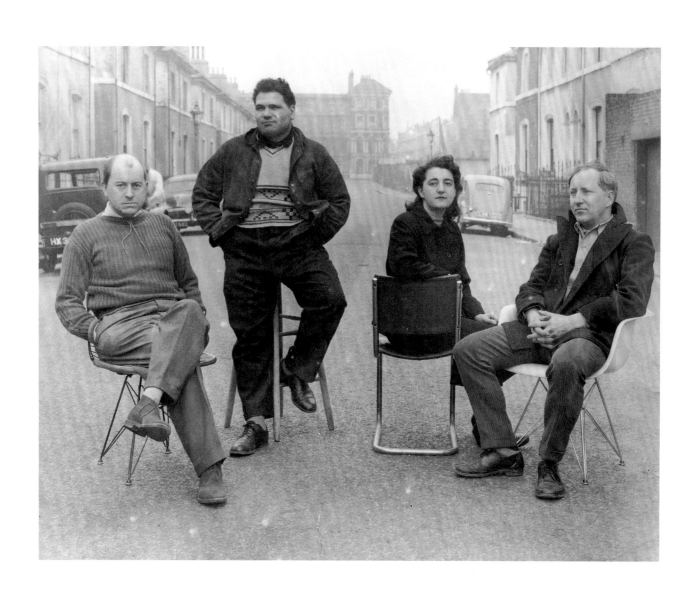

Nigel Henderson, Eduardo Paolozzi, Alison and Peter Smithson 1956 Nigel Henderson

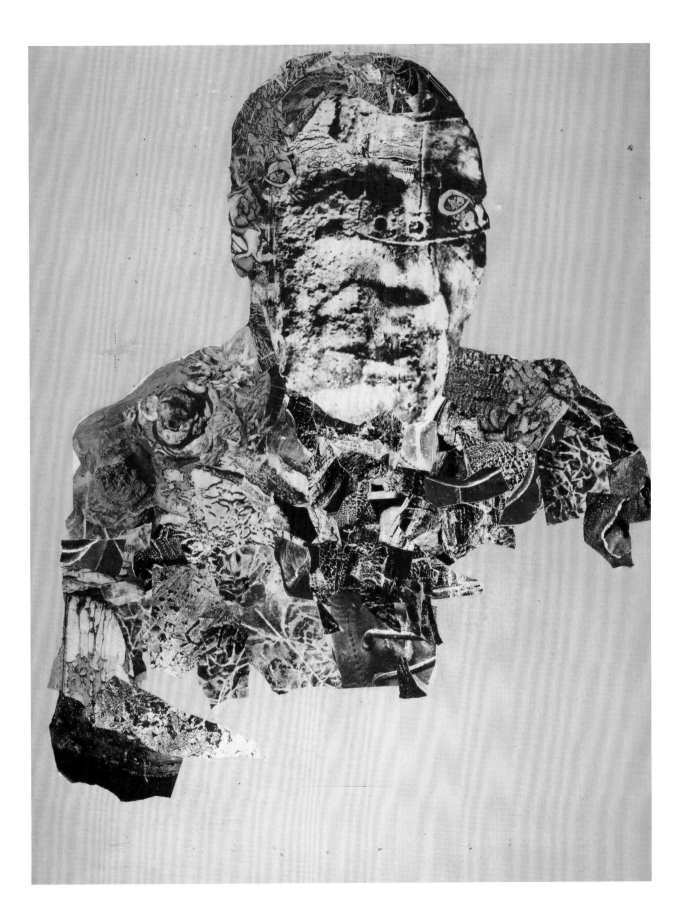

Head of a Man 1956 Nigel Henderson

have noted the rich assortment of objects and appliances, the extensive presence of people is overlooked. By way of preparation, Hamilton compiled a list of categories for inclusion and the sequence is illuminating: 'Man, Woman, Food, History, Newspapers, Cinema, Domestic Appliances, Cars, Space, Comics, TV, Telephone, Information'.[7] In assembling the image, Hamilton drew upon the American magazines made available by McHale and the final composition depicts no less than nine figures, of different types, represented by a variety of means.

In addition to the central figure of the strongman (this category making a reappearance after its debut in Paolozzi's 'Bunk' lecture), the line-up comprises: a naked female pin-up, a woman using a vacuum cleaner, a cinema advertisement featuring Al Jolson, three comic-strip characters, a historic portrait of a man, and the televised head of a woman speaking into a telephone. These figures are seen in the setting of an ambiguous domestic room containing numerous objects that collectively evoke consumerism and the role of the mass media. As such, the collage runs the entire gamut of themes that subsequent Pop artists were to explore further, including space, cinema, pin-ups, comic strips, newspapers, automotive design and packaging. At the same time the representation of the figures sets out a template for the language of Pop portraiture. Its appropriated images range from overtly recognizable subjects (for example, Jolson), to covert subjects (notably the pin-up, rendered anonymous by magazine reproduction) and fantasy portraits (the comic-book characters).

The precursors of American Pop

On 11 August 1956, three days after *This is Tomorrow* opened in London, Jackson Pollock was killed in a car crash. Pollock had been the most celebrated exponent of Abstract Expressionism, the movement that had placed New York at the centre of the modern art world. With his death it seemed to many that a golden era had drawn to a close. The question that now loomed was what would replace it? Within the New York art arena there was a growing anxiety that a once heroic movement was now destined to be diminished by repetition and imitation – unless it was challenged and a successor found. This concern came to the surface in early 1958 when Alfred Barr, the Director of the Museum of Modern Art, during a panel discussion at the Club, New York's equivalent of London's Institute of Contemporary Arts, publicly challenged his audience with the question: 'Is the younger generation rebellious or is it basking in the light of half a dozen leaders?'[8]

The void left by Abstract Expressionism influenced directly the emergence of Pop Art in New York. Those artists who came to prominence in the early 1960s, and who are seen as forming the hard core of American Pop – Warhol, Lichtenstein, Wesselmann, Rosenquist and Oldenburg – shared with their British counterparts

a preoccupation with the daily evidence of mass culture. However, there were significant differences. British Pop evinced a fascination with the perceived glamour and affluence of American commercialism, but this was worship from a distance. In contrast, American artists were close to the source and in some ways took for granted the material benefits of a society whose prosperity had been growing steadily since the end of the Second World War. By the mid-1950s, the mass-media machine in London was gaining ground. But in New York it was well established with multiple television channels, numerous newspapers, literally hundreds of glossy magazines, vast numbers of cinemas, and billboards throughout the city. The emergence in New York of what, in the early 1960s, became Pop Art can therefore be viewed as a response to its indigenous popular culture. But the immersion of American artists in urban culture must also be seen as a response to the problem of how to cope both with the dominance of Abstract Expressionism and with the vacuum that would be left by its demise.

These were issues that had increasingly occupied two artists in particular from around 1954. Jasper Johns and Robert Rauschenberg made the vital first steps in effecting a transition from abstract painting to art that re-engaged with the external world. Both these artists moved in this direction by incorporating recognizable objects within an abstract context, and in both cases the role of portraiture in their work has been largely underestimated.

For Johns, the decisive advance occurred in assemblages such as *Untitled* 1954 (p.64). This work is one of a number that incorporated casts made from life, taken either from his own body or from those of friends. In terms of its physical make-up, the piece encapsulates the abstract-figurative dilemma. A box-like construction is divided into two compartments, the top half comprising a collaged area incorporating textual and pictorial elements. In some ways, this area resembles the collages made by the earlier German Dadaist Kurt Schwitters. The bottom compartment is occupied by a plaster cast taken from the face of Rachel Rosenthal, a friend of the artist. It is not known whether the cast preceded the construction of the box, or whether the box was made to accommodate the cast. It is clear, however, that at this time it was Johns's practice to make many such casts, which were then distributed around the studio, awaiting use. Johns went on to make two larger works also incorporating cast body parts, notably *Target with Plaster Casts* and *Target with Four Faces* (p.65), both 1955. These works reverse the earlier arrangement by placing the figurative elements in sequence above a painted collage area.

The significance of these assemblages lies in the way that they chart Johns's progress, through the incorporation of recognizable elements, towards art that

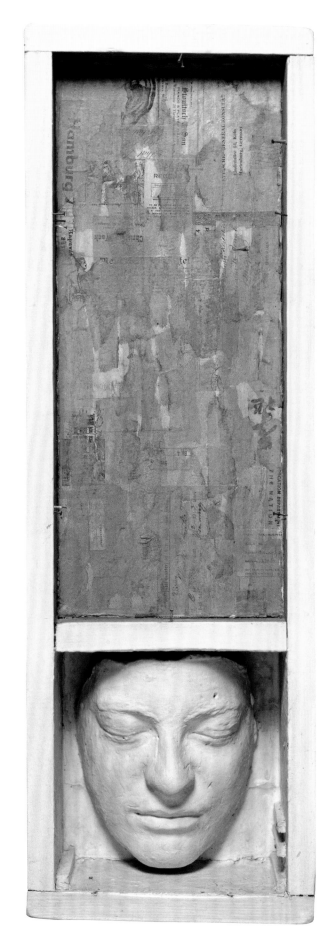

Untitled 1954 Jasper Johns

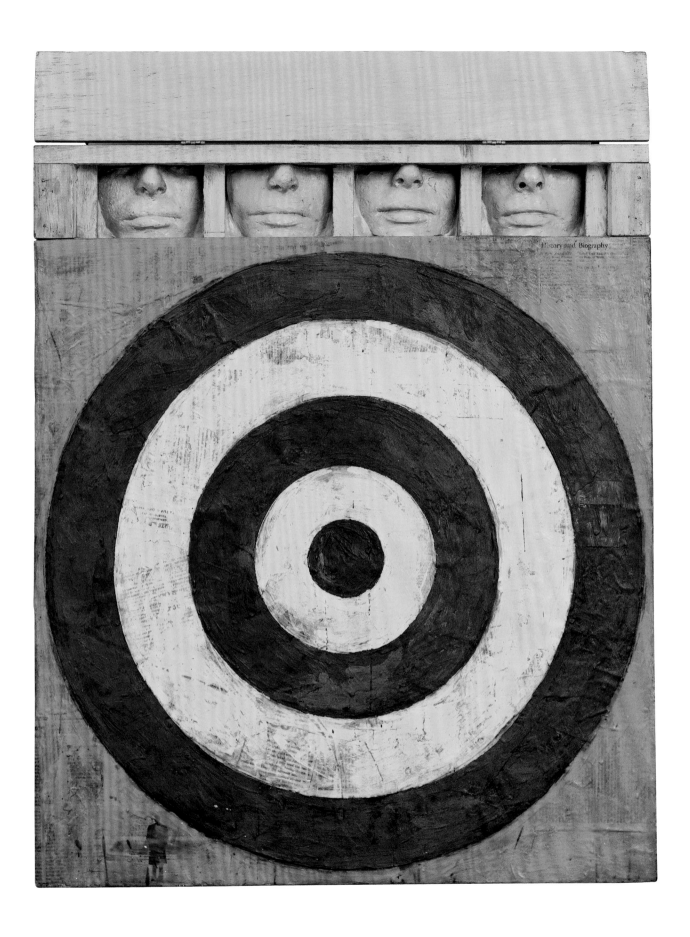

Target with Four Faces 1955 Jasper Johns 65

Gloria 1956 Robert Rauschenberg

Trophy V (for Jasper Johns) 1962 Robert Rauschenberg 67

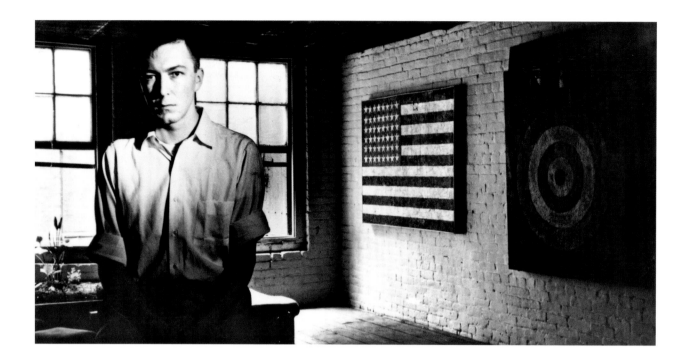

Jasper Johns at Pearl Street, with
Flag **(1954) and** *Target with Plaster*
Casts **(1955)** 1955
George Moffet

reconnects with the real world. They renounce the then prevailing ethos of non-
objective expression, and instead are poised, as it were, between art and life.
In contrast to the highly inflected surfaces of Abstract Expressionist painting,
Johns's works appear mute. They declare nothing other than their own objectivity
and, to that extent, they break with the adherence to personal revelation that
lies at the heart of the art of the preceding generation. Here, however, lies the
importance of the covert portraits that inhabit the works. The faces and body
parts function as signs: of Johns's own presence and that of other individuals.
As such, they introduce within the work an element – the human body – that is
universally recognized as a site for experience. In this way, though they deny the
gestural expressiveness of contemporary painting and instead assert their status
as constructed objects, such works continue to suggest a sense of human life.

Parallel with these developments, the imperative to reconnect with the outside
world increasingly motivated Rauschenberg's work from mid-1954 onwards.
Around this time he began to incorporate found images and three-dimensional
objects within an abstract, painted matrix. Between 1955 and 1962, the idea of
the Combine – a hybrid of painting and sculpture – dominated Rauschenberg's
work. But whereas Johns used plaster-cast portraits as a way of reconnecting
art with the physical world and to suggest human experience, Rauschenberg's
richly textured surfaces function differently. The Combines evoke the complexity
and diversity of reality by creating art from a dense, concentrated mass of
heterogeneous material. He explained: 'I think a picture is more like the real world
when it's made out of the real world.'[9] The highly evocative and associative nature

of Rauschenberg's materials reinforces this impression. The works include paper, cloth, wood, metal, photographs, newscuttings and a plethora of objects – from stuffed birds to coke bottles – that resonate with a sense of urban existence.

In some Combines, Rauschenberg made explicit use of portrait-related material to charge particular works with a human presence. In *Gloria* 1956, for example, a duplicated newspaper photograph is collaged across the top of the surface area, linking with the similar serial arrangement in Johns's plaster assemblages. However, where Johns's casts have a covert portrait subject, the newspaper photographs make an overt reference to a recognizable figure: the New York socialite, Gloria Vanderbilt. Moreover, the repetition of the image can be seen as a reference to her third marriage, as announced in the accompanying headline. Close inspection of the surface of other Combines reveals the way that Rauschenberg went on to embed in his work a panoply of portraits, encompassing dancers, sportsmen, statesmen, the statue of Liberty, comic-strip characters, pin-ups from magazines, found photographs of unidentified individuals and reproductions of earlier works of art, as well as numerous photographs carrying more personal significance.

As Paul Schimmel, Chief Curator of the Museum of Contemporary Art, Los Angeles, has pointed out, such is the autobiographical nature of much of this material that the works can be viewed as self-portraits. Schimmel has also indicated that when, in the later Combines made in the early 1960s, Rauschenberg 'stepped back and represented himself in a more distant way than he had in the earlier Combines, he also began a series of five similarly distant portraits of his closest friends at the time'.[10] The *Trophy* series comprises works dedicated to Merce Cunningham, Teeny and Marcel Duchamp, Jean Tinguely, John Cage and Jasper Johns. Rauschenberg's *Trophy V (for Jasper Johns)* 1962 (p.67) demonstrates his achievement in creating an apparently abstract work which, through incorporating images and objects associated with Johns's own art – a map of America, a window frame and a ruler – evokes the presence of another individual. Viewed in this way, the *Trophy* series announces a vein of metaphorical portraiture that was to characterize the subsequent work of a number of Pop artists.

Peter Blake and Ray Johnson

The examination of popular culture undertaken by the Independent Group in London, and the admission of references to the real world made in the work of Johns and Rauschenberg in New York, were parallel tributaries flowing independently and without mutual awareness. They were not, however, the only manifestations of the growing interest in the images and objects of mass culture.

In the context of the development of Pop Art, two other artists can also be seen as significant precursors, namely Peter Blake in London and Ray Johnson in New York.

In contrast to the analytical and somewhat cerebral nature of these other developments in Pop Art, the work of Blake and Johnson demonstrates a fascination with popular imagery in which there is an affecting sense of intimate personal involvement. Blake commented: 'I was just painting what I was about, the person I was and the things I knew.'[11] As such, his work contains a strong element of self-portraiture. At times this is covert, as in *Children Reading Comics* 1954, which depicts Blake and his sister. Elsewhere the reference is explicit, as in *Self-Portrait with Badges* 1961 (right). But, in common with Rauschenberg, Blake's self-portraiture also works metaphorically. His work includes portraits and other images that evoke personal interests and enthusiasms, as in *Girlie Door* 1959 (p.96). Equally, Johnson's collaged portraits of film stars, musicians and other artists also carry an implication of personal significance, reflecting a deeply felt rapport with the subject. As a result he preferred not to sell certain works, which meant that many of the prophetic collages he made from the mid-1950s remained unseen until the following decade. Significantly, and arising from the immersion of both these artists in popular culture, portraiture is central to their work.

Johnson began cutting images from books and magazines, and combining this figurative source material with other abstract shapes and areas of ink wash, in 1953–4. Many of the small collages, or 'moticos', that Johnson produced refer directly to iconic celebrities, among them Marilyn Monroe, James Dean and Elvis Presley. As such, they form a transition between the language of Abstract Expressionism, with which he was directly acquainted, and the imagery of Pop Art, which they prefigure. The poetic, allusive and psychologically charged nature of Johnson's images invests them with an expressive and symbolic force, which retains something of the work of the preceding generation while setting his art at a remove from the Pop mainstream.

Nowhere is this more evident than in Johnson's celebrated collage portrait of Elvis Presley, made around 1956–7, whose title *Oedipus (Elvis #1)* (p.72) alludes to the undercurrent of meaning which attaches to his images. It was Johnson's practice to manipulate the impeccable surfaces of the materials he appropriated, sanding them and letting ink and paint run across them in order to create evocative accidents to which he could respond. The power of this particular image derives not least from the way the artist has introduced passages of red ink so that blood appears to flow from Presley's eyes. According to the art collector

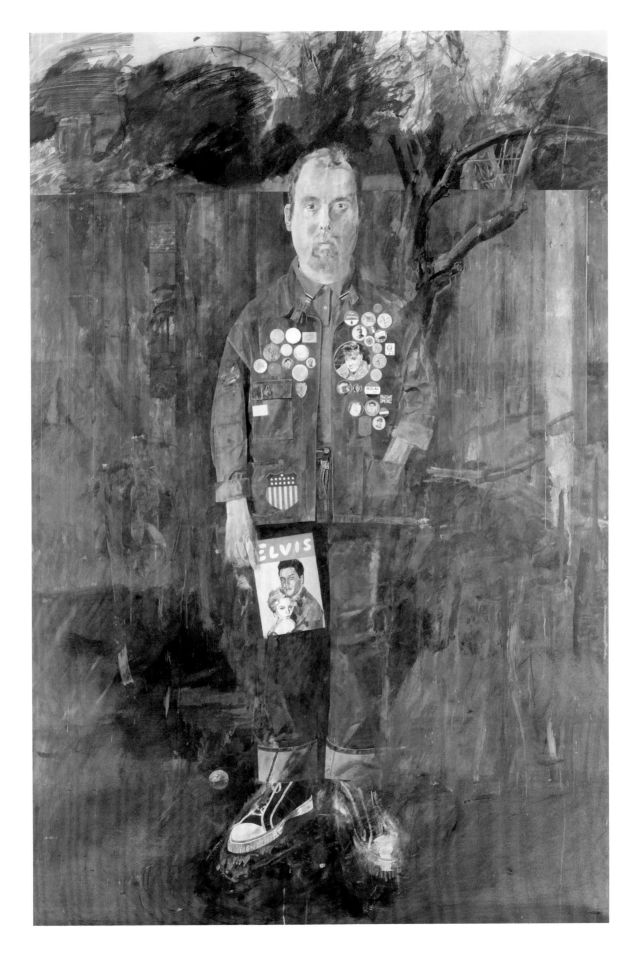

Self-Portrait with Badges 1961 Peter Blake

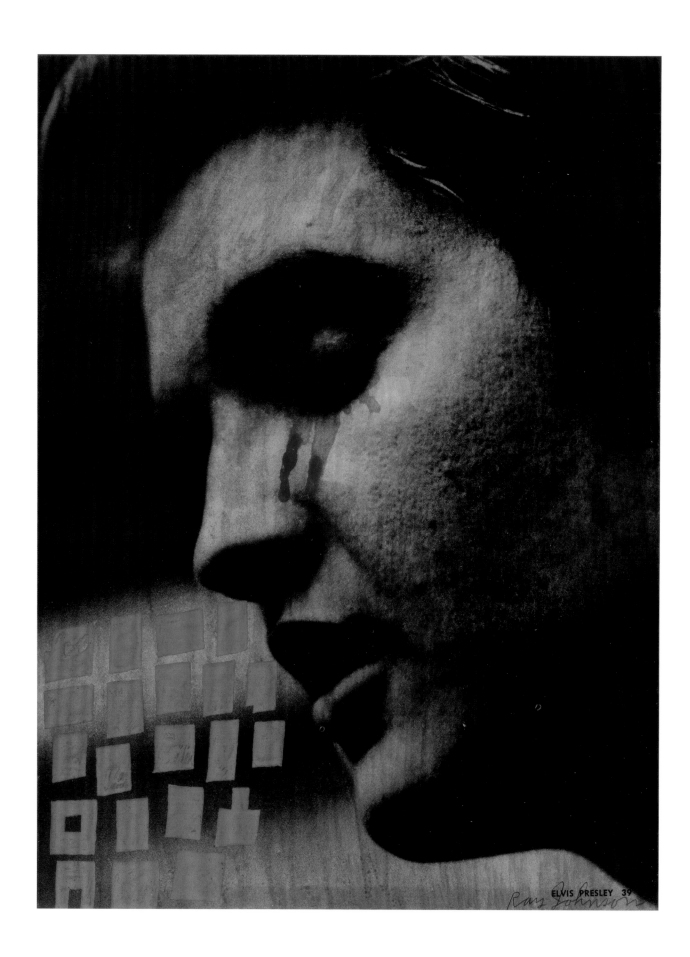

Oedipus (Elvis #1) 1956–7 Ray Johnson

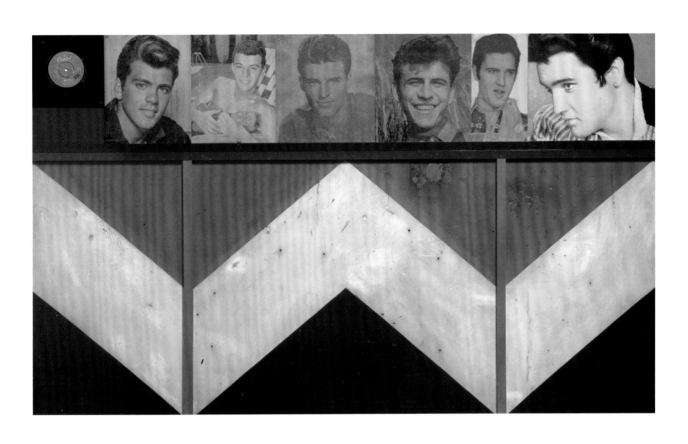

William S. Wilson, Johnson, when discussing this work with him, confided, 'I am the only painter in New York whose drips mean anything.'[12] Apparently Johnson identified Elvis with Oedipus, who in Greek mythology killed his father and blinded himself. According to Wilson, a further level of metaphorical meaning connects the Elvis/Oedipus image with Johnson himself who, by turning to popular imagery, was murdering his own artistic 'father', Jackson Pollock.

This image, and two other slightly later works, *James Dean (Lucky Strike)* 1957 (right) and *Hand Marilyn Monroe* 1958 (p.76), all convey Johnson's ability to concentrate a remarkable emotional energy into a relatively small-scale work. The image of Dean, who died tragically young in a car accident in 1955, is again overlaid with areas of red ink, suggesting the violent nature of his death. The portrait of Monroe is one of the earliest of many appearances by this celebrated figure in the iconography of Pop, following her inclusion by Hamilton in *Just what is it that makes today's homes so different, so appealing?* (p.42) but prefiguring later references by Blake, Phillips, Oldenburg, Rosenquist, Warhol, Boty and Hamilton again in 1965. Whereas most of these works postdate her death, Johnson's image, in the context of those of the recently deceased Dean and the metaphorically wounded Presley, carries an uncannily prescient pathos. The expressive dimension found in Johnson's work is uncharacteristic of Pop. But the complex importance that he accorded portraiture, in the context of popular imagery, anticipates later developments in Pop Art.

Blake was attracted to American culture as a teenager. He admired the attitude of American youth as represented in the films he saw and in the comic books he read. Subsequently this interest embraced cinema, pin-ups, fashion and in particular the pop music that emanated from America, where musicians such as Bo Didley, Chuck Berry, Elvis Presley and Little Richard all assumed the status of popular icons. Blake's interest in popular culture was, however, far from being connected exclusively with America or even with images transmitted by the mass media. His work is underpinned by an abiding nostalgia, and in many cases it has associations with his own early life. His imagery is replete with references to fairgrounds, wrestling contests, circuses, carnivals and other manifestations of popular culture that exist beyond the world of glossy consumerism. At the centre of these works, however, is the impression of admiration for his subjects, a level of personal engagement in his portraits of film stars and musicians that has the connotation of hero worship. This sense of convergence between the artist and the admiring fan arguably led to some of the purest expressions of Pop Art.

Blake's *Girlie Door* 1959 (p.96) is one of the first major statements by a British Pop artist. Impressively direct, it presents an arrangement of collaged photographs

NOTES

1 Quoted in '"Eduardo Paolozzi, Retrospective Statement" – The Independent Group, 1990' in *Eduardo Paolozzi: Writings and Interviews*, ed. Robin Spencer (Oxford, 2000), p.72.

2 *Ibid.*

3 The collages were published as a portfolio of forty-five screenprints entitled *BUNK!* in 1972.

4 Quoted in *Eduardo Paolozzi: Works in Progress* (exh. cat., Kolnischer Kunstverein, 1979), p.7.

5 Lawrence Alloway, 'The Development of British Pop', in *Pop Art*, Lucy R. Lippard with contributions by Lawrence Alloway, Nancy Marmer, Nicolas Calas (London, 1966), p.32.

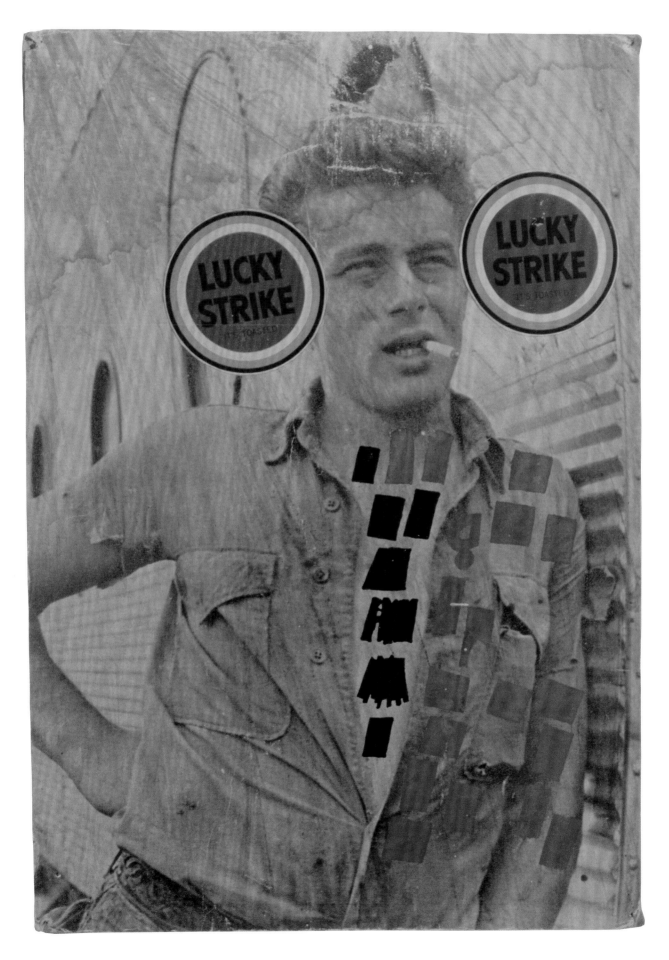

James Dean (Lucky Strike) 1957 Ray Johnson

Hand Marilyn Monroe 1958 Ray Johnson

6 Quoted in *This is Tomorrow* (exh. cat., Whitechapel Gallery, 1956), reprinted in *Richard Hamilton* (exh. cat., Guggenheim, New York, Stattishche Galerie im Lenbachhaus, Munich, March–May 1974), p.24.

7 Quoted in Richard Morphet, 'Catalogue', in *Richard Hamilton* (exh. cat., Tate Gallery, London, June–September 1992), p.149.

8 Quoted in Fred Orton, *Figuring Jasper Johns* (Reaktion Books, London 1994), p.92.

9 Quoted in Calvin Tomkins, *Off the Wall: Robert Rauschenberg and the Art World of Our Time* (New York, 1981), p.37.

10 Paul Schimmel, 'Autobiography and Self-Portraiture in Rauschenberg's Combines', in *Robert Rauschenberg Combines* (exh. cat., Metropolitan Museum of Art, New York, and tour, December 2005–May 2007), p.227.

11 Quoted in Natalie Rudd, *Peter Blake* (London, 2003).

12 William Smith Wilson, 'Jackson Pollock and Ray Johnson: participant observers', in *Dear Jackson Pollock* (exh. cat., Pollock-Krasner House and Study Center, May–August 2003), p.34.

taken from Blake's own collection of pin-ups. A number are portraits of female heart-throbs from silent films, but the majority depict film stars then at the height of their fame: Gina Lollobrigida, Kim Novak, Elsa Martinelli, Shirley MacLaine and Marilyn Monroe in a scene from *Some Like it Hot*. The surface on which these images are arranged is an illusory door, complete with keyhole and doorknob, painted in household enamel. The distribution of the photographs is deliberately informal, mimicking the way in which teenage fans might pin up pictures for their own amusement and contemplation on the back of their bedroom doors.

Blake's subsequent use of collaged popular imagery in such works as *Got a Girl* 1960–61 (p.73) is illuminating. It reveals, for the first time, the influence of American art on British Pop artists. Blake acknowledges that by the late 1950s he was familiar with the work of Johns and Rauschenberg. Indeed, Johns's *Target with Four Faces* (p.65) was reproduced on the cover of the January 1958 edition of *Art News*, a publication of which Blake would have been aware. In *Got a Girl*, a sequence of collaged photographs of pop stars is incorporated directly above an abstract painted area, an arrangement that echoes Johns's assemblages with plaster casts. Portraiture provides the link between Johns's and Blake's work, but there is a further significance. Whereas Johns concealed the identity of the subject, Blake advanced the argument into new territory by incorporating images of famous faces, those of the pop stars Fabian, Frankie Avalon, Ricky Nelson, Bobby Rydell and Elvis Presley. As with Johnson's work, this was an important step, an unmistakable bridge between fine art and popular culture afforded by portraiture.

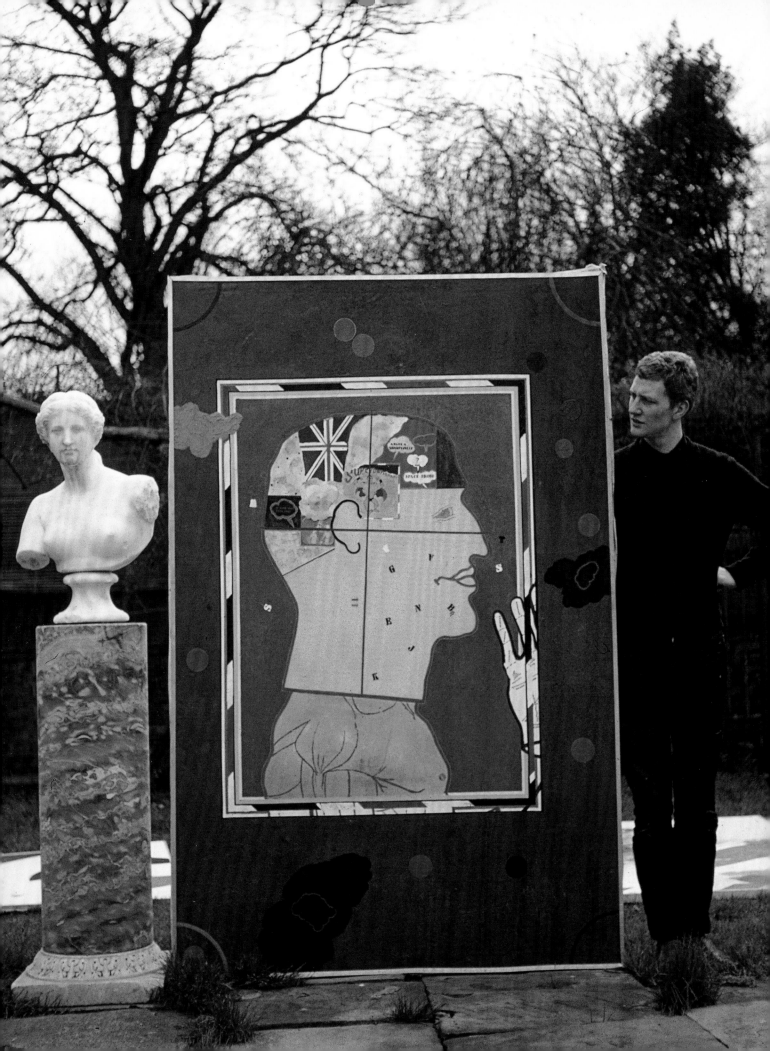

Portraits and the Question of Style

The period from 1960 to 1962 saw the simultaneous emergence of Pop Art in Britain and America, reflected in a growing recognition that something was in the air: a brash new style defined by a younger generation of artists that was breaking with old forms of expression and outmoded ideas.

In New York in 1960, the Judson Gallery, the Reuben Gallery and Martha Jackson Gallery showed work by Dine, Oldenburg, Johns, Rauschenberg and others. The following year, Rauschenberg had a show of Combine paintings at the Leo Castelli Gallery. This was followed shortly after, at Tanager Gallery, by Wesselmann's first solo exhibition featuring collages from the *Great American Nude* series (p.103). In 1962, Dine, Rosenquist and Lichtenstein all had their first one-man exhibitions, and *Art International* was quick to respond, publishing an article by Max Kozloff that connected the work of these artists. At the Ferus Gallery, Los Angeles, Warhol had an exhibition of his Campbell's Soup Can paintings. The year concluded with a group show at the Sidney Janis Gallery featuring the 'New Realists'. In all but name, Pop had arrived.

In London, the rise of Pop was stealthier – at least at first. In early 1960, Hamilton gave a lecture on media techniques at the Institute of Contemporary Arts, and in March, Hamilton, Paolozzi and Alloway participated in a radio talk entitled 'Artists as Consumers' on the BBC's Third Programme. In January 1961, Hamilton's article 'For the Finest Art Try – Pop!' appeared in the London publication, the *Gazette*. Meanwhile, at the Royal College of Art, Derek Boshier, Caulfield, Hockney, Jones,

Derek Boshier in Notting Hill
March 1962 Tony Evans

Boshier contemplates his painting *Man Playing Snooker and Thinking of Other Things* 1961 in his Notting Hill garden. This work, in common with Allen Jones's painting *Interesting Journey* 1962, takes the form of an imaginary portrait in which the subject's thought processes are revealed.

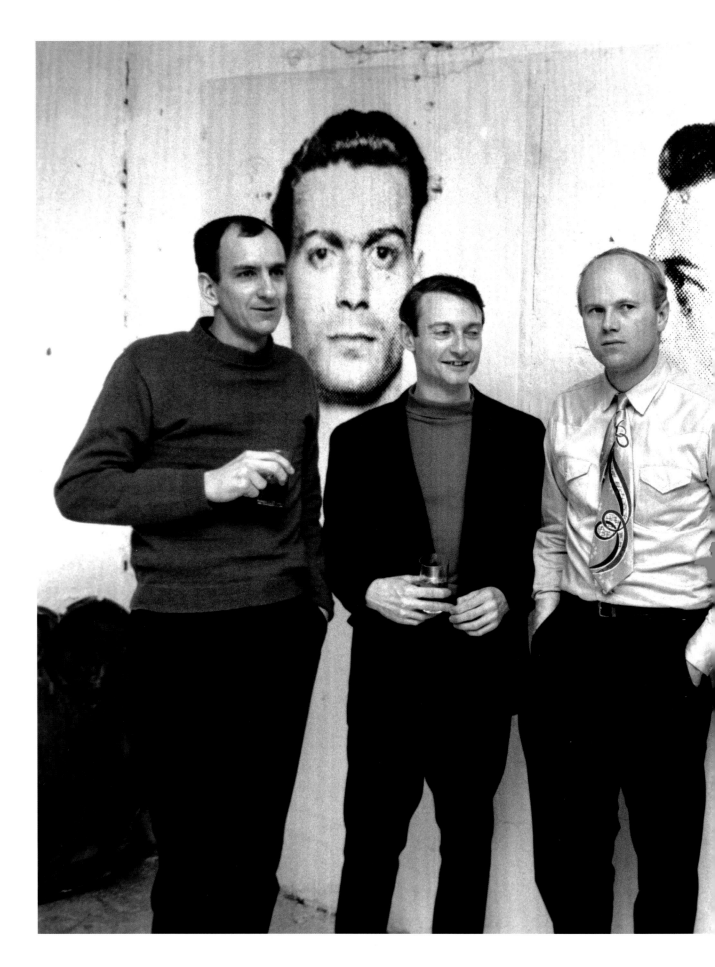

Tom Wesselmann, Roy Lichtenstein, James Rosenquist, Andy Warhol and Claes Oldenburg at the Factory celebrating the opening of Warhol's Stable Gallery 21 April 1964 Ken Heyman

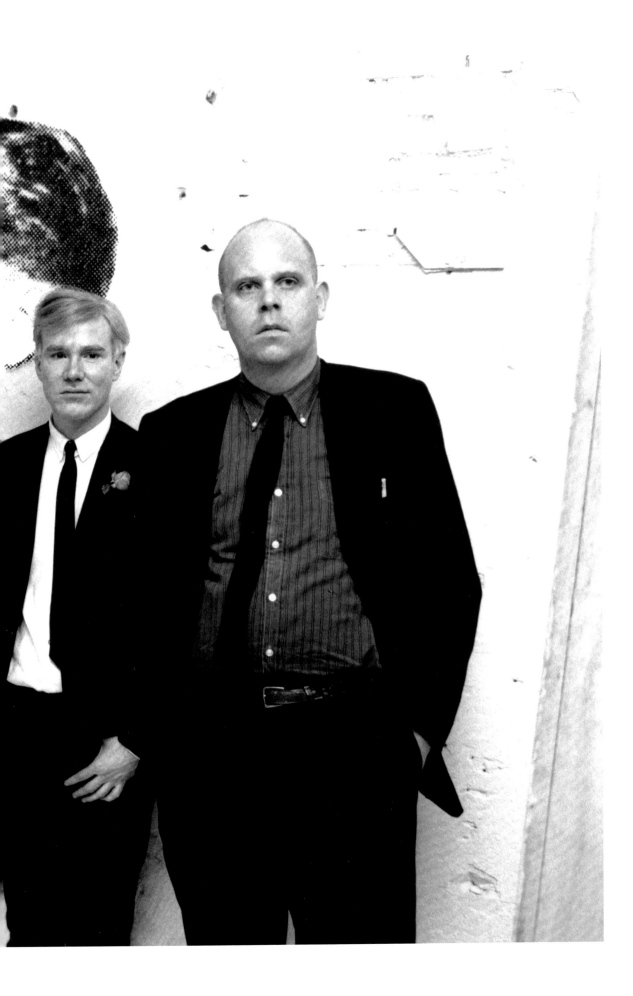

R.B. Kitaj and Phillips were making paintings that would come to be identified with the emergent movement. The turning point came in February 1961, when works by all these artists were included in the *Young Contemporaries* exhibition at the RBA Galleries, London, and Alloway advised that they should be grouped together, to provide a sense of cohesion and common purpose.

In fact, the incipient movement – both British and American – was characterized by a striking divergence of styles, imagery and ways of working. Setting aside the more marked differences between these transatlantic counterparts, even those artists working in proximity to each other – for example at the Royal College of Art – took their imagery from a wide range of sources, and evolved distinctive personal styles, producing work that is highly individual. The same is true of the so-called New Realists shown together in New York: the work of artists such as Dine, Lichtenstein and Rosenquist was from the outset extremely different in approach, handling and appearance. That said, there were also significant common denominators. Apart from a shared fascination with modern urban culture and a corresponding desire to reflect the world as it was experienced, for most of these artists the issue of finding a style – of defining a visual language – was paramount. This is particularly true of American Pop artists who were grappling with the question of how to renew art after Abstract Expressionism. British artists were also seeking new ways of commenting on the world and of interpreting personal experience of modern life. Style defines an artist, providing both a language and an identity. In addressing the issue of style, it is highly significant that artists associated with Pop, on both sides of the Atlantic, not only resorted to imagery with personal or autobiographical significance, but used self-portraiture as a vehicle.

For Dine, the equating of the artist's own image with questions of a purely artistic nature was a central concern, and in some ways this took precedence over an involvement with the imagery of urban culture. He observed:

> I don't believe there was a sharp change and this is replacing Abstract Expressionism … Pop Art is only one facet of my work. More than popular images, I'm interested in personal images, in making paintings about my studio, my experience as a painter, about painting itself.[1]

These ideas are manifest in *Green Suit* 1959 (right). Dine created the work at a time of personal trauma. Having survived a car accident, the artist then heard a radio report about the death of a friend in a car crash. Using his own tattered clothes, Dine projected the violence of these incidents onto a personal object that symbolized himself. This metaphorical self-portrait was rendered more complex by

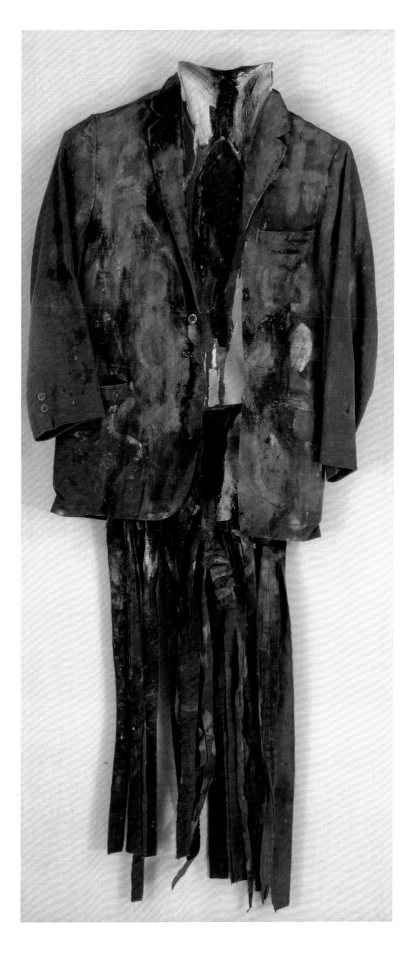

Green Suit 1959 Jim Dine

the addition of paint, besmirching the fabric of his suit, a provocative image that resonates with a sense of physical identification between a painter and the material that defines him. At the same time, the confrontation between paint and real object encapsulates the artist's stylistic predicament, as if torn between the legacy of Abstract Expressionism and the lure of New Realism.

Hockney's association with Pop Art was relatively brief, given that he quickly moved beyond an involvement with images derived from popular culture. However, the following comment suggests that the issue of appropriation in his work – whether of images derived from consumerism or of pre-existing styles – was a strong point of connection with the evolving Pop ethos:

> [artistic freedom] could be gained by borrowing from any source, whether this be from [one's] own life or imagination, from poetry, from magazines and photographs, from commonplace objects or from the work of other artists.[2]

For Hockney, images of the human figure, and covert self-portraits in particular, provided an armature for exploring stylistic appropriation. The paintings that he made at the Royal College of Art address the issue of style directly, moving freely between elements drawn from Francis Bacon, Jean Dubuffet, street graffiti and children's art. Such is the prominence given to these different means of representation that there can be little doubt that 'style' is the underlying subject of his early Pop work. Its apogee is *I'm in the Mood for Love* 1961 (p.86), which Hockney completed shortly after returning to London from his first trip to New York in the summer of 1961. His fellow student Kitaj, who was older than Hockney, had encouraged the younger artist to find his subject matter in personal experience. Using a range of allusions, *I'm in the Mood for Love* evokes Hockney's homosexuality, a practice that was then illegal. It depicts the artist in New York, devilishly horned and following a street sign that reads 'Queens uptown'. An appropriated calendar format, complete with dates, supplies a context for the image. Stylistically, the portrait combines a deliberate awkwardness with painterly confidence, as if Hockney is investigating a range of options. In common with Dine, therefore, he uses a covert self-portrait to address issues of a deeply personal and a purely artistic nature.

In terms of their handling of paint, both Dine and Hockney celebrated the painterliness of Abstract Expressionism. By combining this technique with covert portraiture, they parodied the element of personal revelation inherent in the earlier movement. In this respect Hockney was influenced to some extent by Richard Smith, a former Royal College of Art student, who went to New York in 1959 and returned two years later with a new awareness of the scale and confidence of

Paris Match
28 February 1959

This cover of *Paris Match*, 28 February 1959, No 516, was the basis for Richard Smith's painting *MM* (right). The painting was one of fifty works included in the exhibition *Homage to Marilyn Monroe*, held at the Sydney Janis Gallery in 1967. Smith's painting epitomizes the transition from Abstract Expressionism to Pop in the way that abstract mark-making and painterly gesture have been infiltrated by portrait-related imagery derived from the mass media. *MM* appears to relate to the area to the bottom right of the *Paris Match* title box.

I'm in the Mood for Love 1961 David Hockney

Mr Art 1962 Larry Rivers 87

American painting. Although Smith's main interests were the 'things' produced by consumer culture, he made an evocative portrait of Marilyn Monroe (p.85), derived from a cover of *Paris Match*. Also influential was the work of the American painter Larry Rivers, which Hockney knew from reproductions. Rivers visited London in late 1960, bringing with him a close, home-grown, acquaintance with the sensibility of the New York School. Rivers's portrait of the London-based critic David Sylvester, *Mr Art* (p.87), painted in 1962, exhibits a characteristic playfulness, fusing the Abstract Expressionists' language of gestural mark-making with a recognizable image. In this way, Rivers, like Smith, used portraiture in a subversive way that not only returned painting to the external world; it also drained the language of Abstract Expressionism of purely subjective meaning by applying it descriptively.

For most Pop artists, however, a break with the autographic bravura of Abstract Expressionism was an imperative. In their different ways, Jones, Boshier, Caulfield, Lichtenstein and Warhol each used portraiture as a way of distancing their work from the subjective preoccupations of the preceding generation. For each, the predicament of an artist seeking a cooler, more detached means of expression was articulated through images that have a recognizable personal significance, or in ways that operate more allusively.

While Jones's early paintings demonstrate an ostensible interest in urban imagery, notably in those works that depict London buses, his underlying subject was the nature of the creative act. The process of invention, in which imagination is given form, was an abiding preoccupation, expressed in the artist's practice of making small, automatic drawings. Such images, not simply those rooted in popular culture, were his primary source material. These ideas are the subject of *Interesting Journey* 1962 (right), a self-portrait, albeit in a highly stylized form, in which the artist depicted himself with eyes from which flow twin streams of abstract shapes and colours. These elements evoke the artist's interior life, the 'Interesting Journey' of the title referring to the artist's flow of thought. The image is notable, not least for its adoption of a multi-coloured and harder-edged style influenced by Wassily Kandinsky, whom the artist admired, as well as by contemporary design. But its main significance lies in the way in which a portrait of the artist symbolizes the private process of creation.

Boshier's painting *Man Playing Snooker and Thinking of Other Things* 1961 (p.90) may also be seen as a kind of metaphorical self-portrait. A large head is shown in profile, its interior exposed as if to reveal an anthology of private images: a flag, a comic-book cover and several phrases represented as thought bubbles. The man depicted is not identified, but the focus on his subjective experiences suggests

Man Playing Snooker and Thinking of Other Things 1961 Derek Boshier

autobiographical content. As such the image is a witty parody of the confessional nature of Abstract Expressionist painting, being at once deeply personal and yet, in terms of the handling of paint, uninflected and non-expressive.

For Caulfield, who joined the Royal College of Art in 1960, one year after the arrival of Hockney, Boshier and the other students linked with Pop, the issue of finding a personal style was no less pressing. He knew and admired the work of Americans such as Johns but quickly recognized the problems arising from imitation. Caulfield's difficulty was compounded by an equal resistance to falling in line with his peers' involvement with imagery derived from consumer culture. Caught between these contradictory impulses, he gradually evolved a highly distinctive way of working, characterized by a deliberate avoidance of a virtuoso handling of painting in favour of a flat, factual style closer to the signwriter's art. In this, he was encouraged by the example of Juan Gris, the early Cubist master, whose understated, somewhat impassive way of working attracted Caulfield. In addition to works that pay homage to Gris, Caulfield made a rare excursion into portraiture with his *Portrait of Juan Gris* 1963 (p.92). The portrait's links with its named subject are more indirect than the title suggests. Caulfield modelled the head on a photograph of Gris by Man Ray, transplanting this onto a blue-suited figure based on drawings made from life. Stylistically, too, the portrait says little about Gris, being closer to Caulfield's own mature way of working. Rather, the portrait can be seen as a personal metaphor in which Caulfield's signature style is identified with an image of the painter he admired.

From the outset, the reaction to Lichtenstein's paintings based on comic strips focused on the appropriated nature of his imagery. In that respect, his work epitomized a central tenet of the Pop aesthetic. But, as a result, the deeper, portrait-related significance of Lichtenstein's art has not been fully recognized. This additional dimension was inherent from the outset. In *Look Mickey* 1961 (p.44), Lichtenstein's first comic-strip painting, the Disney characters Donald Duck and Mickey Mouse are shown fishing. In one way, the painting can be seen as a straightforward portrait of two well-known figures. Lichtenstein has not questioned their fictitious nature. Simply accepting their media-created reality as animated characters, they have been recontextualized – portrayed – in the language of painting. But there is a more profound connotation to this image. In seeking a stylistic alternative to Abstract Expressionism, Lichtenstein parodied that earlier language by echoing brush marks, splashes and other painterly devices. In *Look Mickey*, the surface of the water looks suspiciously like a giant brush mark. Viewed in that light, Donald's exclamation – 'I'VE HOOKED A BIG ONE!!' – satirizes the abstract painters' heroic immersion in the movement of paint as a way of capturing subjective experience. In *Mr Bellamy* 1961 (p.93),

Portrait of Juan Gris 1963 Patrick Caulfield

NOTES

1 Quoted in Mario Amaya, *Pop as Art: A Survey of the New Super-Realism* (London, 1965), p.78.

2 Quoted in Peter Clothier, *David Hockney* (New York and London, 1995), p.15.

3 Quoted in Victor Bockris, *Warhol* (London, 1989), p.210.

Lichtenstein's metaphorical use of comic-strip images struck an even more personal note. The square-jawed pilot muses: 'I AM SUPPOSED TO REPORT TO A MR. BELLAMY. I WONDER WHAT HE'S LIKE.' While the image was derived from the newspaper comic *Steve Roper*, Lichtenstein's text actually referred to Richard Bellamy, an early supporter of Pop, with whose gallery – the Green Gallery in New York – Lichtenstein was associated. Images such as this can be viewed as witty self-portraits.

The equating of the artist's own image with issues of style is epitomized in the series of photomat self-portraits made by Warhol in 1964. Prior to 1963, Warhol had based his portraits of the famous – Marilyn Monroe, Elvis Presley and Elizabeth Taylor, among others – on publicity photographs. He first used a photobooth to provide a source image for a painting in mid-1963, in response to a commission for a portrait of Ethel Scull, the wife of Robert C. Scull, who was a major early collector of Pop Art. Warhol returned to this method later that year, and again in 1964 (right), as a way of producing source imagery for a series of self-portraits. Warhol's mechanically-produced portrait is entirely non-committal. The face is presented staring straight ahead, the expression is deadpan and the pose is bland; the image's simplified tones contribute little in terms of contextualizing detail. When Warhol processed this image as a series of silkscreen paintings, the effect of emotional distance was accentuated by the addition of various flat colours, tinting the figure and background and serving mainly to differentiate each image. Around the time he made these images, Warhol told *Newsweek* magazine, 'Everything is art – if it's right.'[3] The self-portraits are an unflinching statement of this outlook. They are a determined assault on the idea of art as personal expression, subverting the image of the artist as a heroic visionary. Self-portraits produced by machines and printing processes identified the Pop artist with the world of mass production, becoming a saleable commodity like any other.

Fantasy and Fame

Girlie Door 1959
Peter Blake

In Blake's *Girlie Door*, art and fan worship find common ground. The illusory bedroom door supports an array of pin-ups and heart-throbs, including a photograph of Marilyn Monroe (bottom right) who makes an early appearance in Pop Art portraiture.

Between 1962 and 1965 Pop Art moved to centre stage, commanding an international audience that saw in the new style a mirror for modern life. In Britain on 26 January 1964, the cover of the *Sunday Times* magazine reproduced Roy Lichtenstein's painting *Hopeless* and asked: 'Pop Art: Way Out or Way IN?' The *New York Times* magazine responded in May with the article: 'Pop Art Sells ON and ON – Why?' The following year Mario Amaya's book *Pop as Art* provided the first survey of British and American Pop and concluded: 'By 1965, Pop Art has invaded life in a number of ways as no other art style has done with the exception of Op Art.'[1]

Amaya's recognition that Pop had infiltrated 'life' acknowledged a movement whose focus transcended a concern with the objects of mass culture and the language of advertising. Increasingly, the imagery of Pop evinced a fascination with the human aspects of these cultural changes. No less than mass-produced objects, individuals achieved instant widespread visibility through exposure in the cinema, television, newspapers and advertising. Fame was something that happened to people, and Pop artists responded by scrutinizing the mechanisms and consequences of the creation of celebrity. At the same time, advertising and mass-media imagery created a huge audience for individuals who remained anonymous, their identity effaced by endless reproduction. While models such as Twiggy would achieve celebrity, most – particularly those advertising consumer goods – were condemned to remain nameless stereotypes. For many Pop artists, the relation between the famous image and the person became a contested zone,

generating questions about the loss of identity and the creation of fantasy figures. Rosenquist, for example, commented: 'I was fascinated by how people advertise themselves.'[2] Portraiture provided an effective means of reflecting and probing these human issues.

At the centre of these developments, images of the female figure proliferated. The mass media had carte blanche with the perception of women – apparently more malleable than their male counterparts – creating super-charged domestic saints, tragic madonnas or erotic *femme fatales*. The roots of Pop's engagement with such themes can be traced to Hamilton's remarkable series of paintings begun in 1957, which explores the appeal of automotive advertising to a male audience by exploiting female sexual allure. Many of these works include covert portraits. In *Hommage à Chrysler Corp* 1957 (p.102), a photograph of the lips of Voluptua, an American late-night television star, is collaged onto the female figure. Hamilton's painting transforms her into the fantasy figure par excellence, a de-personalized confection of composite attributes, merging the promise of sexual availability and the technological sophistication of automotive design. The image identifies a car chassis with the female body, the headlamps alluding to breasts. This impossible marriage of biology and technology was developed further in subsequent paintings, notably *Hers is a Lush Situation* 1958, which embodies Sophia Loren's lips, and *$he* 1958–61, which was based on a photograph of Vikki ('the back') Dougan, taken from *Esquire* magazine. These works attack two targets: the cliché of product promotion and the image of women as presented in the increasingly available girlie magazines.

This is not to say that the 1960s mass media was a conduit for unbridled sexual imagery. America, in particular, remained conservative about sexuality – at least in public – and hardcore pornography was illegal. However, both Britain and America witnessed the release of softcore magazines, such as Hugh Hefner's glossy publication *Playboy*, which contained female nude pin-ups. Pin-ups were hardly new, having been mass-produced during the Second World War. But the availability of such imagery commercialized the pin-up, sustaining the perception that female sexuality was marketable. The connection with consumerism now made the pin-up a fertile source for Pop artists.

The media sexualized the image of women and Phillips's painting *For Men Only – Starring MM and BB* 1961 (right) reflects the changing sensibility. The work incorporates two collaged magazine photographs of the film stars Marilyn Monroe and Brigitte Bardot, both of whom were the objects of intense male sexual fascination. Phillips has added the phrase 'Cert X' over the head of Bardot, emphasizing the 'adult' nature of their allure. At the foot of the painting there

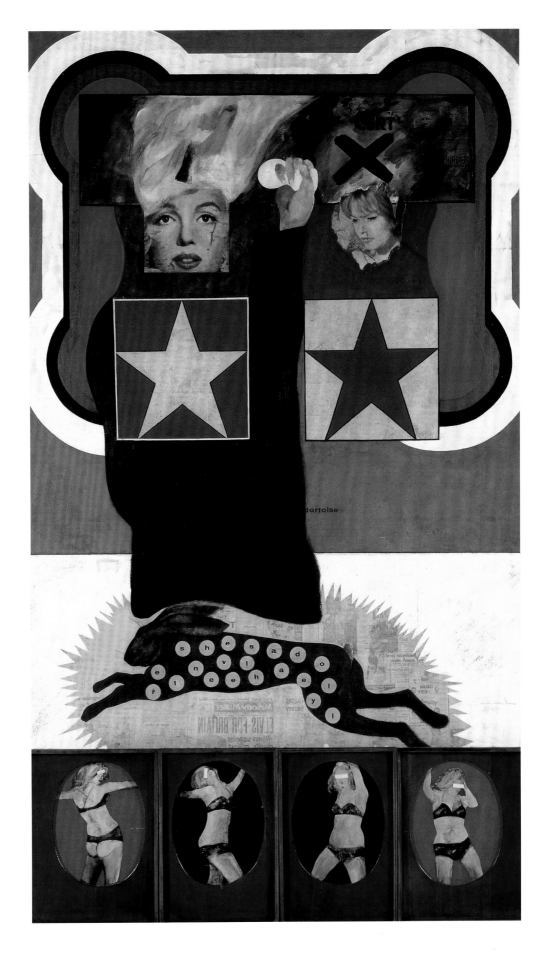

For Men Only – Starring MM and BB 1961 Peter Phillips

are four images of a stripper painted from photographs, a concession perhaps to the more confrontational charge that collaging the photographs themselves would have carried. Even so, the individual letters above the figure spell out the message 'She's a doll' and the entire ensemble is set within a construction echoing the shape of a game-board. Portraying Monroe and Bardot in this way indulges male sexual fantasy, implying that sex is a game, a new form of leisure.

Where Phillips is relatively playful, Allen Jones's images of women took fantasy portraiture to new extremes. Jones's own comments are illuminating:

> At the end of the 1950s life painting and figure painting had lost their edge … but a new approach developed from the realization that it was possible to refer to the human figure in a vital way by forming a new visual language that drew upon previously untapped sources of visual potential. Our 'nature' and inspiration was the urban culture all around us: advertising, cinema, the proliferation of magazines and the pinball culture imported from America.[3]

From 1964 to 1965, Jones lived in America, staying at the Chelsea Hotel in New York, and it was during this period that he discovered a vast new source of visual potential in the book stores on 6th Avenue. Prompted by Hockney, he became fascinated by the fetish magazines he saw there, intrigued by 'the vitality of this kind of drawing of the human figure, which had been produced outside the fine art medium'.[4] He collected quantities of this material, together with mail order catalogues, in order to build a library of reference images that would feed into his art. Central to this activity was Jones's perception that the raw vitality and aggressive strength of non-art images of women could be used to invigorate their depiction in a fine art context. An early manifestation of this shift, made in America, was *Curious Woman* 1964–5 (p.104). Drawing upon fetish imagery and objects – the figure's breasts were made using 'falsies' bought in New York – Jones created an extraordinary icon of the modern media-generated woman, portraying her as sexually confrontational and nubile, yet stripped of identity. The image conforms to the conventions of a three-quarter-length portrait, complete with attributes, the head turned slightly to one side. But all traces of individuality have been effaced, creating instead an erotic stereotype.

The evocation of modern woman as the anonymous, mass-produced object of male fantasy inhabits Wesselmann's series of sexually charged images, numbered and titled *Great American Nude* (p.103). Writing under the pseudonym Slim Stealingworth, Wesselmann explained that 'the nudes were not intended to be portraits in any sense'.[5] In each work, a nude figure is presented without individualizing features; as such they read almost as ciphers for female sexuality.

These painted reclining figures are presented in the context of collaged photographs of consumer goods. These include various convenience foods, ice creams, drinks, cigarettes and a host of domestic desirables, from televisions and radios to bathroom fittings and framed reproductions of Old Master paintings. The nude is situated ambiguously among these things, part-consumer and part-object, another delicious treat or convenience perhaps for the acquisitive viewer. The paintings evoke the Great American Dream of ubiquitous mass availability, a world of objects – and people reduced to the status of objects. Despite Wesselmann's disclaimer, such images have their roots in portraiture. Nearly all were based on drawings made from life, either of his girlfriend Claire or other friends. But this transformation is significant. A covert portrait of an individual has been recontextualized within the domain of mass culture and, as result, has lost all trace of personal identity.

If pin-up magazines presented women as sex objects then, by equating female sexuality with the desirability of consumer products, advertising presented women as commodities. This media-created paradox – in which individuals are portrayed as products, and products are invested with an exaggerated importance – was the subject of the pin-up paintings that Mel Ramos commenced in 1964. This series depicts nude females posing enticingly with mass-produced convenience foods, notably chocolate bars, a packet of cheese spread, a Coca-Cola bottle and, as in *Hunt for the Best* 1965 (p.105), a bottle of ketchup. Frequently the object is invested with phallic characteristics. The alliance of sex and consumer products reprises Hamilton's earlier exploration of this theme. But Ramos's paintings exposed and parodied the underlying erotic content of advertising strategy, the exaggerated size of the tumescent objects attaining a calculated absurdity. Unlike Wesselmann's paintings, however, the models are not depersonalized. Ramos's images depend for their satirical effect on a believable woman interacting with an enhanced product. For that reason, Ramos initially used his wife Leta as a model, later relying on the centrefolds of *Playboy* magazine as source images, which he then combined with advertising material. His use of covert portraits personalized the figure and contained a fantastic juxtaposition within the bounds of reality. The result was to make that juxtaposition all the more disturbing.

Part of the reason that fame exercised a fascination for so many Pop artists was its double-edged nature. At one extreme, the media could take an ordinary individual, strip them of their identity, and expose them to the gaze of millions. Advertising, newspapers and television had the power to confer instant visibility, albeit in most cases briefly and without lasting effect. At the other, the media machine could transform people into celebrities. Men and women could, by virtue of endlessly repeated images, attain instant recognition, being elevated far above

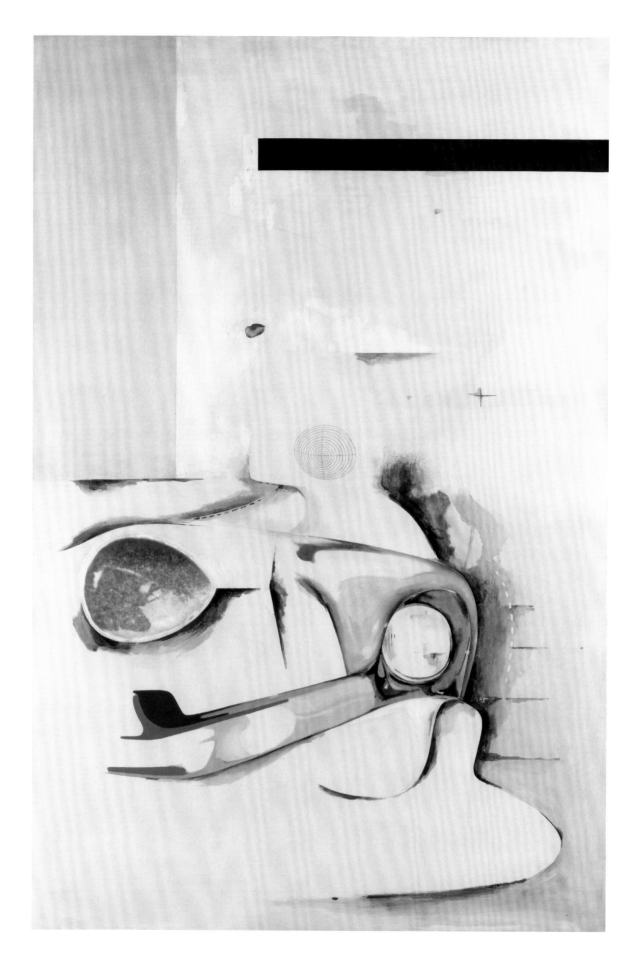

Hommage à Chrysler Corp 1957 Richard Hamilton

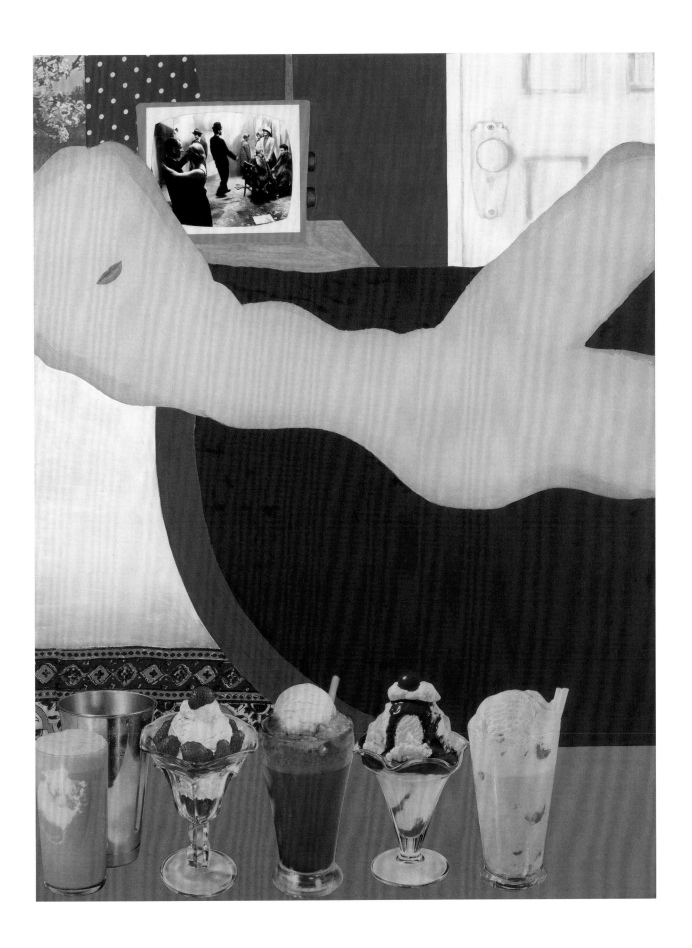

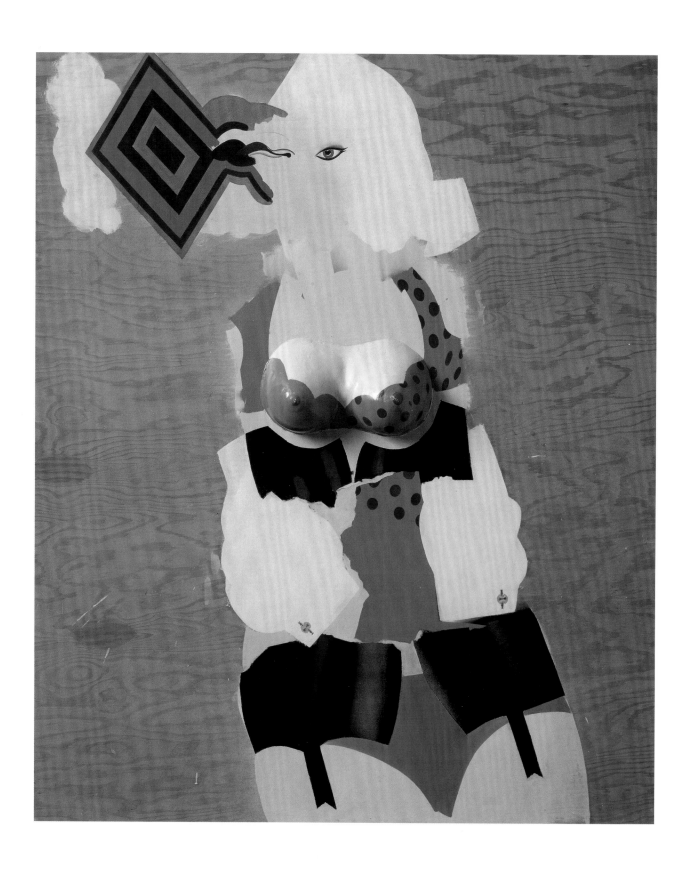

Curious Woman 1964–5 Allen Jones

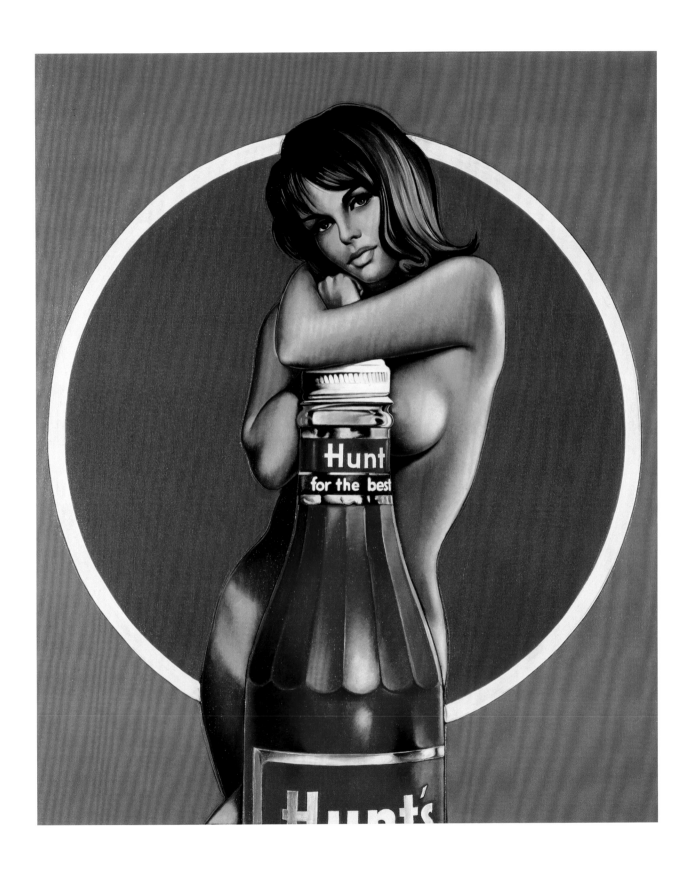

the level of ordinary mortals. The façade of stardom – the famous face – extended the convention of portraiture dramatically, becoming synonymous with the creation of celebrity status. Among Pop Art's many portraits of 'stars', one subject in particular stands out and sheds light on the evolution of Pop's relationship with the phenomenon of fame. That subject is Marilyn Monroe.

Early Pop Art portraits of the film goddess celebrate her iconic status. Her appearance in works by Blake, Johnson and Phillips reflects an uncritical fascination with her media image. When Monroe committed suicide on 4 August 1962, the ensuing storm of publicity changed the way the actress was perceived. The impression of a glittering star became occluded by speculation about the unhappy circumstances of her private life. This, however, served only to intensify interest in the media and among artists. After her death, portraits of Marilyn proliferated. Indeed, in December 1967, the Sidney Janis Gallery in New York exhibited fifty works of art by various artists, including a number associated with Pop, notably Hamilton, Oldenburg, Rosenquist and Warhol. While many of the works displayed paid tribute to the fallen idol, a number of portraits of Marilyn made by certain Pop artists after her death are notable for the way they explore the façade of fame, deconstructing it in order to make sense of its connection with the individual it concealed.

Boty's painting, *The Only Blonde in the World* 1963 (right), was based on a newspaper photograph. As such it contrasts with many other Pop representations of Monroe, which tend to incorporate photographs more or less directly. Whereas the manipulation of photographs implies a certain detachment, Boty's reliance on painting introduces a degree of sensual involvement with the image. Monroe is represented within the context of various abstract coloured shapes that carry an up-beat, emotive resonance. This invests the portrait with a certain poignance. Anyone viewing the painting could not have been unaware of Monroe's death, and the high-key colour acts as a reminder of the vitality that had been extinguished. Boty's portrait emphasizes these human qualities, presenting Monroe as a vivacious woman, smiling and at ease. One of the few female Pop artists, Boty explored territory of a rather different kind from that of her male counterparts, who probed more closely the complexities of Monroe's sexual magnetism.

In this respect D'Arcangelo's portrait, *Marilyn* 1962 (p.108), was startlingly direct. Appropriating the style of paper cut-outs found in magazines, the screen legend's image is presented as a fabrication. Monroe is depicted as a faceless mannequin, without individual characteristics. A set of features – eyes, nose and lips – is presented alongside, complete with scissors, as if inviting the viewer to assemble the façade of her mystique. The image seems to say that all is artifice, the screen

Pauline Boty 29 October 1963
Michael Ward

Boty came to the attention of the British public when she appeared with Peter Blake, Derek Boshier and Peter Phillips in Ken Russell's 1962 documentary film, *Pop! Goes the Easel*. Like Blake, Boshier and Phillips, Boty's point of view was frequently that of the admiring fan, and her work depicts stars such as Marilyn Monroe and Elvis Presley. Here Boty is standing alongside her portrait of the designer Celia Birtwell, who, in turn, is depicted with her 'heroes'.

The Only Blonde in the World 1963 Pauline Boty

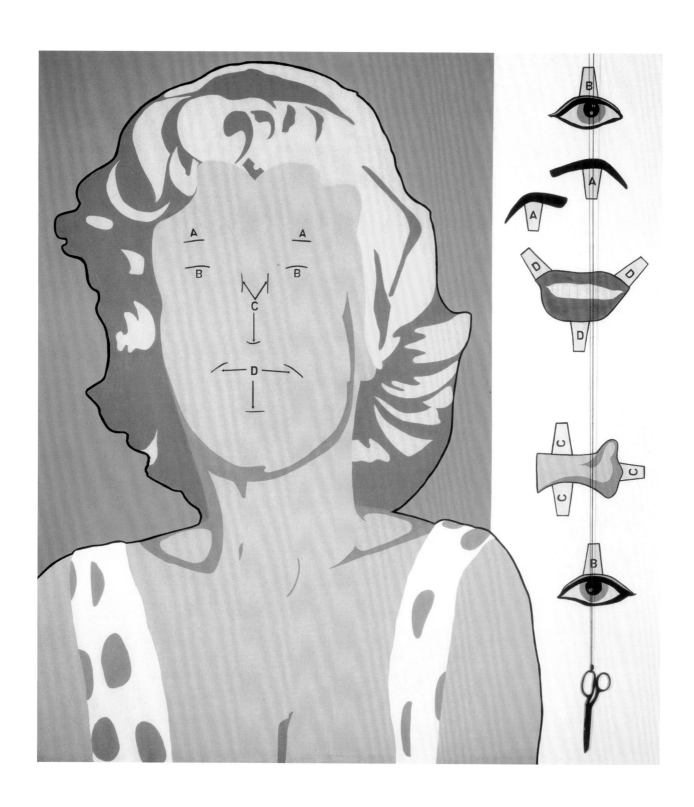

Marilyn 1962 Allan D'Arcangelo

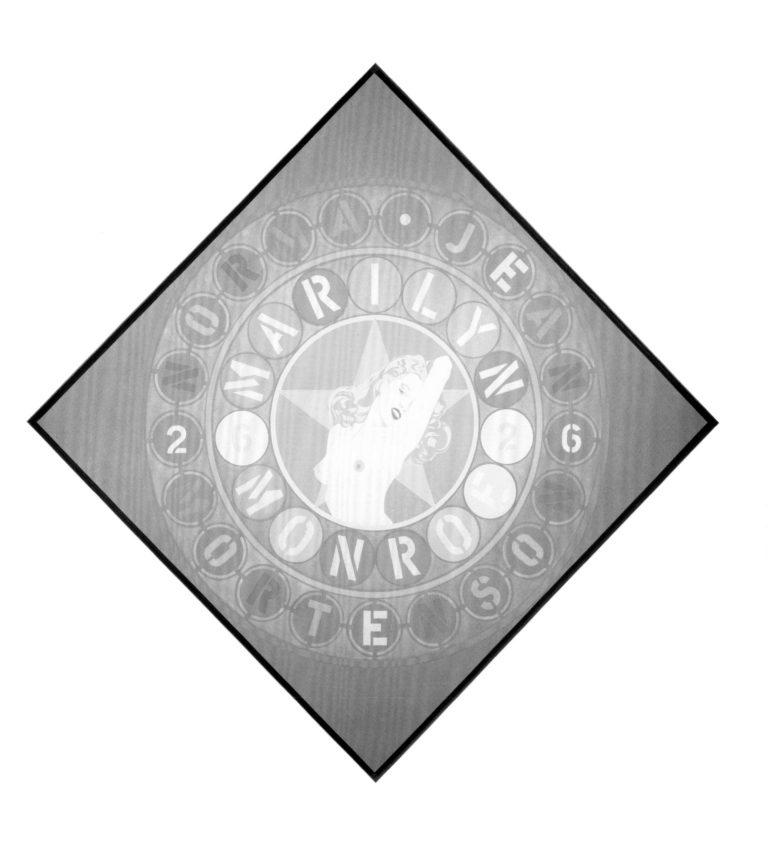

The Metamorphosis of Norma Jean Mortenson 1967 Robert Indiana

persona simply a mask behind which no trace of the individual remains. Among Pop's critiques of fame, this image ranks as one of its most brutal commentaries on the capacity of the media to dehumanize. D'Arcangelo's portrait focused on Marilyn's famous 'image' and literally took it apart. The process of deconstruction was continued by Warhol, Hamilton and Oldenburg. But for these artists it was the fracture between the fragile individual and her media image, her personal vulnerability, and, ultimately, the fact of her death, which were the prime concerns. In different ways, through the Marilyn figure, the idea of fame was refracted through the lens of tragedy.

When Warhol heard of Monroe's suicide he responded by creating a series of portraits (pp.112–13,114). Using a still from one of Monroe's films, *Niagara* (right), he transferred the black-and-white image to a silkscreen, facilitating multiple printings onto prepared painted canvases. These over-printed images were then manipulated further through the addition of paint. His prolonged engagement with this subject produced twenty-three portraits, including *Marilyn Diptych* 1962 (p.114) comprising serial repetition of Monroe's features. Warhol's involvement with the subject of Monroe can be seen as the unfolding of a deepening preoccupation with the nature of fame. At its centre stands artifice. Warhol began with a publicity photograph, an invented image that masks the real person. The 'mask' was then progressively enhanced through the addition of garish colour, forcing a further disjunction with reality. The final portrait is a metaphor for fame: a fabricated persona, in which the 'real' person has become enmeshed with their 'image'. Of this process, Warhol observed: 'I don't know where the artificial stops and the real starts.'[6]

Near the end of her life Monroe confided to an interviewer that she hated the way being a sex symbol had transformed her into a thing. Three years after her death, Hamilton's multiple portrait, *My Marilyn 1965* (p.115) took the star's fate as its subject. Hamilton based this work on a series of photographs published in *Town* magazine shortly after her death. Taken by the photographer George Barris, they show Monroe posing on a beach. Hamilton has arranged the twelve images so that they read as contact prints. Monroe's contract specified that she could approve or veto all such publicity material and the individual frames reveal her crossings-out, indicating rejection and also an indication of approval in the single phrase 'good'. The images bear testimony to the process of Monroe's self-examination, criticism and denial, frame after frame being negated. Hamilton's manipulation of the material emphasizes this process through a progressive obliteration of Marilyn's image. By these means, the viewer witnesses the way the mechanism of fame leads inexorably to the gradual disappearance of the person.

The publicity still that inspired Andy Warhol's 'Marilyn' series 1953

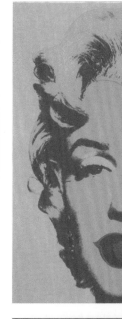
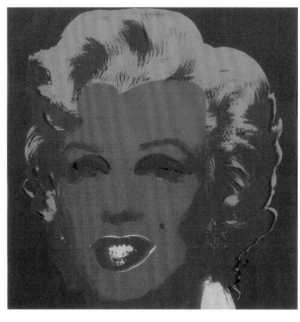
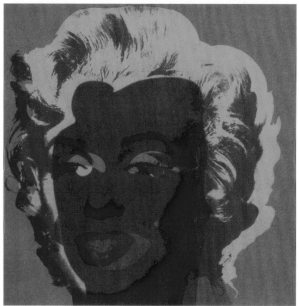
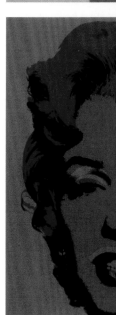

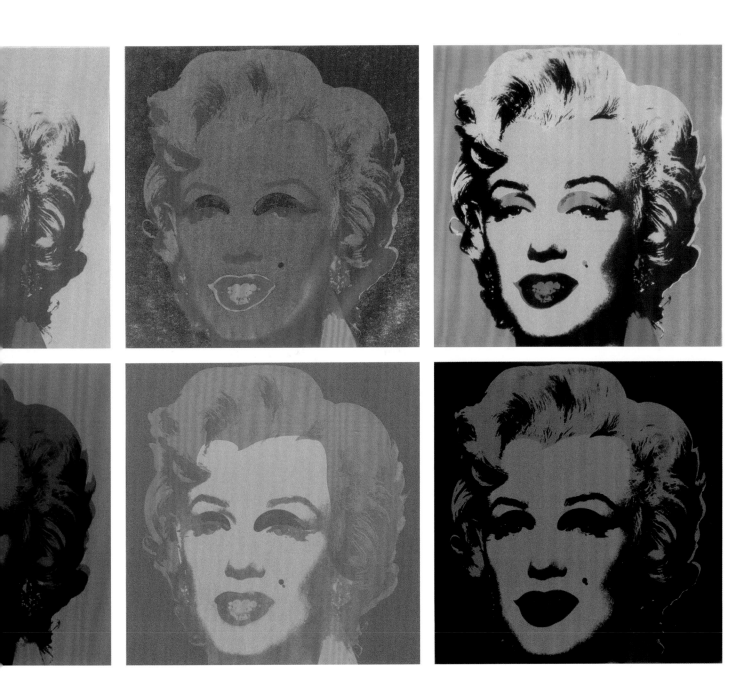

Marilyn Monroe (Marilyn) 1967 Andy Warhol 113

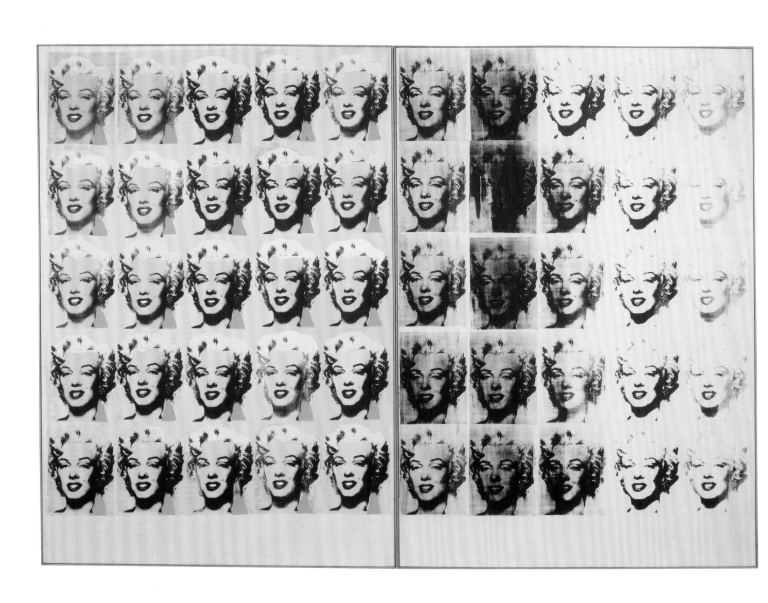

Marilyn Diptych 1962 Andy Warhol

My Marilyn 1965 Richard Hamilton

Ghost Wardrobe for MM 1967 Claes Oldenburg

NOTES

1 Mario Amaya, *Pop as Art: A Survey of the New Super-Realism* (London, 1965), p.72.

2 Quoted in Walter Hopps and Sarah Bancroft, *James Rosenquist: A Retrospective* (Guggenheim Museum, New York, 2004), p.29.

3 Quoted in Andrew Lambirth, 'Prologue: Raw Material', in *Allen Jones: Works* (London, 2005), p.14.

4 Quoted in Victor Arwas, *Allen Jones* (London, 1993), p.35.

5 Quoted in Slim Stealingworth, *Tom Wesselman* (New York, 1980), p.24.

6 Quoted in Gretchen Berg, 'Nothing to Lose – Interview with Andy Warhol', *Cahiers du Cinema*, May 1967, p.40.

The idea that fame transforms the individual is central to Robert Indiana's painting *The Metamorphosis of Norma Jean Mortenson* 1967 (p.109). Based on a nude photograph that appeared in the first issue of *Playboy*, published in 1953, the painting provides a poignant reminder of Monroe's early search for stardom when she was plain Norma Jean Mortenson. In Indiana's painting, the image of Norma Jean has become a cipher for sexual allure, a dehumanized symbol drained of reality, recast as Marilyn Monroe. Oldenburg's sculpture, *Ghost Wardrobe for MM* 1967 (left), took this process to its tragic conclusion. Using real objects – a clothes rail and hangers – Marilyn is portrayed as an absence. Sinuous lengths of cord, suggesting the ghostly skeleton of her clothes and underwear, are all that remain. Marilyn has become an apparition that exists somewhere between the real person and her public image. Oldenburg's portrait is a kind of annihilation, implying that the real tragedy of fame is that those it touches, it also consumes.

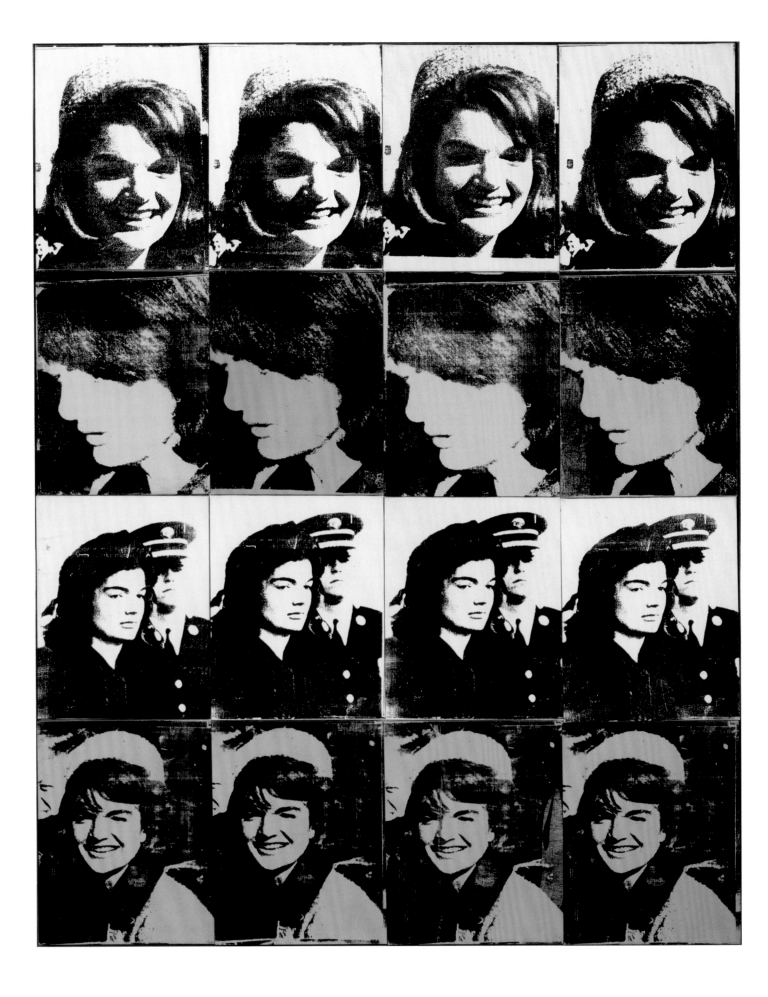

Innocence and Experience

16 Jackies 1964
Andy Warhol

One of numerous paintings of
Jacqueline Kennedy made by
Warhol following the assassination
of John F. Kennedy in 1963. The
juxtaposition of images derived from
photographs of Jackie taken before
and after Kennedy's murder is a telling
evocation of optimism replaced by
disillusionment, a rite of passage that
came to define the 1960s.

In many ways Pop Art gave the 1960s a face. Responsive to the events and
sensibility that define the period, the portrait that emerged evokes complex social
change, turbulent political developments and rapid technological advance. But
just as no single epithet could ever adequately encapsulate the era, there is no
definitive visual representation either. Pop Art's portrait of the times is an ever-
changing face, yet one in which there is a clear sense of a coming of age.

Gerald Laing, whose affiliation with Pop dates from around 1963, effectively
summarized the mood that attended the emergence of the new realism:

> In the early sixties there was a general feeling of optimism fuelled by our emergence
> from the post-war period … coupled with a belief in the ability of technology to solve
> our temporal and perhaps even our spiritual problems. This change in attitude seemed
> to call for a new art, one which was precise, methodical, clear and uncompromising,
> one which could be glimpsed as one sped past on one's way to the airport in the City
> of Tomorrow.[1]

This optimism and, to some extent, celebratory innocence, were certainly captured
by Blake. In the absence of any single defining characteristic, the emergence of a
more affluent younger generation – responsive to American style and music, and
with money to spend on magazines and records and in dance halls – is certainly
a conspicuous feature of the late 1950s and early 1960s in Britain. At the heart
of youth culture was pop music, the interest in which, after 1963, reached a

The 1962 Beatles 1963–8 Peter Blake

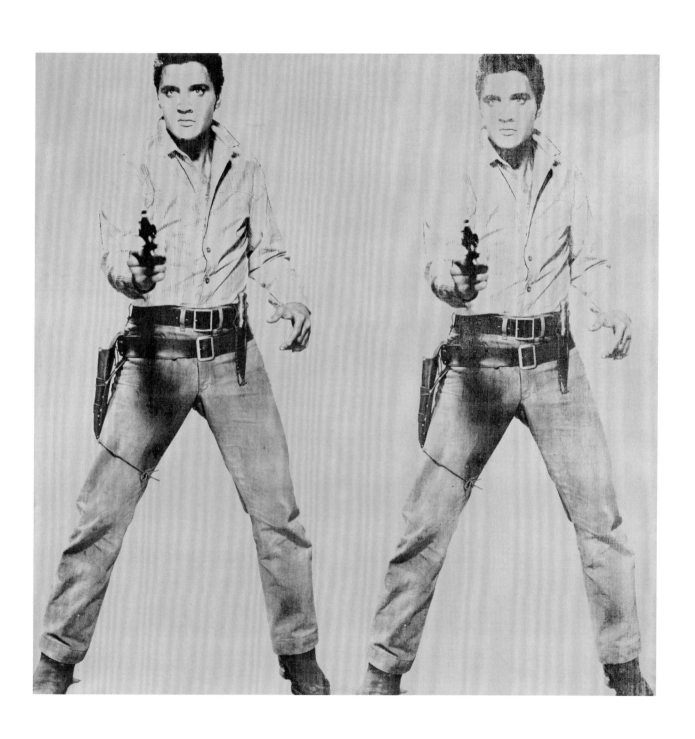

Double Elvis 1963 Andy Warhol 121

phenomenal peak. By mid-1963, the Beatles had seized the attention of the British public, establishing 'Beatlemania' as a force to be reckoned with. Blake's group portrait, *The 1962 Beatles* 1963–8 (p.120) attests to the mass audience commanded by the 'Fab Four'. In much the same way that a teenage fan might go about it, Blake painted the work from photographs reproduced in *Pop Pics* magazine, the date in the centre of the image referring to the year the photographs were taken. The white rectangles in the corner of each individual portrait were created to receive the autographs of each musician. This ambition was later abandoned and the blank spaces now serve to suggest that, among Pop Art portraits, this image is perhaps the most unaffected consummation of art and popular culture: uncritical, uncomplicated and entirely celebratory.

This sensibility contrasts with Warhol's way of working when producing *Double Elvis* 1963 (p.121), an image that could be seen as complementary to Blake's. In 1963, the Beatles were unknown in America. Warhol's portrait of Presley, one of a series shown at the Ferus Gallery, Los Angeles in September 1963, depicts the apotheosis of American rock 'n' roll, dressed as a gun-slinger, an image derived from a publicity shot for one of Presley's films. However, while Blake's perspective was that of the enthusiast, Warhol's could hardly have been more detached. Presenting Elvis in a cinematic context distanced the star not only from his identity as a person; it also separated him from his principal persona as a musician. 'Vacant, vacuous Hollywood,' Warhol observed, adding: 'I like American films best, I think they're so great, they're so clear … their surfaces are great. I like what they have to say: they don't really have much to say, so that's why they're so good.'[2] Warhol dispatched the portraits to his dealer, Irving Blum, unstretched and in a roll, with instructions that Blum could stretch the canvases any way he liked. Blake had responded as a fan, seeking a closer identification with his teenage idols through the hand-painted replication of their photographed images. The opposite is true of Warhol, who treated his subject's fame as pure surface, as an impenetrable, ultimately meaningless, veneer.

A similar difference in psychology marks the responses of British and American Pop to another source of mass interest: the space race. As Laing points out, many saw technological advance as a panacea to problems of a spiritual nature. There was a belief that scientists could not only solve humanity's difficulties but also point a path to the future. For that reason, the accelerating advances into space were viewed with a combination of fascination, awe and hope. In itself, the pace of developments was breathtaking. In 1961, Yuri Gagarin orbited the earth, followed a year later by the American astronauts, Glenn, Carpenter and Schirra. The launch of the satellite Telstar also took place in 1962. Two years later, Ranger VII took close-up photographs of the moon's surface. In 1965, Soviet

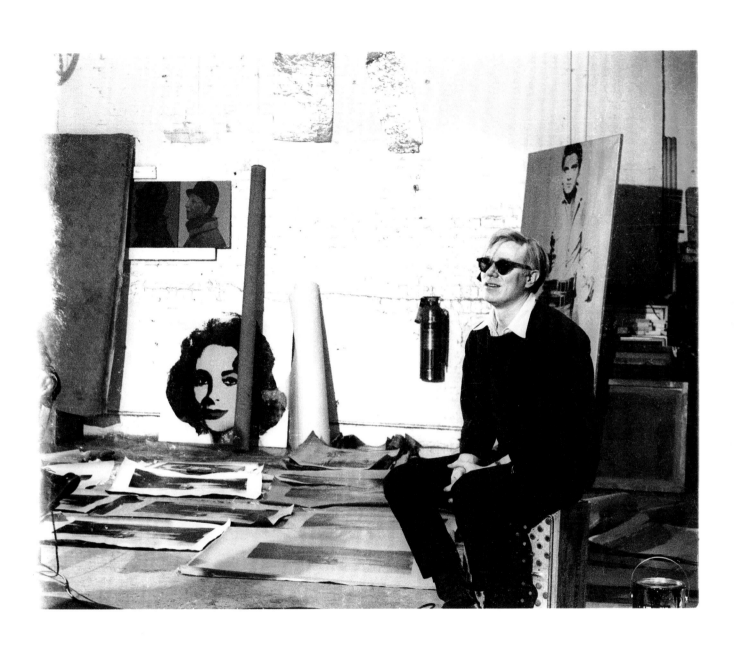

and American astronauts walked in space; the next year both countries landed unmanned spacecraft on the moon. With the conquest of space underway, images of rockets and astronauts defined the new age.

In terms of Pop's response, once again the British view was that of the admiring spectator seeking a closer involvement with the subject. Boshier's painting, *The Most Handsome Hero of the Cosmos and Mr Shepherd* 1962 (right), includes a tiny, double portrait of the Russian cosmonaut Yuri Gagarin standing next to his American counterpart Alan Shepard (his surname misspelt in Boshier's title). These two figures are set in a semi-diagrammatic representation of the cosmos, in which the earth's curvature, gigantic clouds, a star map, the launch of a rocket and inscribed quotations from newspaper reports are elements. The disparity between the size of the figures and the surrounding context is an effective device, evoking the vast, almost abstract nature of space. The painting conjures the heroic nature of the space race, an endeavour at once exciting, dangerous and competitive.

These emotive aspects are also caught by Laing in *Astronaut 4* 1963 (p.126), one of several paintings he made which incorporate images of astronauts. By the time he made this painting, Laing had evolved his signature style of scaling up small photographs found in newspapers, freely enlarging the dot formations of the originals but preserving their tonal values. As Laing later explained, 'I intended it to be clear to the observer that my paintings were paintings of reproductions of reality, not of reality itself. They were a glorification of the consumer-directed and homogenized popular image, which in itself is a type of perfection.'[3] Laing's ostensible subject, like Boshier's, is the American astronaut Alan Shepard, who is shown in close-up during his orbital space mission in 1961. Laing's portrait focuses on a number of interests, not least an immersion in American culture and the depiction of new kinds of experience connected with acceleration and zero gravity. Entry into space is seen as a brave adventure. This impression is underlined by the heraldic depiction of flames, which evoke the space-explorer as a kind of modern-day knight. But, as Laing made clear, his subject was not only a new breed of super-hero. It was also the language of popular, mass-reproduced images. As such, this work addressed directly the issue raised by Hamilton quoted earlier; that of fabricating 'a new image of art to signify an understanding of man's changing state'.

In their different ways, man's changing state is the subject of paintings by Hamilton and Rauschenberg, both of whom incorporate portraits of the American president, John F. Kennedy, in the context of the space race. The connection is explained by the reference to a speech by Kennedy in which he implored his

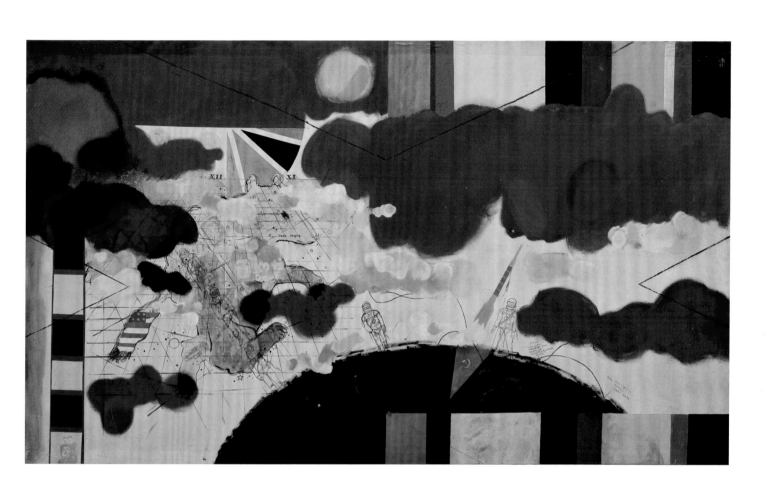

The Most Handsome Hero of the Cosmos and Mr Shepherd 1962 Derek Boshier

Astronaut 4 1963 Gerald Laing

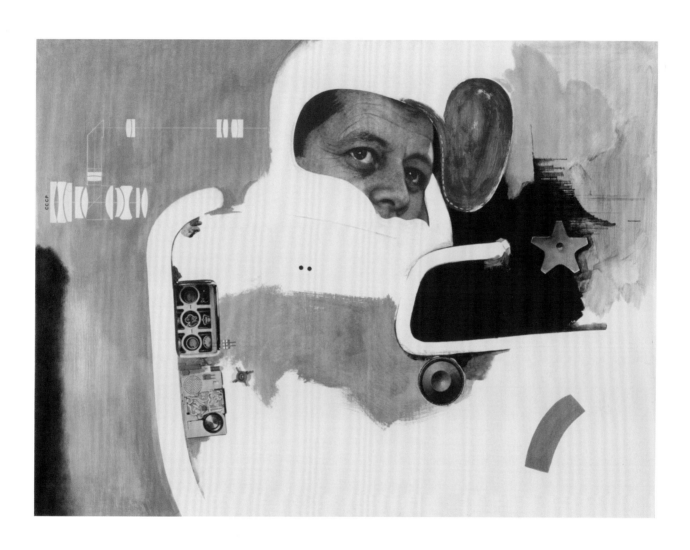

Towards a definitive statement on the coming trends in men's wear and accessories (a) 'Together let us explore the stars'
1962 Richard Hamilton

listeners: 'Together let us explore the stars'. These words form the subtitle of Hamilton's painting, *Towards a definitive statement on the coming trends in men's wear and accessories* 1962 (p.127). Part of a group of paintings that explore different aspects of masculinity, this work addresses man in a technological environment. Using images derived from photographs of early orbital space missions, Kennedy himself is represented as an astronaut. In Rauschenberg's *Retroactive II* (p.130) and *Buffalo II* (p.131), both 1964, the president is shown in everyday wear, but is no less the embodiment of the technological age through being surrounded by a dizzying profusion of images evoking movement and communication. Since 1962, Rauschenberg had, like Warhol, screenprinted images directly onto canvas. *Express* 1963 (right), is one of the earliest paintings in which he demonstrated a mastery of this new way of working: a collage-like method which, when combined with passages of gestural paint, enabled disparate images from many different sources to be drawn together, allowing improvisational flexibility. *Express* combines portraits of the choreographer, Merce Cunngingham, with the dancer's trio (Carolyn Brown, Viola Farber and Steve Paxtoff). These images are set within a plethora of visual fragments in which a rider on horseback, a nude woman, and a line of mountaineers can all be glimpsed. In common with Hamilton, in such works Rauschenberg advanced a new kind of portraiture, rooted in collage, in which old hierarchies between the figure, objects and setting have been broken down.

On 12 June 1965, it was announced that the Beatles were to be awarded the MBE. Pop music, it seemed, had become not only respectable but also official. The association of the 1960s with an ethos of fun, leisure, fashion, affluence and youth was consecrated the following year when *Time* magazine paraded a Pop-style collage on the cover of its April 1966 issue, announcing: 'LONDON: The Swinging City'. With the advent of cheaper air travel, traffic between America and Britain intensified, not least in terms of a dramatic increase in the number of American tourists visiting London, which was now perceived as the epicentre of the new culture. America, which had been seen by Alloway and the Independent Group in the mid-1950s to be 'producing the best popular culture',[4] ten years later found itself looking back across the Atlantic.

But already, in both countries, the tide was turning. Again, Gerald Laing is illuminating: 'For me the decade has the structure of a tragedy, with the optimism of the first two or three years succeeded by the hubris of radical politics, sexual freedom, drugs and moral relativism, and the nemesis of dislocation and disease.'[5] Of course, from one perspective none of these things was ever entirely absent. The early 1960s also saw the appalling effects of thalidomide, the Cuban Missile Crisis, the Profumo Affair, civil rights demonstrations in the southern states of

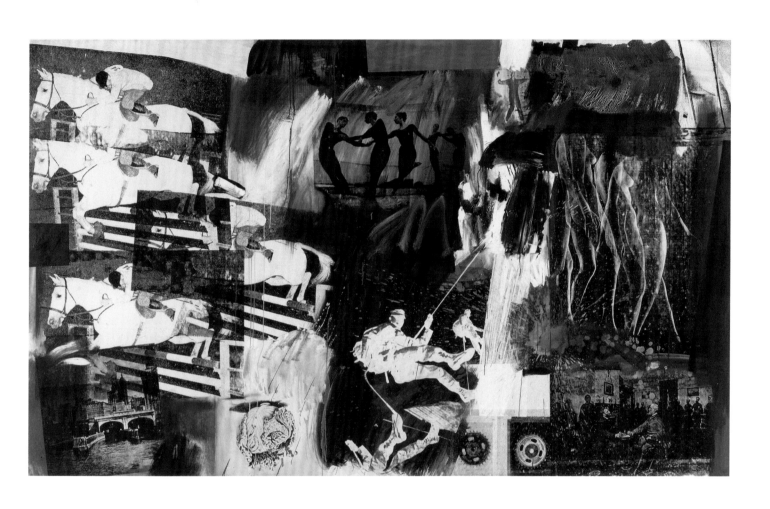

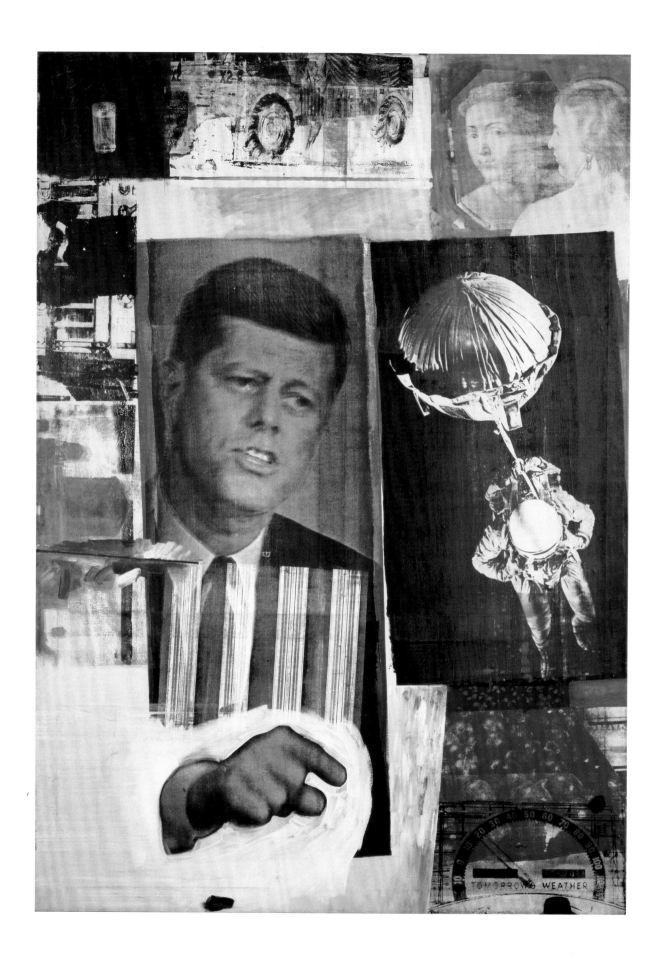

Retroactive II 1963 Robert Rauschenberg

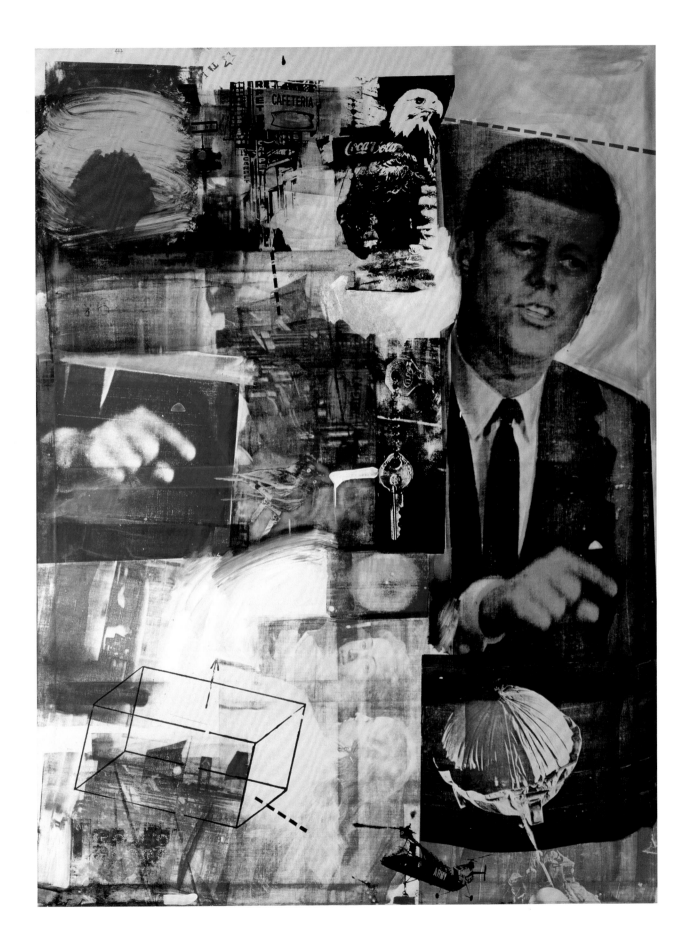

Buffalo II 1964 Robert Rauschenberg

America, the assassination of President John F. Kennedy, the explosion of China's first atomic bomb, the assassination of Malcolm X, the Moors Murders in Britain and demonstrations in Washington against the Vietnam War. Seen in this light, the Swinging Sixties is at best a very partial view of a much more complicated and darker period. But even so, Laing has a point. While the first half of the 1960s were no less troubled than any other period in history, there was a growing sense, from the middle of the decade, that the initial optimism had faded. This view hardened with succeeding events: race riots in Chicago and Brooklyn, the bombing of Hanoi, the Aberfan disaster in Wales, demonstrations in New York and Washington against the continuing American involvement in Vietnam, the assassinations of Martin Luther King and Senator Robert F. Kennedy, student protest in both America and Europe, and civil conflict in Northern Ireland. Increasingly, strife seemed a sign of the times.

Charged as it was by human issues, this change in sensibility is apparent in the portraiture produced by Pop artists. In some cases, a perception of the darker underbelly of modern life had been evident from the outset. The work made during the 1960s by Colin Self, who studied at the Slade, is distinguished by a profound anxiety about the threat of nuclear annihilation. His work is closely associated with Pop, not least in terms of the way its imagery derives from contemporary culture: cinemas, ice lollies, sofas and modern furnishings are recurrent themes. But these images are juxtaposed with elements signifying threat and aggression, bombers and fall-out shelters providing an ever-present backdrop. In particular, *Two Waiting Women and B52 Nuclear Bomber* 1963 (right), which was made while Self was a student, encapsulates the tension between the passive women sporting contemporary fashions and the warring violence of men, embodied by the bomber passing overhead. The women are part-covert and part-fantasy portraits, combining images copied from a mass-produced fashion poster with imaginative invention.

The perceived threat of a nuclear holocaust hangs over the 1960s, colouring the international scene and internal political debate. For Hamilton, who was a supporter of nuclear disarmament, the danger posed was identifiable with those politicians responsible for influencing government policy. His *Portrait of Hugh Gaitskell as a Famous Monster of Filmland* 1964 (p.134) depicts the leader of the Labour Party who, in Hamilton's view, had done little while in opposition to arrest the Conservative government's commitment to an independent nuclear deterrent. That the majority view within the Labour movement had condemned a proliferation of British nuclear weapons made Gaitskell's role all the more contemptible. Gaitskell died in January 1963, but Hamilton overcame qualms about the project and proceeded to portray the politician's sinister aspect. Using

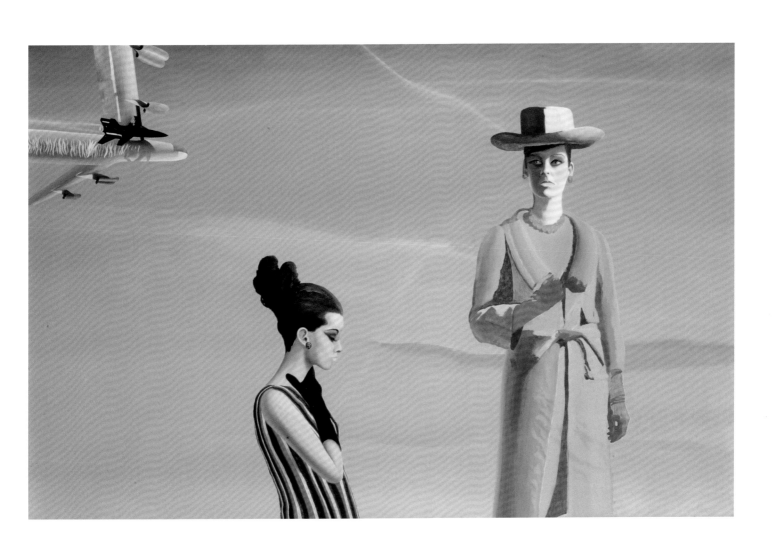

Two Waiting Women and B52 Nuclear Bomber 1963 Colin Self

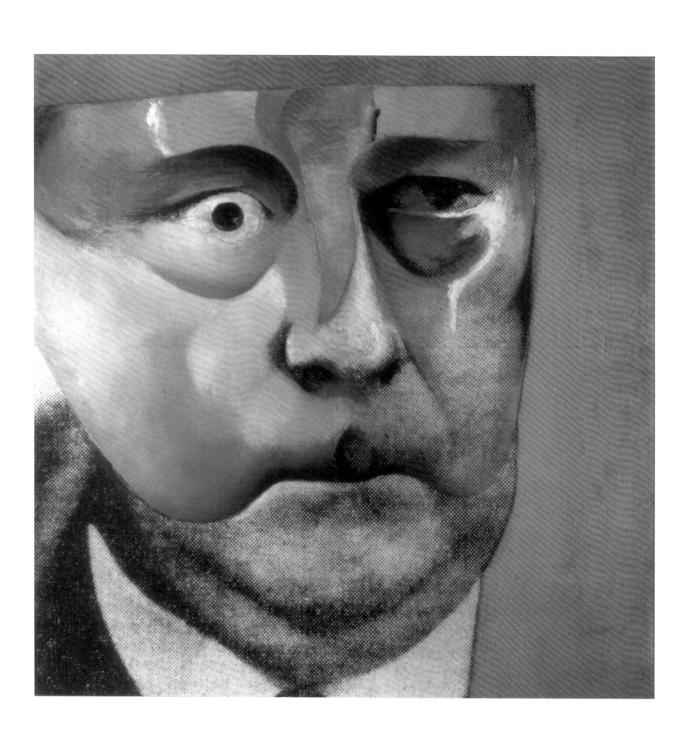

Portrait of Hugh Gaitskell as a Famous Monster of Filmland 1964 Richard Hamilton

an enlarged newspaper photograph as the basis for the image, he overpainted this with a mask motif derived from the cover of the magazine *Famous Monsters of Filmland*, which showed Claude Rains in the leading role of the *Phantom of the Opera*. This elision of reality and fiction, and their derivation from mass-media sources, is an important staging post – an explicit re-defining of the boundaries of portraiture according the aesthetics of Pop Art.

It also serves as a reminder that, even as the subject matter of Pop developed beyond the imagery of consumerism to embrace wider social and political themes, issues of style and the means of expression remained centrally important. The capacity of style to inform meaning is central to Rosenquist's monochromatic paintings, an aspect of his work that proceeded alongside his large, colourful, billboard-inspired paintings. Two monochromes, *Head on another shape: Study for Big Bo* 1966 (p.136) and *Daley Portrait* 1968 (p.137), were derived from black-and-white photographs. During the process of painting, both enlarging this original source material and refusing to admit colour reflected a wish to sustain the anonymity and mystery of the original images. Rosenquist's portraits of Bo McGhee, the blues musician, and Richard D. Daley, the controversial mayor of Chicago, are highly ambiguous images: disembodied, abstracted and fragmentary. As portraits they are difficult to grasp, like memories. But there is also a suggestion that the image projected by musicians and politicians, though larger than life, has an inescapable unreality.

Joe Tilson also placed a premium on the material fabric of the work of art, while demonstrating the capacity of the language of Pop to engage with highly politicized topics. His *Page 16: Ecology, Fire, Air, Water, Earth* 1969–70 (p.140) belongs to a series of twenty works, in mixed media, which demonstrate an overt concern with contemporary issues, from civil rights, black power and the Vietnam War, to cinema, fashion, and the actions of various politicians and leaders. Portraiture, drawing on images taken from an array of sources, is the dominant characteristic of these works. In *Page 16*, the line-up of personalities comprises: Stokely Carmichael (a member of the Black Panther group), Sigmund Freud, a Cadaveo girl from Brazil, Claude Lévi-Strauss, Herbert Marcuse, Ho Chi Minh, William Burroughs, Che Guevara, Malcolm X, Buckminster Fuller, the author Frantz Fanon, and Chairman Mao. As such, the work advances a panoply of appropriated portraits connected both with the 1960s and with modern culture. Unusually in Pop, these images are presented without significant modification. However, the selection itself, and the emphatic hand-made quality of the box construction that accommodates the portraits, evinces a covert subjective content. As the artist has pointed out, 'my intentions were to make an art from my thoughts and feelings of that time, [a] sort of ongoing self-portraiture'.[6]

Head on another shape: Study for Big Bo 1966 James Rosenquist

Daley Portrait 1968 James Rosenquist 137

Portrait Surrounded by Artistic Devices 1965 David Hockney

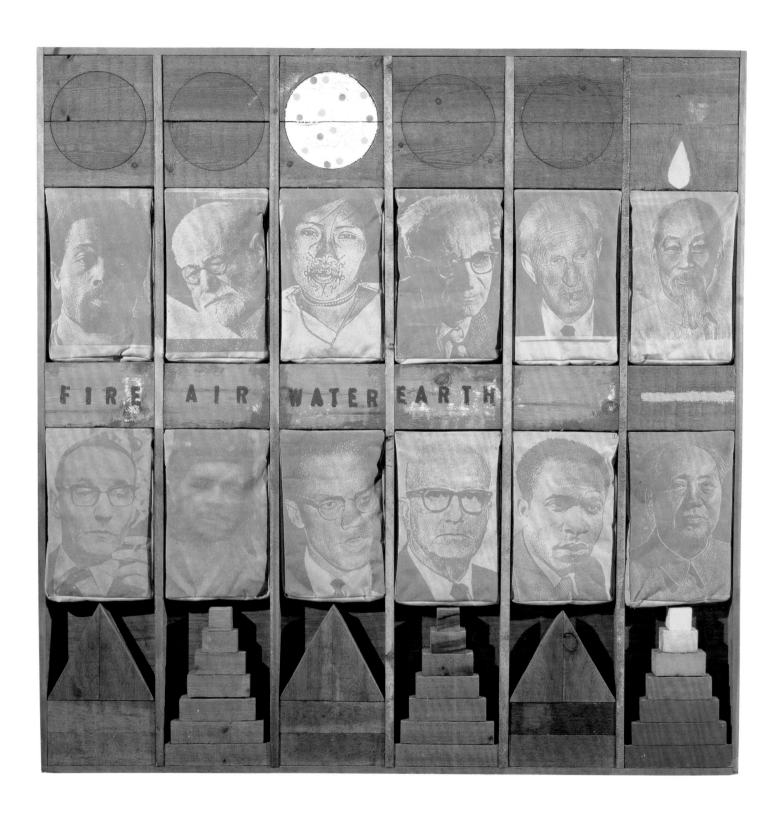

Page 16: Ecology, Fire, Air, Water, Earth 1969–70 Joe Tilson

Even when the expressive mood darkened, stylistic issues continued to be closely connected with portraiture and content of a personal, often concealed, nature. Lichtenstein's *In the Car* 1963 (frontispiece) presents a melodramatic image derived from a comic strip. But the artist's manipulation of that image, simplifying and strengthening the composition and individual elements, remained part of Lichtenstein's artistic agenda to achieve a stylistic unity, 'a new classicism', lacking in the original. Lichtenstein's painting not only accepts the comic-strip characters as suitable subjects for art, but also through his reworking creates a portrait of his source material. Similarly, Kitaj's painting *Walter Lippman* 1966 (p.139), brings together various appropriated portraits, including those of the American journalist named in the title (bottom right), the actor Robert Donat (with wine glass), and the actresses Joan Fontaine (on ladder) and Mai Zetterling. These personalities are combined within an abstract setting reminiscent of the composition of a De Stijl painting. As such, the work reads as a portrait both of particular individuals and of an artistic style. The same elision is evident in Hockney's *Portrait Surrounded by Artistic Devices* 1965 (p.138), which combines a covert portrait of his father with stylistic elements referring to Cézanne and contemporary American abstract painting. In all these cases, style and portraiture go hand in hand, the first presented as a surface, the second as a mask, together forming a screen behind which the personality of the artist has retreated. In sharp contrast to the extreme subjective revelation of Abstract Expressionism, by the late 1960s Pop portraiture had evolved as a highly stylized art form, partly advancing and partly concealing the presence of the artist.

Two portraits exemplify this position. Hamilton's *Swingeing London 67 (a)* (p.142) is one of several versions of the same subject made in 1968–9. This painting was made as a response to press reports of the arrest in 1967, on drugs charges, of Mick Jagger and the art dealer Robert Fraser. Based on a photograph reproduced in the *Daily Mail*, it shows them handcuffed together in a police van. Their hands are raised, obscuring their faces. As a result, the protagonists' demeanour is ambiguous. Even so, the image suggests that Swinging London had apparently run its course. The glare of publicity exposed celebrity as a lifestyle restricted, like any other, by the rule of law. In 1967 Andy Warhol produced a new series of large-scale self-portraits (p.143) based on an original photograph. Each variant incorporates a different colour, progressively inflecting the images without arriving at a definitive version. As in the Hamilton, a hand gesture introduces an element of ambiguity. In each version, Warhol is shown reaching upwards so that his face is partially hidden. At the end of a period in which rapid change gave way to rising uncertainty, these portraits by Hamilton and Warhol seem poised between disclosure and concealment. They portray ambivalence, the enduring emblem of an extraordinary generation, whose dream of progress had slipped away.

NOTES

1 Quoted in Giles Auty, interview with Gerald Laing, in *Gerald Laing: 1963–1993: A Retrospective* (exh. cat., The Fruitmarket Gallery, Edinburgh, 1993), p.45.

2 Quoted in Victor Bockris, *Warhol* (London, 1989), pp.178–9.

3 Quoted in *Space, Speed, Sex, Works from the early 1960s* by Gerald Laing (exh. cat., Hazlitt, Holland-Hibbert, London, November–December 2006), p.54.

4 Lawrence Alloway, 'The Development of British Pop', in *Pop Art*, Lucy R. Lippard with contributions by Lawrence Alloway, Nancy Marmer, Nicolas Calas (London, 1966), p.32.

5 Quoted in Auty, op. cit., p.45.

6 Joe Tilson, reply dated 5 December 2006 to a written questionnaire from the author.

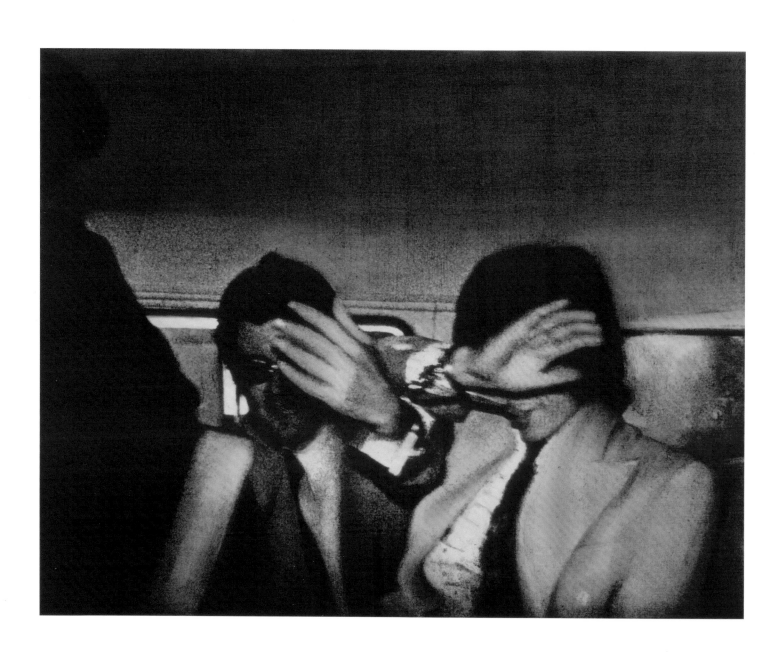

Swingeing London 67 (a) 1968–9 Richard Hamilton

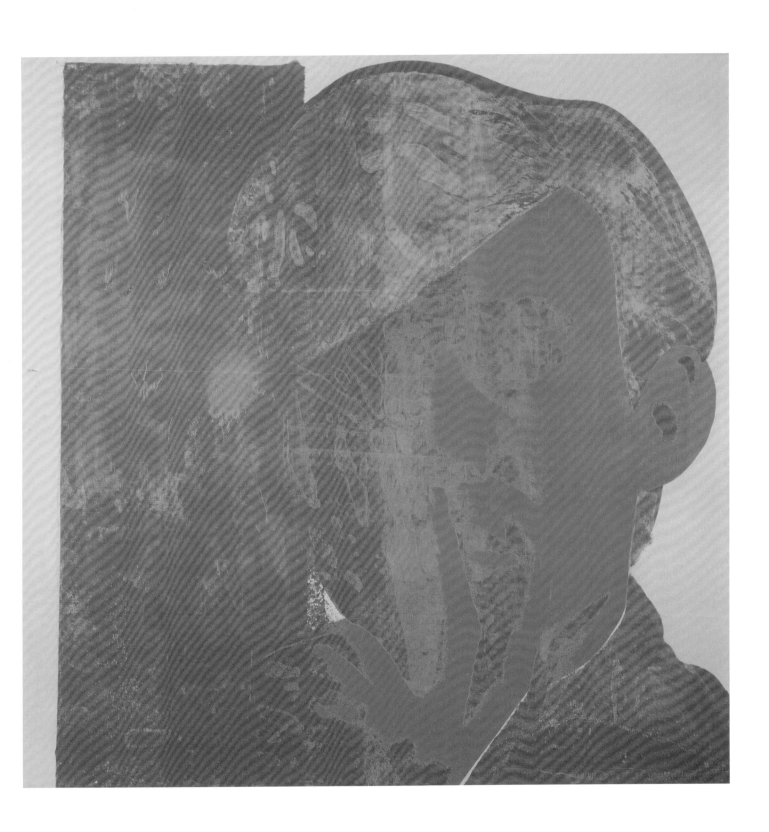

Self-portrait 1967 Andy Warhol 143

Pop Art Portraits and Film

During the 1960s the dialogue between American and British Pop Art portraiture was continued in unexpected but significant ways by Warhol's remarkable series of films, the *Screen Tests*, and by Peter Gidal's short film *Heads*. Although neither was widely known at the time, these seminal works nevertheless extended the conventions of portraiture by embracing time-based media, creating new ways of representing a sitter.

Between 1964 and 1966, 189 individuals visited Andy Warhol's Manhattan studio (the silver-painted loft known as the Factory), to sit before a 16mm Bolex camera and have their portraits made on film. In all, Warhol made 472 silent film portraits, known as 'stillies' before they acquired their definitive title of *Screen Tests*. A single 100-foot roll of black-and-white film was used for these static motion portraits, which required just under three minutes to make and, as Warhol usually projected them at a slower speed, took slightly longer to watch. The films were the result of Warhol's desire to explore the use of a movie camera in order to create a portrait that embraced change and movement. Through the medium of film, Warhol's immersion in the ideas of sequence, repetition and seriality – important themes that inform his paintings and his graphic works – deepened. Embodying the conventions of the formal photographic portrait, his sitters were positioned face to face with the camera, and then charged with the additional imperative of holding a pose for the three-minute recording.

During the 1960s Peter Gidal's experimental films were shown at underground venues, such as the New Arts Lab in Drury Lane, London as well as the London

Filmmakers' Co-operative. Gidal was a writer and influential teacher as well as a filmmaker, teaching art theory and practice at the Royal College of Art from 1971 to 1983. Made in 1969, not long after his arrival in London, Gidal's series of time-based portraits, entitled *Heads*, reveals his admiration for Warhol's film portraits of New York's beau monde of the 1960s and shares certain qualities with the earlier work. Emphasizing the formal aspects of the medium, his films reflect his preoccupation with the passage of time and structural editing. Gidal employed silent, black-and-white film, too, but unlike Warhol's portraits, Gidal's thirty-one sitters were filmed in a tight close-up so that their faces appear cropped, which contributes to what the filmmaker called 'clinical subjectivity'. Framed in this way, each portrait emphasizes the foreground of the work; 'the non-illusory use of film structure and film situation'.

The subjects of Warhol's *Screen Tests* comprise a diverse range of sitters including early Warhol superstar 'Baby' Jane Holzer, poet Allen Ginsberg, actor Dennis Hopper, filmmaker and Warhol's chief assistant Gerard Malanga, actress and socialite Edie Sedgwick, singer Lou Reed, writer Susan Sontag and artist Salvador Dalí. *Heads* comprises portraits of Charlie Watts, Bill West, Jane, John Blake, Linda Thorson, Marsha Hunt, Steve Dwoskin, Thelonius Monk, Peter Townshend, David Hockney, Marianne Faithfull, Carol Garney-Lawson, David Gale, Richard Hamilton. Dieter Meier, Rufus Collins, Leslie Smith, Anita Pallenberg, Claes Oldenburg, Francis Bacon, Adrian Munsey, Carolee Schneemann, Andrew Garney-Lawson, Jim Dine, Vivian, Prenai, Winston, Gregory Markopoulos, Rosie, Patrick Procktor and Francis Vaughan.

ARTISTBIOGRAPHIES

Richard Hamilton UK

Peter Blake UK

Derek Boshier UK

Claes Oldenburg US

Tom Wesselmann US

James Rosenquist US

Richard Smith UK

Jasper Johns US

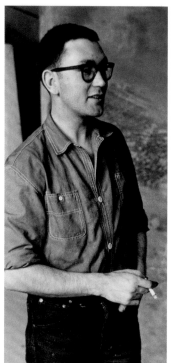

Joe Tilson UK

Eduardo Paolozzi UK

Robert Rauschenberg US

Allen Jones UK

Pauline Boty UK

Jim Dine US

Patrick Caulfield UK

Ray Johnson US

Peter Phillips UK

Gerald Laing UK

Robert Indiana US

R.B. Kitaj US

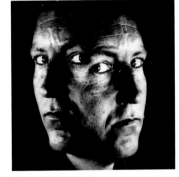

Nigel Henderson UK

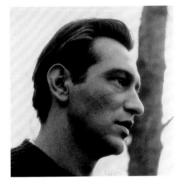

Allan D'Arcangelo US

David Hockney UK

Mel Ramos US

Colin Self UK

Larry Rivers US

Roy Lichtenstein US

Andy Warhol US

Peter Blake
1932–

Photograph by Tony Evans, 1963

Born in Dartford, Kent, Peter Blake studied art at the Gravesend School of Art (1949–51) and London's Royal College of Art (1953–6). On receiving the Leverhulme Research Award to study popular art he travelled in Europe (1956–7); further awards included the Guggenheim Painting Award (1958), First Prize Junior Section in the John Moores Liverpool Exhibition (1961), a CBE (1983) and a knighthood (2002). Blake was elected Member of the Royal Academy of Arts, London in 1979, and became an Honorary Doctor of the Royal College of Art, London in 1998. During the 1960s he taught at several London art schools including St Martin's (1960–62) and the Royal College (1964–76). He lives and works in London.

Since 1954, Blake's work has been included in group exhibitions worldwide on a regular basis. His first solo exhibition was at Portal Gallery, London in 1962. In 1969, he had his first retrospective at City Art Gallery, Bristol, followed by retrospectives at the Stedelijk Museum, Amsterdam, touring to Hamburg, Arnhem and Brussels in 1973–4; the Tate Gallery, London touring to Hanover in 1983; and, most recently, Tate Liverpool in 2007.

Blake's paintings and graphic work have included Pop subjects since the 1950s and his mass appeal has caused him to be featured in numerous television programmes and films. He designed the album cover for the Beatles' album, *Sgt. Pepper's Lonely Hearts Club Band* in 1967 with Jann Haworth, a fellow co-founder of the Brotherhood of Ruralists (1975). Other popular designs include the poster for the *Live Aid* concert (1983) and the cover for Paul Weller's *Stanley Road* album (1995).

Derek Boshier
1937–

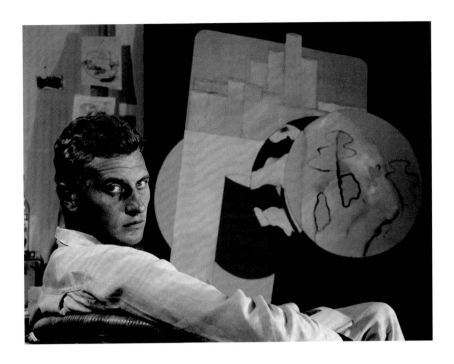

Photograph by Jorge Lewinski, 1963

Derek Boshier was born in Portsmouth, Devon and educated at Yeovil School of Art (1953–7) and Guildford College of Art (1957–9). As a student at the Royal College of Art, London (1959–62), he was associated with Pop, but differed from his fellow students in his satirical treatment of popular subjects. Work made during this period criticized the manipulative power of advertising, the Americanization of Europe and the growth of commercial culture. Boshier's early Pop phase terminated in the autumn of 1962, when he travelled to India on a one-year scholarship. On his return, his work became more abstracted and minimalist in form, expanding into sculpture, and later into photography, film and collage. Throughout the 1970s, Boshier's work remained politically and socially engaged and in 1979 he returned to painting and Pop themes. He moved to Houston, Texas in 1980 to teach, designing graphic work for David Bowie and The Clash, and painting cowboys. After a brief interval in England, Boshier relocated to Los Angeles in the late 1990s and returned to themes and images from his formative Pop works.

Pauline Boty
1938–66

Photograph by Michael Ward, 1964

Pauline Boty lived in London all her short life. She studied stained glass at Wimbledon School of Art (BA, 1954–8) and at the Royal College of Art (MA, 1958–61), where she began making surrealist-influenced collages and abstract paintings. In 1961 she participated in one of the first exhibitions of British Pop Art at the A.I.A. Gallery, London. She and her collages featured in Ken Russell's BBC television film documenting British Pop, *Pop! Goes the Easel*. By 1963 she was using images of such celebrities as Elvis Presley and Marilyn Monroe in her paintings, in combination with allusions to other British Pop artists and a celebratory attitude to female sexuality. Boty's first solo show was at the Grabowski Gallery, London in 1963 and she was included in many group exhibitions in England during the mid-1960s. Her work became increasingly political and socially critical up until her premature death from leukaemia. In 1998 it was the subject of a solo exhibition at the Mayor Gallery, London entitled *The Only Blonde in the World*. Boty was included in *Art & the 60s from Tate Britain* at Auckland Art Gallery in 2006.

Patrick Caulfield
1936–2005

Photograph by Jorge Lewinski, 1965

Born in London, where he lived, worked and died, Patrick Caulfield studied at the Chelsea School of Art (1956–60) and at the Royal College of Art (1960–63), subsequently teaching at Chelsea until 1971. In 1964 he was included in the *New Generation* exhibition of Pop Art at the Whitechapel Art Gallery, London and had his first solo show at Robert Fraser Gallery, London in 1965. Since this time, Caulfield's paintings and prints have featured in numerous key group exhibitions worldwide. His retrospectives include those at the Walker Art Gallery, Liverpool, touring to the Tate Gallery, London (1981); the Serpentine Gallery, London (1992–3); and the Hayward Gallery, London, organized by the British Council and touring to Luxemburg, Lisbon and New Haven, Connecticut (1999–2000). He was awarded a CBE in 1996. In the early 1960s Caulfield took the stylization of such early modernists as Juan Gris, Magritte and Léger as the starting point for his images of objects, interiors and architectural details. Adopting the anonymous technique of the sign-painter, he used areas of flat colour and heavy black outline to isolate and iconicize clichéd art subjects. His subsequent work continued to analyze the conventions of twentieth-century painting.

Allan D'Arcangelo
1930–98

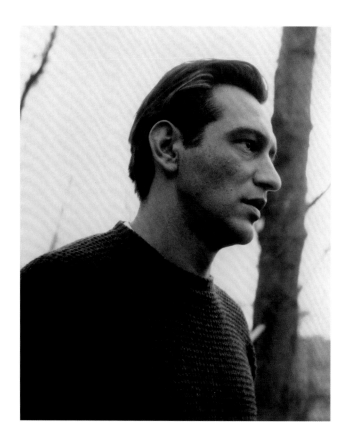

Unknown photographer, 1969

Allan D'Arcangelo was born and raised in Buffalo, New York. He studied at the University of Buffalo (BFA, 1948–53), the New School for Social Research in New York City (1953–4) and at Mexico City College (1957–9). His first exhibition was at the Galería Genova, Mexico City in 1958. He returned to New York City in 1959 where he had his first solo exhibition at the Fischbach Gallery in 1963, establishing his best-known field of imagery – the American highway. From 1962 to 1975 he was a prolific print-maker. His first Pop paintings focused on the human figure, sometimes with a political charge or an undercurrent of satire. By contrast, his highway paintings, which often include such real materials as wire fencing and Venetian blinds, are characterized by the absence of humanity. D'Arcangelo taught at the New York School of Visual Arts and at Brooklyn College where he was professor emeritus. He received a Guggenheim Fellowship in 1987–8. His work has featured in several recent Pop surveys, including *The Power of Pop* at the Stiftung Museum Kunst Palast, Düsseldorf (2003) and *Pop Classics* at the Aarhus Kunstmuseum (2004).

Jim Dine
1935–

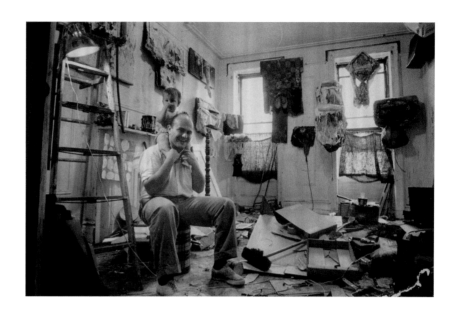

Photograph by Yale Joel, 1959

Born and raised in Cincinnati, Ohio, where he studied at the Arts Academy (1951–3) and later at the Boston Museum School and Ohio University (BFA, 1954–7), Jim Dine moved to New York in 1958. Here he became involved with the early performances known as Happenings, centred on the Judson Gallery, where he exhibited in 1958 and 1959. He had his first solo show at Reuben Gallery, New York in 1960. His assemblages, created by affixing household objects to canvases, caused him to be associated with Pop, while a strong autobiographical content differentiated him from other Pop artists of the early 1960s. Recurring imagery included painting implements, household tools, hearts and bathrobes. Drawing is central to his practice. Dine has had major retrospectives at the Whitney Museum of American Art, New York in 1970 and at the Metropolitan Museum of Art, New York in 1978. More recent solo exhibitions include *Walking Memory, 1959–1969* at the Solomon R. Guggenheim Museum, New York, in 1999. Dine's work features regularly in worldwide exhibitions of Pop Art, prints, drawings and photographs. He lives in New York and Putney, Vermont.

Richard Hamilton
1922–

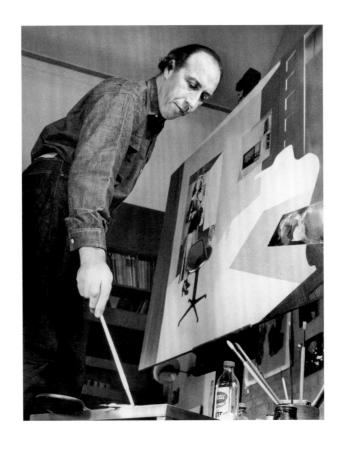

Photograph by Jorge Lewinski, 1964

Richard Hamilton was born and raised in London, where he lived until he moved to Oxfordshire in 1978. He studied art at Westminster Technical College and St Martin's School of Art (1936), at the Royal Academy Schools (1939–40 and 1946) and at the Slade School of Fine Art (1948–51). A leading member of the Independent Group formed at the Institute of Contemporary Arts, London in 1952, Hamilton began working with advertising and other mass-media material during the late 1950s. He did not exhibit this seminal Pop art until his first solo show at the Hanover Gallery, London in 1964. During the mid to late 1960s he made work based on Marcel Duchamp's art. In 1968 he began his ongoing series of Polaroid Portraits, exhibited at the Ikon Gallery, Birmingham in 2001. Hamilton's 1976 collaboration with Dieter Roth was exhibited at the Museu Serralves – Museu de Arte Contemporânea, Porto in 2002. He published his writings and lectures, *Collected Words*, in 1982. Retrospectives of his work include those at the Tate Gallery, London, touring to Eindhoven and Bern (1970); the Solomon R. Guggenheim Museum, New York, touring to Cincinnati and Berlin (1973); and the Museum Ludwig, Cologne and MACBA, Barcelona (2003). Hamilton's prolific and multi-faceted production has caused him to be identified with many artistic movements and has been exhibited frequently in major museums worldwide.

Nigel Henderson
1917–85

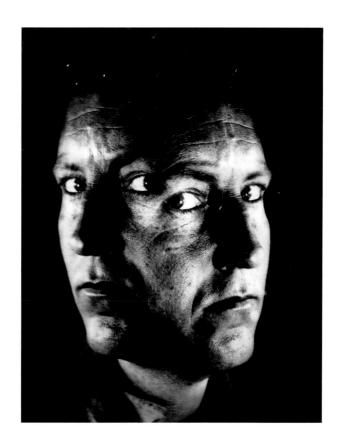

Photograph by Nigel Henderson, 1953

Nigel Henderson was born in London and studied biology at Chelsea Polytechnic (1935–6) before working as an assistant picture restorer at the National Gallery. After serving as a pilot in the Second World War (1939–45), he received a serviceman's grant to study at the Slade School of Fine Art, London (1945–7). Here he met Eduardo Paolozzi who gave him a photographic enlarger in 1949, initiating Henderson's interest in photography. Influenced by Surrealism, he began creating photograms and experimenting with distressed photography and collage techniques. Between 1949 and 1952 he took documentary photographs of east London. Henderson was associated with the Independent Group, founded in 1952 at the Institute of Contemporary Arts, London. He co-organized and participated in the *Parallel of Life and Art* exhibition at the ICA in 1953 and was included in the seminal Pop exhibition *This is Tomorrow* at the Whitechapel Art Gallery in 1956. Henderson had his first one-man exhibition at the ICA in 1961 and another major exhibition at Kettle's Yard, Cambridge in 1977. In 2001 the National Galleries of Scotland organized a touring retrospective of Henderson's work. He moved to Thorpe-le-Soken, Essex in 1954, remaining there for the rest of his life.

David Hockney
1937–

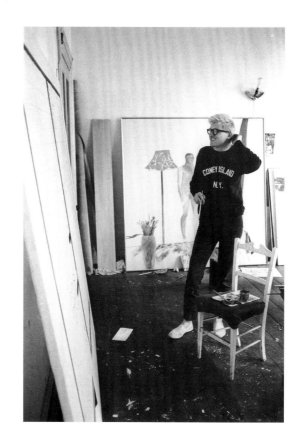

Photograph by Tony Evans, 1963

David Hockney was born in Bradford, Yorkshire, attending Bradford School of Art (1953–7) and the Royal College of Art, London (1959–62), where his artistic innovation heralded an association with Pop. Hockney had his first solo exhibition at the Kasmin Gallery, London in 1963. In the same year he visited Los Angeles for the first time. After several protracted visits, he set up permanent residence there in 1976, simultaneously maintaining homes in London and later Yorkshire. Portraiture is central to Hockney's oeuvre, which is based on intimate observation of familiar surroundings and an engagement with issues of representation. In the late 1960s he became famous for stylized images of Californian landscapes and swimming pools. Photography, at first the basis for his paintings, became a significant focus in the mid-1970s, when he began making photographic assemblages inspired by Cubism. Drawing, printmaking and set design have also featured extensively. Hockney had his first retrospective in 1970 at the Whitechapel Art Gallery, London. Since then his many retrospectives have included those at the Yale Center for British Art, New Haven, touring North America and the Tate Gallery, London (1980); Los Angeles County Museum of Art, touring to the Metropolitan Museum of Art, New York and Tate Gallery, London (1988); a drawing retrospective at Hamburger Kunsthalle, the Royal Academy, London and Los Angeles County Museum of Art (1995); and photoworks retrospectives at Museum Ludwig, Cologne (1997) and the Museum of Contemporary Art, Los Angeles (2001). The National Portrait Gallery, London presented a retrospective of Hockney's portraits in 2006.

Robert Indiana
1928–

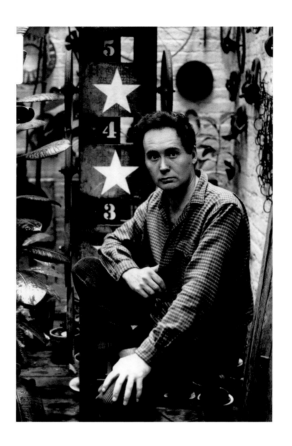

Photograph by John Adroin, 1962

Born Robert Clark, Robert Indiana took the name of his birthplace – New Castle, Indiana – as part of his artistic identity. He attended art classes at the Munson-Williams-Proctor Institute, Utica (1947–8) before studying full time at the Chicago Art Institute School (1949–53) and the Edinburgh College of Art, Scotland (1953–4). In 1954 Indiana moved to New York, where he became associated with Pop and had his first solo exhibition at the Stable Gallery in 1962. The theme of the American Dream has been central to Indiana's work since the early 1960s, when he developed a personal style through the use of typesetters' letters and numbers. His paintings, sculptures, silkscreen prints and posters are characterized by bright monotone colours in simple geometric formats. Indiana's most famous image is his graphic rearrangement of the word 'love' to form a popular design resembling a logo. This work was the starting point of his LOVE show at the Stable Gallery in 1966. In 1973 the first of a regular series of 8 cent LOVE stamps was produced by the United States Postal Service. Scaled-up in three-dimensions, Indiana's LOVE appears as public sculpture in many American cities. In 1964 he collaborated with Andy Warhol on a film entitled *Eat* and used the same word, massively enlarged, to decorate the New York State pavilion at the New York World's Fair. He had a retrospective at the Philadelphia Institute of Contemporary Art in 1968, the same year he exhibited at documenta 4, Kassel. More recent retrospectives include those held at the Musée d'Art Moderne et d'Art Contemporain, Nice in 1998 and at the Portland Museum of Art in 1999. In 1978 Indiana settled in Vinalhaven, Maine.

Jasper Johns
1930–

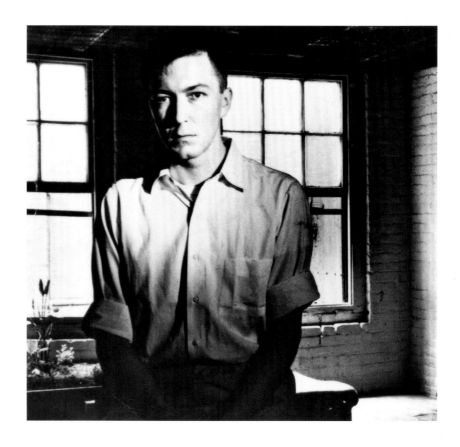

Photograph by George Moffet, 1955
(detail; see p.68)

Born in Augusta, Georgia, Johns grew up in South Carolina where he studied art briefly at the University of South Carolina before serving two years in the United States Army, partly in Japan. From 1952 he lived in downtown New York, working in a bookstore to support himself until 1958, when had his first solo show at the Leo Castelli Gallery, New York. During this period he met Robert Rauschenberg, Merce Cunningham and John Cage. He began making his first flag, target and number paintings in 1954, using wax on canvas. His focus on the three-dimensionality of the painting and his representation of banal objects constituted a significant shift from the expressive mode of Abstract Expressionism, heralding the arrival of Pop Art. In 1960, inspired by Marcel Duchamp, Johns began a series of sculptures of ordinary objects in painted bronze; in the same year he embarked on printmaking, subsequently an essential part of his practice. Johns had a retrospective at the Whitney Museum of American Art, New York in 1977, touring the United States, Europe and Japan. Retrospectives of Johns's prints were held at the Museum of Modern Art, New York, travelling around the United States, Europe and Japan in 1986; and at the Fine Arts Museum of San Francisco in 2005. In 1990 a retrospective of his drawings toured from the National Gallery of Art, Washington, DC, to Basel, London and New York. Johns has received numerous awards, including the Grand Prix at the 43rd Venice Biennale (1988). In 1996 he moved to Connecticut, where he is still based. Major museums worldwide continue to host exhibitions of Johns's work in all media.

Ray Johnson
1927–95

Unknown photographer, 1960s

Johnson was born in Detroit, Michigan and studied painting under Joseph Albers at Black Mountain College, North Carolina in the late 1940s. In 1948 he moved to New York, where he lived for twenty years before relocating to Long Island in 1968. By 1954, frustrated with abstract painting, he began to cut up his canvases to make collage – the art form for which he is best known. He combined images from popular culture with areas of abstraction, creating increasingly layered 'moticos' on panels. In 1961, in response to the Happenings movement in New York, Johnson invented 'Nothings' performances, which he continued to stage throughout his life. In the 1950s he began to experiment with mail art, creating the New York Correspondance School. He had his first solo show at One Wall Gallery and Wittenborn Books, New York in 1948, followed by solo exhibitions at the Whitney Museum of American Art, New York (1970), North Carolina Museum of Art (1976) and Walker Art Gallery, Minneapolis (1978). In 1999 the Wexner Center for the Arts, Columbus, Ohio organized a retrospective of Johnson's *Correspondances* that premiered at the Whitney Museum of American Art, New York.

Allen Jones
1937–

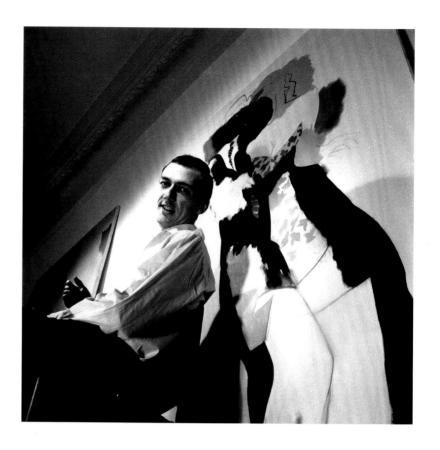

Photograph by Jorge Lewinski, 1962

Allen Jones was born in Southampton and studied at Hornsey College of Art (1955–9, 1960–61) and the Royal College of Art (1959–60), both in London. His first solo exhibition was at Arthur Tooth and Sons, London in 1963. In the same year he participated in the 3rd Paris Biennale, where he was awarded the Prix des Jeunes Artistes. Jones was included in *The New Generation* exhibition at the Whitechapel Art Gallery, London in 1964. He had a retrospective at the Walker Art Gallery, Liverpool touring London, Sunderland, Baden-Baden and Bielefeld in 1980; and at the Barbican Art Gallery, London in 1995. He had a solo show at the Royal Academy, London in 2002. At first inspired by the brightly coloured abstractions of Wassily Kandinsky and Robert Delaunay, Jones began to use sexual imagery in 1963 with fused male/female figures. From the mid to late 1960s a fetishistic eroticism became an explicit element in his sculptures, paintings and graphic work, derived from representations of the female figure in commercial imagery. Jones has spent extended periods living in the United States. He now lives and works in London.

R.B. Kitaj
1932–

Photograph by Jorge Lewinski, 1963

Born in Cleveland Ohio, R.B. Kitaj studied art at the Cooper Union Institute, New York (1950–51 and 1952–3), broken by a year at the Academy of Fine Art, Vienna. After serving a term in the United States Army, he studied at the Ruskin School of Drawing, Oxford (1958–9) before completing his studies at the Royal College of Art, London (1959–61). Here he met David Hockney and became an early influence on British Pop. His first solo exhibition at the Marlborough New London Gallery in 1963 was followed by many exhibitions worldwide, including major retrospectives at the Hirshhorn Museum and Sculpture Garden, Washington in 1981; and at the Tate Gallery, London, touring to Los Angeles County Museum of Art and the Metropolitan Museum of Art, New York in 1994–5. In 1976 Kitaj curated an influential exhibition celebrating figurative art for the Arts Council of Great Britain entitled *The Human Clay*. He published the *First Diasporist Manifesto*, discussing the Jewish dimension in his art, in 1989. The *Second Diasporist Manifesto* was published in 2005. Kitaj has received numerous awards and honorary doctorates; he was elected to the American Academy of Arts and Letters in 1982 and to the Royal Academy of Art, London in 1985. He settled in Los Angeles in 1997.

Gerald Laing
1936–

Unknown photographer, 1966

Gerald Laing was born in Newcastle-upon-Tyne. He served in the Royal Military Academy, Sandhurst (1953–5) and the Royal Northumberland Fusiliers (1955–60) before studying at St Martin's School of Art, London (1960–64). Strongly identifying with the American Pop sensibility, he moved to New York after his graduation in 1964, remaining there until 1969. During this period he developed a personal iconography from mass-media sources, mixing figurative elements with a graphic breakdown of cinematic and photographic reproduction. His paintings and prints of female stars, femmes fatales, bathing beauties, drag racers, astronauts and skydivers constitute a representation of idealized beauty and lifestyle that perfectly encapsulated the spirit of the American Dream. Laing had solo exhibitions at the Institute of Contemporary Arts, London and Richard Feigen Gallery, New York in 1964. His project *Hybrid*, made in collaboration with Peter Phillips, was exhibited at the Kornblee Gallery, New York in 1966. Laing's retrospectives include the Scottish National Gallery of Modern Art, Edinburgh (1971) and the Herbert Art Gallery, Coventry (1983). A retrospective of his Pop period (1964–9) was organized by Hazlitt Holland-Hibbert, London in 2006. Since 1970 he has lived and worked in Kinkell Castle, near Dingwell in Scotland.

Roy Lichtenstein
1923-97

Photograph by Ken Heyman, 1964

Famous for introducing the comic strip into high art, Roy Lichtenstein was born in New York, where he studied at the Art Students League (1939). Further art studies at Ohio State College in 1940–43 and 1946–9 were interrupted by war service (1943–6). Lichtenstein had his first solo show at the Carlebach Gallery, New York in 1951. Having painted in a non-figurative, Abstract Expressionist style for most of the 1950s, he began to incorporate loosely drawn cartoon figures, such as Mickey Mouse and Donald Duck, into his paintings around 1960. In 1961, scaled-up and refined cartoon-strip images became the overt subject of his work, making reference to commercial printing processes through the use of standard flat colours, strong black outlines and large Ben Day dots. Speech balloons, text and images cropped from advertisements also featured. From 1964 his work began to explore the contradictions of three-dimensional representation in painting through imagery of stylized landscapes, consumer-product packaging, famous paintings, geometric elements and parodies of Abstract Expressionist brushstrokes. Subsequent works played on the characteristics of other major twentieth-century movements. Lichtenstein participated in the 33rd, 34th and 35th Venice Biennales (1966, 1968 and 1970) and documenta 4 and 5 in Kassel (1968 and 1972). His retrospectives include those at the Pasadena Art Museum in 1967 and the Solomon R. Guggenheim Museum, New York, touring the United States in 1968. In 1994, the New York Guggenheim organized a major retrospective of his paintings and sculpture touring Los Angeles, Montreal, Munich, Hamburg, Brussels and Ohio.

Claes Oldenburg
1929–

Photograph by Jorge Lewinski, 1966

Born in Stockholm, Sweden, Claes Oldenburg lived in the United States and Norway before his family settled in Chicago in 1936. He studied literature and art history at Yale University, New Haven (1946–50) and took evening classes in fine art at the Art Institute of Chicago (1950–54), becoming an American citizen in 1953. In 1956 he moved to New York City, where he met artists involved in early performance work, such as George Brecht, Allan Kaprow and Jim Dine. At the Judson Gallery, New York, he exhibited his first Pop art objects in 1959. In 1959–60 Oldenburg used a mixture of collage, plaster and papier-mâché to create signs and oversized representations of such consumer goods as clothes and food, offering them for sale in The Store, an art environment in the form of a shop that he opened in his studio in 1961. He also used the objects in Happenings, staged between 1960 and 1962. Oldenburg began designing public monuments in the form of massively scaled-up ordinary objects in 1965. From 1976 these were produced largely in collaboration with his wife, the Dutch art historian Coosje van Bruggen. Oldenburg was included in the 32nd Venice Biennale in 1964 and had a retrospective at the Stockholm Moderna Museet in 1966. He had a solo exhibition at the Museum of Modern Art, New York in 1969, followed by retrospectives at the Pasadena Art Museum (1971–2), the Walker Art Center, Minneapolis (1975), the Museum Ludwig, Cologne (1979) and the National Gallery of Art, Washington, DC in partnership with the Solomon R. Guggenheim Museum, New York, touring Los Angeles, Bonn and London (1995).

Eduardo Paolozzi
1924-2005

Photograph by Lewis Morley, 1959

Eduardo Paolozzi was born in Edinburgh, where he studied briefly at the College of Art (1943) before enrolling at the Slade School of Fine Art in London (1944–7). A short sojourn in Paris (1947–9) introduced him to primitive art, Dada and Surrealism, influencing the development of collage as a central element in his work. Paolozzi was a significant member of the Independent Group, founded in 1952 at the Institute of Contemporary Arts, London, which established a new programme of aesthetics, attacking the cosiness of postwar British culture and promoting Pop themes: urban imagery, commercialism and mass marketing. He was included in the 1957 São Paulo Bienal and the 30th Venice Biennale (1960). The recipient of numerous sculpture awards in Europe and the United States, Paolozzi had retrospectives at the Tate Gallery, London (1971) and at the Nationalgalerie, West Berlin (1975). His portraits were exhibited at the National Portrait Gallery, London in 1988. In 1994 the Yorkshire Sculpture Park hosted an exhibition of his sculpture and graphics to celebrate Paolozzi's seventieth birthday. His many public commissions include the ceramic wall murals in Tottenham Court Road Underground Station, London and a monumental sculpture, *Newton After Blake*, for the new British Library, London.

Peter Phillips
1939–

Photograph by Jorge Lewinski, 1963

Peter Phillips was born in Birmingham, where he studied at the College of Art (BA, 1955–9) before attending the Royal College of Art, London (MA, 1959–62). He went to New York in 1964 after being awarded a Harkness Fellowship and travelled in North America with Allen Jones in 1965. Since 1966, he has lived in Switzerland, Mallorca and Germany. Strongly influenced by Jasper Johns's flag and target paintings of the late 1950s, Phillips borrowed his imagery and hard-edged formal patterns from game boards, funfairs, pin-ups, comic books and other popular sources, using an airbrush to achieve flat, uninflected surfaces. He had solo exhibitions at the Kornblee Gallery, New York in 1965 and 1966, and Galerie Bischofberger, Zurich in 1968 and 1969. During the 1970s Phillips travelled throughout the United States, Africa, the Far East and Australia. His retrospectives include those at the Westfälischer Kunstverein, Münster (1972); Walker Art Gallery, Liverpool, touring Oxford, Newcastle-upon-Tyne, Edinburgh, Southampton and London (1982–3); Casal Solleric, Palma de Mallorca (1997); and Galleria Civica, Modena (2002). Phillips's prints and paintings have featured in several recent museum and gallery Pop surveys.

Mel Ramos
1935–

Photograph by Leta Ramos, 1964

Mel Ramos was born in Sacramento, California and studied art and art history at San José State College (1954–5) and at Sacramento State College (1955–8). In 1961 he began to paint male comic-strip characters – his first Pop paintings – progressing to female comic-strip characters in 1963. After participating in *Pop! Goes the Easel* at the Contemporary Art Museum, Houston in 1963, Ramos had his first solo exhibition at the Bianchini Gallery in New York in 1964. In the same year he began to focus on female figures derived from pin-up magazines and advertisements, combining them with branded products and including large-scale lettering in his images. From 1972 he painted nudes based on works by such artists as Ingres, Modigliani, Manet and de Kooning. He had a retrospective in 1977 at the Oakland Museum of California. In the 1980s landscape replaced the female nude as his subject. Ramos had a major retrospective touring Lingen, Mannheim, Kiel and Vienna in 1994–5 and a solo exhibition at the Museum Moderna Kunst–Stiftung Wörlen, Passau in 1999. Since 1992 Ramos has been based in Oakland, California and Horta de San Juan, Spain.

Robert Rauschenberg
1925–

Photograph by Rachel Rosenthal, 1954
(detail; see p.41)

Born in Port Arthur, Texas, Rauschenberg altered his name from Milton Ernest to Robert while studying at the Kansas City Art Institute in 1947–8. In 1948 he attended the Académie Julian in Paris and Black Mountain College, North Carolina, returning intermittently until 1952. Here he met Merce Cunningham and John Cage, with whom he collaborated closely in later years. He also studied at the Art Students League, New York (1949–51). For his first solo exhibition at Betty Parsons Gallery, New York in 1951 Rauschenberg presented his Black Paintings and his White Paintings. In 1953 he began the Red Paintings series that evolved the following year into the Combines, the work for which he is best known. Mixing gestural painting with sculpture by incorporating objects from everyday life, the Combines bridge Abstract Expressionism and Pop. During this period Rauschenberg shared ideas with Jasper Johns, his studio neighbour. He began to work with silkscreen, until then only a commercial medium, in 1962, combining magazine photographs of current events with painted brushstrokes. The Jewish Museum, New York organized Rauschenberg's first retrospective in 1963; the following year he had a retrospective at the Whitechapel Gallery, London and won the Grand Prix at the 32nd Venice Biennale. He worked on many collaborative projects, including printmaking, performance, choreography, set design and art-and-technology works throughout the 1960s. He began splitting his time between Captiva, Florida and New York in 1970. In 1997–9 a major retrospective organized by the Solomon R. Guggenheim Museum, New York toured Houston, Cologne and Bilbao.

Larry Rivers
1923–2002

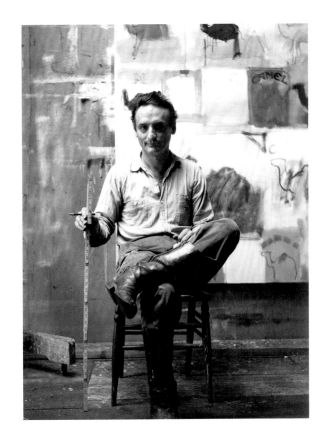

Photograph by Shunk Kender, 1960s

Born Yitzroch Loisa Grossberg in the Bronx, New York, Larry Rivers initiated his artistic career as a jazz saxophonist in 1940, when he also changed his name. He began painting in 1945, studying art at the Hans Hofmann School, New York (1947–8) and at New York University (1948–51). Rivers had his first solo exhibition at the Jane Street Gallery, New York in 1949. He participated in the 4th São Paulo Bienal (1956) and in documenta 6, Kassel (1977). Although influenced by Abstract Expressionism, in the early 1950s Rivers worked figuratively, painting his family and friends and making life-sized figure sculptures. He began to develop imagery from mass-produced designs on cigarette packs and banknotes in the late 1950s, anticipating Pop Art. During the early 1960s Rivers spent time in London and Paris. In 1969 he turned to spray cans, airbrush painting, acrylics and, later, to videotapes. In 1978 he began the Golden Oldies series, reworking his imagery of the 1950s and 60s. Rivers had his first American touring retrospective in 1965. Subsequent retrospectives included those at the Museo de Arte Contemporaneo de Caracas (1980); the Guildhall Museum, East Hampton and Lowe Art Museum, Coral Gables, Florida (1983); and the Corcoran Gallery of Art, Washington, DC (2002).

James Rosenquist
1933–

Unknown photographer, 1965

One of the leaders of American Pop, James Rosenquist was born in Grand Forks, North Dakota. His art was influenced by his experience of working as a commercial billboard painter, while studying art at the University of Minnesota (1952–4). After moving to New York in 1955, where he studied at the Art Students League, he painted billboards in Times Square and met Jasper Johns and Robert Rauschenberg. In 1960 Rosenquist began to put together fragments of images, derived mainly from advertisements, creating huge canvases that referred directly to the culture and politics of the time. In these works bizarre juxtapositions form a commentary that questions technological developments and contemporary values. He had his first one-man exhibition at Green Gallery, New York in 1962. In 1965 he began working with lithographs and created his most famous work, the 26-metre wide painting *F-111*. Rosenquist's many retrospectives have included those held at the National Gallery of Canada, Ottawa (1968); the Whitney Museum of American Art, New York and the Wallraf-Richartz Museum, Cologne (1972); and the Solomon R. Guggenheim Museum, New York (2003). His collages, paintings, drawings, sculptures and prints are included in all major Pop surveys. Rosenquist lives and works in New York and Tampa, Florida.

Colin Self
1941–

Photograph by Jo Keys, 1964

Born and raised in Norwich, where he attended the Art School, Colin Self studied painting at the Slade School of Fine Art, London (1961–3). During this time he met David Hockney and Peter Blake, becoming associated with the early phase of British Pop. Bombs and other missiles featured frequently in Self's early work on paper and canvas as an expression of anxiety about Cold War politics. A visit to the United States in 1965 generated a series of Fall-out Shelter drawings, inspired by nuclear shelters he had seen in New York. He portrayed such common motifs from contemporary American life as the hot dog, employing a technique of obsessively worked drawing in a combination of pencils and ballpoint pens. He subsequently returned to Norwich, where he still lives and works. He participated in the 3rd Paris Biennale (1967), the 1971 São Paolo Bienal and *The Pop Art Show* at the Royal Academy, London (1991–2), touring Cologne, Madrid and Montreal. The Tate Gallery, London presented *Colin Self: 60 works in the Tate Collection* in 1995–6.

Richard Smith
1931–

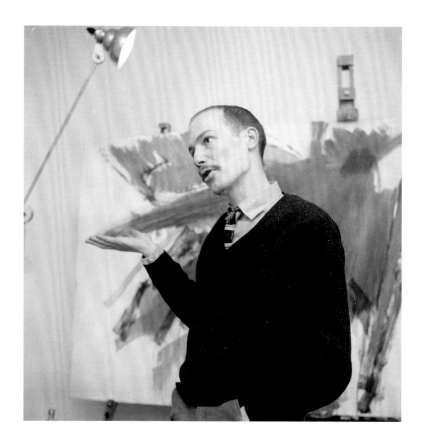

Photograph by Ken Harding, 1958

Born in Letchworth, Hertfordshire, Richard Smith studied at the Luton School of Art (1948–50) and the St Albans School of Art (1952–4) before moving to London to attend the Royal College of Art (1954–7) with Peter Blake and Joe Tilson. A sojourn in New York from 1959 to 1961 on a Harkness Fellowship introduced Smith to the imagery of Pop – billboards and glossy magazines – which influenced the large-scale, sumptuously layered paintings that he exhibited in his first solo show at the Green Gallery, New York in 1961. For the remainder of the 1960s, Smith's paintings combined formal abstraction with the imagery of consumer products, corporate symbols and everyday objects. In the early 1970s, Smith began making paintings constructed with aluminium tubes, canvas and string, reminiscent of kites. He had one-man exhibitions in London at the ICA (1962), the Whitechapel Art Gallery (1966) and the Hayward Gallery (1973), and in New York at the Jewish Museum (1968); in 1970 he represented Britain in the 35th Venice Biennale. Smith continues to exhibit paintings and prints regularly in London and New York. He was included in *Art from the '60s – This was Tomorrow* at Tate Britain in 2004.

Joe Tilson
1928–

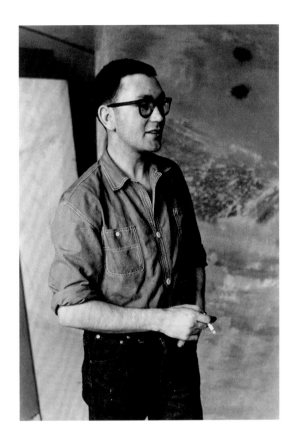

Photograph by Roger Mayne, 1960

Born in London, Joe Tilson worked as a carpenter and joiner (1944–6) and served in the RAF (1946–9) before attending St Martin's School of Art, London (1949–52) and the Royal College of Art (1952–5), winning the Prix de Rome in his final year. Making constructions and paintings, prints and multiples, rooted in his personal history and often playing with geometric abstraction, Tilson was associated with the early phase of British Pop. However, his dissatisfaction with certain values in modern life caused him to diverge from his previous celebration of consumer society and technological innovation and to return to traditional craftsmanship in wood and a concern with symbolism in nature. Tilson was included in the 2nd Paris Biennale (1961) and in the 32nd Venice Biennale (1964). He had his first solo exhibition at the Marlborough Gallery, London in 1962, and his first retrospective at the Boijmans Van Beuningen Museum, Rotterdam in 1964. Further retrospectives include those at Vancouver Art Gallery (1979), the Arnolfini Gallery, Bristol (1984) and the Royal Academy of Arts, London (2002). Tilson lives and works in London and Cortona, Tuscany.

Andy Warhol
1928–87

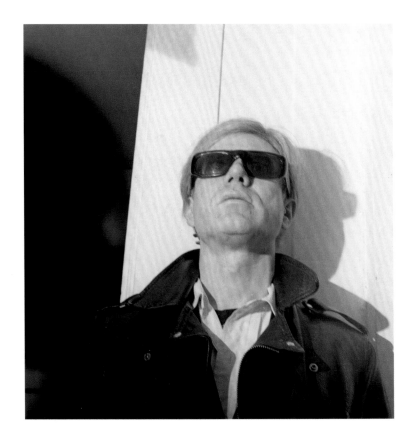

Photograph by Weegee (Arthur Fellig), 1960

The personification of Pop, Andy Warhol was born Andrew Warhola in Pittsburgh, where he studied pictorial design at the Carnegie Institute of Technology (1945–9). He moved to New York in 1949 and worked as a commercial artist and illustrator, specializing in images of shoes. In 1952, Warhol's first solo show, at the Hugo Gallery, New York, exhibited his illustrations for Truman Capote's writings; he continued to publish reproductions of his drawings throughout the 1950s. In 1960 Warhol began to make paintings based on mass-produced images and ordinary consumer items, such as Campbell's soup cans and Coca-cola bottles. He quickly took up the technique of mass production: at his studio, known as the Factory, a team of assistants silkscreened the imagery of his obsessions – death and disasters, glamour, objects of consumer culture. During the 1960s he became the most iconic figure of American art, at the centre of a group of 'Superstars', making repetitive and erotic experimental films; painting portraits of film stars, pop idols and politicians; photographing homoerotic nudes and famous people at parties; producing a record; and founding the magazine *Interview*. In 1968 Warhol was shot and seriously wounded by Valerie Solanas, bringing the Factory era to an end. In 1970 a major retrospective of Warhol's work, organized by the Pasadena Art Museum, travelled throughout the United States and Europe. Warhol published his autobiography, *The Philosophy of Andy Warhol*, in 1975. The Andy Warhol Museum, holding more than 12,000 works by the artist, was established in Pittsburgh in 1994. His work continues to be exhibited in solo and group exhibitions worldwide.

Tom Wesselmann
1931–2004

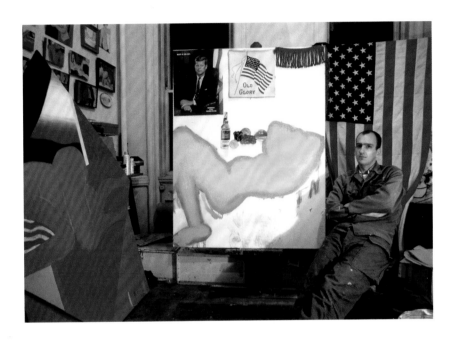

Photograph by Jerry Goodman, 1961

Tom Wesselmann was born and raised in Cincinnati, Ohio, where he studied at Hiram College (1949–51), Cincinnati University (1951–2 and 1954–6, BA Psychology) and Cincinnati Art Academy (1954–6). He began to draw cartoons during two years' military service (1952–4). In 1956 he moved to New York City to study art at the Cooper Union, where he graduated in 1959, specializing in painting. As a reaction against Abstract Expressionism, he made small collages of torn paper representing the figure. Wesselmann is best known for his Great American Nude series, begun in 1960 – flat, billboard-like representations of faceless naked women, which he began to exhibit in 1961 in his first solo show at the Green Gallery, New York. He also made giant still lives composed of common domestic objects and collage elements taken from advertising images – the dominant subjects of early Pop. He had a major touring retrospective in Japan in 1993–4 organized by the Museum of Contemporary Art, Sapporo and a retrospective at MACRO, Rome in 2005.

LIST OF PLATES

*An asterix refers to a work in the exhibition at the National Portrait Gallery, London, followed by its catalogue number

Frontispiece* (cat.33)
In the Car 1963
Roy Lichtenstein
Oil and magna on canvas
1720 x 2035mm (67¾ x 80in)
Scottish National Gallery of Modern Art
© The Estate of Roy Lichtenstein/DACS, London 2007

'The Age of Boom': Britain and the United States in the 1950s–1960s

Page 14
President John F. Kennedy with Prime Minister Harold Macmillan in Britain
1 June 1961
Brian Seed
© Time & Life Pictures/Getty Images

Page 17
Advertising in New York
5 February 1954
Andreas Feininger
© Time & Life Pictures/Getty Images

Page 18
Advertisement in *Picture Post*
27 March 1954
Unknown photographer
Picture Post/Hulton Archive
© Getty Images

Page 19
America's first space walk
3 June 1965
Unknown photographer
© NASA

Page 21
The Beatles receive their MBEs
17 October 1965
Unknown photographer
Daily Express

Page 22
Mary Quant fashion
1 August 1967

Unknown photographer
Press Association
© EMPICS

Page 23
Advertising in London
24 September 1968
Unknown photographer
Evening Standard/Stringer
© Getty Images/Hulton Archive

Page 25
Civil rights riot, Birmingham, Alabama
3 May 1963
Bill Hudson
Associated Press
© EMPICS

Page 26
Moratorium Day peace rally, Washington, DC
15 November 1969
Unknown photographer
Associated Press
© EMPICS

A New Image of Art

Page 38
Peter Phillips
August 1963
Tony Evans
© Tony Evans, Timelapse Library Ltd

Page 41
Robert Rauschenberg and Jasper Johns
1954
Rachel Rosenthal
© Rachel Rosenthal

Page 42* (cat.10)
Just what is it that makes today's homes so different, so appealing? 1956
Richard Hamilton
Cibachrome
260 x 250mm (10¼ x 9¾in)
Private Collection
© Richard Hamilton

Page 44
Look Mickey 1961
Roy Lichtenstein
Oil on canvas

1220 x 1755mm (48 x 69in)
Dorothy and Roy Lichtenstein
Gift of the Artist in Honour of the 50th Anniversary of the National Gallery of Art
© National Gallery of Art, Washington, DC;
© Disney Corporation

Page 47* (cat.14)
St Sebastian No 1 1957
Eduardo Paolozzi
Bronze
2159 x 2184 x 1041mm (85 x 86 x 41in)
Scottish National Gallery of Modern Art

Page 48
Eduardo Paolozzi 1959
Ida Kar
Bromide print
198 x 220mm (7¾ x 8⅝in)
© National Portrait Gallery, London
(NPG x13793)

Precursors of Pop

Page 50* (cat.3)
Meet the People from Ten Collages from BUNK! 1948
Eduardo Paolozzi
Work on paper
359 x 241mm (14⅛ x 9½in)
Tate, London 2007
© Trustees of the Paolozzi Foundation, licensed by DACS, London 2007

Page 53* (cat.1)
Hi Hohe 1946
Eduardo Paolozzi
Collage and mixed media
230 x 150mm (9 x 5⅞in)
Private Collection
© Trustees of the Paolozzi Foundation, licensed by DACS, London 2007

Page 54* (cat.8)
BUNK! Evadne in Green Dimension 1952
Eduardo Paolozzi
Collage, paper glue and string
331 x 254mm (13 x 10in)
Victoria and Albert Museum
Given by the Artist
© Trustees of the Paolozzi Foundation, licensed by DACS, London 2007

Page 55* (cat.2)
**It's a Psychological Fact Pleasure
Helps your Disposition from Ten
Collages from BUNK!** 1948
Eduardo Paolozzi
Work on paper
362 x 244mm (14½ x 9⅝in)
Tate, London 2007
© Trustees of the Paolozzi Foundation,
licensed by DACS, London 2007

Page 56
Summer 1563
Giuseppe Arcimboldo
Oil on limewood
670 x 508mm (26 x 19¾in)
Kunsthistorisches Museum, Vienna/
Bridgeman Art Library

Page 57 top left* (cat.4)
**From Mass Merchandising,
Profit for the Masses** c.1950
Eduardo Paolozzi
Collage and mixed media
350 x 220mm (13¾ x 8⅝in)
Collection The Trustees of
the Paolozzi Foundation
Courtesy Flowers
© Trustees of the Paolozzi Foundation,
licensed by DACS, London 2007

Page 57 top right* (cat.6)
The Return 1951
Eduardo Paolozzi
Collage and mixed media
331 x 254mm (13½ x 10in)
Collection The Trustees of
the Paolozzi Foundation
Courtesy Flowers
© Trustees of the Paolozzi Foundation,
licensed by DACS, London 2007

Page 57 bottom left* (cat.5)
North of the Border 1951
Eduardo Paolozzi
Collage and mixed media
331 x 255mm (13¼ x 10¼in)
Collection Flowers
© Trustees of the Paolozzi Foundation,
licensed by DACS, London 2007

Page 57 bottom right* (cat.7)
To Rule is to Take Orders 1952
Eduardo Paolozzi

Collage and mixed media
228 x 155mm (9 x 6¼in)
Private Collection
© Trustees of the Paolozzi Foundation,
licensed by DACS, London 2007

Page 58* (cat.18)
One Lamp Only 1959
Eduardo Paolozzi
Collage and mixed media
183 x 262mm (9¾ x 10½in)
Collection The Trustees of
the Paolozzi Foundation
Courtesy Flowers
© Trustees of the Paolozzi Foundation,
licensed by DACS, London 2007

Page 59
Poster for *This is Tomorrow* **at
the Whitechapel Art Gallery** 1956
Richard Hamilton
Whitechapel Archive, Whitechapel Art
Gallery, London
© Richard Hamilton

Page 60
**Nigel Henderson, Eduardo Paolozzi,
Alison and Peter Smithson** 1956
Nigel Henderson
Vintage bromide print
301 x 372mm (11⅞ x 14⅝in)
Courtesy of The Mayor Gallery, London
(NPG P1090)

Page 61* (cat.11)
Head of a Man 1956
Nigel Henderson
Photograph on board
1597 x 1216mm (62⅞ x 47⅞in)
Tate, London 2007
© Nigel Henderson Family Estate

Page 64* (cat.9)
Untitled 1954
Jasper Johns
Painted wood, painted plaster cast,
photomechanical reproductions on
canvas, glass and nails
666 x 222mm (26½ x 8⅞in)
Photography by Ricardo Blanc
Hirshhorn Museum and Sculpture Garden,
Smithsonian Institution, Regents Collections
Acquisition Program with Matching Funds
from the Thomas M. Evans, Jerome L.

Greene, Joseph H. Hirshhorn, and Sydney
and Frances Lewis Purchase Fund, 1987.
© Jasper Johns/VAGA, New York/DACS,
London 2007

Page 65
Target with Four Faces 1955
Jasper Johns
Encaustic and collage on canvas with
plaster casts
736 x 660mm (29 x 26in)
Gift of Mr and Mrs Robert C. Scull, 8.1958
© Jasper Johns/VAGA, New York/DACS,
London 2007
© Photo, SCALA, Florence, The Museum of
Modern Art, New York

Page 66
Gloria 1956
Robert Rauschenberg
Oil and paper collage on canvas
1683 x 1607mm (66 x 63in)
The Cleveland Museum of Art
Gift to the Cleveland Society of
Contemporary Art, 1966.333
© DACS, London/VAGA, New York 2007

Page 67* (cat.27)
Trophy V (for Jasper Johns) 1962
Robert Rauschenberg
Oil, collage and found objects on canvas
2438 x 1829mm (96 x 72in)
Honolulu Academy of Arts
Gift of Mr and Mrs Frederick R. Weisman
in honour of James W. Foster, 1971
© DACS, London/VAGA, New York 2007

Page 68
Jasper Johns at Pearl Street, with
Flag **(1954) and** *Target with Plaster
Casts* **(1955)** 1955
George Moffet
© George Moffet

Page 71
Self-Portrait with Badges 1961
Peter Blake
Oil on board
1743 x 1219mm (68 x 48in)
Tate, London 2007
© DACS, London 2007

Page 72* (cat.12)
Oedipus (Elvis #1) 1956–7
Ray Johnson

Tempera and ink wash on magazine page
279 x 212mm (11½ x 8¼in)
William S. Wilson
© The Estate of Ray Johnson at Richard
L. Feigen & Co.

Page 73* (cat.20)
Got a Girl 1960–61
Peter Blake
Enamel, photo collage and record on
hardboard
940 x 1549 x 42mm (37 x 61 x 1⅝in)
The Whitworth Art Gallery, The University
of Manchester
© DACS, London 2007

Page 75* (cat.13)
James Dean (Lucky Strike) 1957
Ray Johnson
Collage on cardboard panel
457 x 406mm (18 x 16in)
The Estate of Ray Johnson at Richard
L. Feigen & Co.
© The Estate of Ray Johnson at Richard
L. Feigen & Co.

Page 76* (cat.15)
Hand Marilyn Monroe 1958
Ray Johnson
Paper and ink collage on painted board
425 x 330mm (16¾ x 13in)
Whitney Museum of American Art,
New York
Purchase with funds from the Paintings
and Sculpture Committee 99.85
© The Estate of Ray Johnson at Richard
L. Feigen & Co.

Portraits and the Question of Style

Page 78
Derek Boshier in Notting Hill
March 1962
Tony Evans
© Tony Evans, Timelapse Library Ltd

Page 80
**Tom Wesselmann, Roy Lichtenstein,
James Rosenquist, Andy Warhol
and Claes Oldenburg at the Factory
celebrating the opening of Warhol's
Stable Gallery**
21 April 1964

Ken Heyman
© Ken Heyman/Woodfin Camp

Page 83* (cat.17)
Green Suit 1959
Jim Dine
Oil and cloth
1574 x 609mm (62 x 24in)
Photography by Ellen Page Wilson
Courtesy PaceWildenstein, New York
© ARS, New York and DACS, London 2007

Page 84
Paris Match
Issue 516, 28 February 1959
Courtesy of *Paris Match*

Page 85* (cat.19)
MM 1959
Richard Smith
Oil on canvas
914 x 914mm (36 x 36in)
Private Collection
© Richard Smith, Courtesy Flowers

Page 86* (cat.22)
I'm in the Mood for Love 1961
David Hockney
Oil on board
1410 x 1165mm (55½ x 45¾in)
Royal College of Art Collection
© David Hockney

Page 87* (cat.28)
Mr Art 1962
Larry Rivers
Oil on canvas
1830 x 1370mm (72 x 53⅞in)
National Portrait Gallery, London
(NPG 6675)
© DACS, London/VAGA, New York 2007

Page 89* (cat.26)
Interesting Journey 1962
Allen Jones
Oil on canvas
635 x 760mm (25 x 29⅞in)
Private Collection, c/o Susannah Pollen Ltd
© Allen Jones

Page 90* (cat.21)
**Man Playing Snooker and Thinking of
Other Things** 1961
Derek Boshier

Oil on canvas
1900 x 1520mm (74¾ x 59⅞in)
The Berardo Museum, Lisbon
© Derek Boshier

Page 92* (cat.31)
Portrait of Juan Gris 1963
Patrick Caulfield
Oil on board
1220 x 1220mm (48 x 48in)
Pallant House Gallery, Chichester
(Wilson Gift through The Art Fund)
© The Estate of Patrick Caulfield/DACS,
London 2007

Page 93
Mr Bellamy 1961
Roy Lichtenstein
Oil on canvas
1422 x 1066mm (55½ x 42⅛in)
Collection of the Modern Art Museum
of Fort Worth, Museum purchase,
The Benjamin J. Tillar Memorial Trust
Acquired from the collection of Vernon
Nikkel, Clovis, New Mexico, 1982
© The Estate of Roy Lichtenstein/DACS,
London 2007

Page 95* (cat.39)
Self-portrait 1964
Andy Warhol
Acrylic, silver paint and silkscreen ink
on canvas
508 x 406mm (20 x 16in)
Stefan T. Edlis Collection
© Licensed by the Andy Warhol Foundation
for the Visual Arts, Inc./ARS, New York and
DACS, London 2007

Fantasy and Fame

Page 96* (cat.16)
Girlie Door 1959
Peter Blake
Collage and objects on hardboard
1220 x 603mm (48 x 23¾in)
Private Collection
Courtesy MaxmArt, Mendrisio
© DACS, London 2007

Page 99* (cat.23)
For Men Only – Starring MM and BB 1961
Peter Phillips

Oil and collage on canvas
2596 x 1531mm (102¼ x 60¼in)
CAMJAP/Calouste Gulbenkian Foundation,
Lisbon
© Peter Phillips

Page 102
Hommage à Chrysler Corp 1957
Richard Hamilton
Oil, metal foil and collage on wood
1479 x 1074 x 67mm (58¼ x 42¼ x 2½in)
© Richard Hamilton

Page 103* (cat.29)
Great American Nude #27 1962
Tom Wesselmann
Oil and collage on panel
1524 x 1219mm (60 x 48in)
The Mayor Gallery, London
© DACS, London/VAGA, New York 2007

Page 104* (cat.40)
Curious Woman 1964–5
Allen Jones
Oil on panel
1220 x 1016mm (48 x 40in)
Private Collection, New York
© Allen Jones

Page 105* (cat.43)
Hunt for the Best 1965
Mel Ramos
Oil on canvas
1213 x 781mm (47¾ x 30¾in)
The Richard Weisman Collection
© DACS, London/VAGA, New York 2007

Page 106
Pauline Boty
29 October 1963
Michael Ward
Bromide print
323 x 219mm (12⅗ x 8⅝in)
© Michael Ward/National Portrait Gallery,
London (NPG x76686)

Page 107* (cat.30)
The Only Blonde in the World 1963
Pauline Boty
Oil on canvas
1224 x 1530 x 25mm (48⅛ x 60¼ x 1in)
Tate, London 2007
© Pauline Boty Estate

Page 108* (cat.24)
Marilyn 1962
Allan D'Arcangelo
Acrylic on canvas with string and scissors
1524 x 1397mm (60 x 55in)
D'Arcangelo Family Partnership
© DACS, London/VAGA, New York 2007

Page 109* (cat.46)
**The Metamorphosis of Norma Jean
Mortenson** 1967
Robert Indiana
Acrylic on canvas
2591 x 2591mm (102 x 102in)
Collection of the McNay Art Museum
Gift of Robert L.B. Tobin
© DACS, London/VAGA, New York 2007

Page 111
**The publicity still that inspired Andy
Warhol's 'Marilyn' series** 1953
Source mechanical
Founding Collection, Andy Warhol Museum,
Pittsburgh

Page 112* (cat.48)
Marilyn Monroe (Marilyn) 1967
Andy Warhol
Portfolio of ten screenprints on paper
910 x 910mm each (35⅞ x 35⅞in each)
Tate, London 2007
© Licensed by the Andy Warhol Foundation
for the Visual Arts, Inc./ARS, New York and
DACS, London 2007

Page 114
Marilyn Diptych 1962
Andy Warhol
Acrylic on canvas
2054 x 1448 x 20mm each (80⅘ x 57 x ¾in)
Tate, London 2007
© Licensed by the Andy Warhol Foundation
for the Visual Arts, Inc./ARS, New York and
DACS, London 2007

Page 115* (cat.41)
My Marilyn 1965
Richard Hamilton
Oil on collage on photo on panel
1025 x 1219mm (40⅜ x 48in)
Ludwig Forum für Internationale Kunst,
Sammlung Ludwig
© Richard Hamilton

Page 116* (cat.47)
Ghost Wardrobe for MM 1967
Claes Oldenburg
Fine cord, hangers, metal, wood and canvas
3048 x 660 x 1180mm (120 x 26 x 46½in)
Private Collection
© Claes Oldenburg and Coosje van
Bruggen

Innocence and Experience

Page 118
16 Jackies 1964
Andy Warhol
Acrylic, enamel on canvas
2032 x 1625mm (80⅜ x 64⅜in)
Collection Walker Art Center, Minneapolis,
Art Center Acquisition Fund, 1968
© Licensed by the Andy Warhol Foundation
for the Visual Arts, Inc./ARS, New York/
DACS, London 2007

Page 120* (cat.37)
The 1962 Beatles 1963–8
Peter Blake
Oil on board
1219 x 914mm (48 x 36in)
Pallant House Gallery, Chichester
(Wilson Gift through The Art Fund)
© DACS, London 2007

Page 121* (cat.36)
Double Elvis 1963
Andy Warhol
Silkscreen and synthetic polymer on canvas
2070 x 2083mm (81½ x 82in)
Froelich Collection, Stuttgart
© Licensed by the Andy Warhol Foundation
for the Visual Arts, Inc./ARS, New York and
DACS, London 2007

Page 123
Andy Warhol at the Factory 1964
Billy Name
© Billy Name/OvoWorks Inc.
© Licensed by the Andy Warhol Foundation
for the Visual Arts, Inc./ARS, New York, and
DACS, London 2007

Page 125
**The Most Handsome Hero of the
Cosmos and Mr Shepherd** 1962
Derek Boshier

Oil on canvas
1220 x 1830mm (48 x 72in)
Courtesy of Museum Sztuki w Lodzi, Poland
© Derek Boshier

Page 126* (cat.32)
Astronaut 4 1963
Gerald Laing
Oil on canvas
1467 x 959mm (57¾ x 37¾in)
Gift of Mr and Mrs Michael Findlay,
University of Mexico Art Museum,
Albuquerque
© Gerald Laing

Page 127* (cat.25)
**Towards a definitive statement on
the coming trends in men's wear
and accessories (a) 'Together let
us explore the stars'** 1962
Richard Hamilton
Oil on canvas and printed reproductions
on panel
610 x 813mm (24 x 32in)
Tate, London 2007
© Richard Hamilton

Page 129* (cat.34)
Express 1963
Robert Rauschenberg
Oil on canvas
1830 x 3050mm (72 x 120in)
Museo Thyssen-Bornemisza, Madrid
© DACS, London/VAGA, New York 2007

Page 130
Retroactive II 1963
Robert Rauschenberg
Oil, silkscreen and ink on canvas
2032 x 1524mm (80 x 60in)
Collection of the Museum of Contemporary
Art, Chicago, partial gift of Stefan T. Edlis
and H. Gael Neeson
© DACS, London/VAGA, New York 2007

Page 131
Buffalo II 1964
Robert Rauschenberg
Oil, silkscreen and ink on canvas
2438 x 1829mm (96 x 72in)
Photography by Michael Tropea
The Robert B. Mayer Family Collection,
Chicago
© DACS, London/VAGA, New York 2007

Page 133* (cat.35)
**Two Waiting Women and B52 Nuclear
Bomber** 1963
Colin Self
Oil on board
1194 x 1816mm (47 x 71½in)
James Moores Collection
© DACS, London 2007

Page 134* (cat.38)
**Portrait of Hugh Gaitskell as a Famous
Monster of Filmland** 1964
Richard Hamilton
Oil and photomontage on canvas
610 x 610mm (24 x 24in)
Arts Council Collection, Hayward Gallery,
South Bank Centre, London
© Richard Hamilton

Page 136* (cat.45)
**Head on another shape: Study for
Big Bo** 1966
James Rosenquist
Oil on shaped canvas
889 x 660mm (35 x 26in)
Hall Collection
© DACS, London/VAGA, New York 2007

Page 137* (cat.50)
Daley Portrait 1968
James Rosenquist
Oil on slit Mylar
622 x 508mm (24½ x 20in)
Private Collection
Courtesy Aquavella Galleries
© DACS, London/VAGA, New York 2007

Page 138* (cat.42)
Portrait Surrounded by Artistic Devices
1965
David Hockney
Acrylic on canvas
1524 x 1829mm (60 x 72in)
Arts Council Collection, Hayward Gallery,
South Bank Centre, London
© David Hockney

Page 139* (cat.44)
Walter Lippman 1966
R.B. Kitaj
Oil on canvas
1829 x 2134mm (72 x 84in)
Collection Albright-Knox Art Gallery, Buffalo,
New York

Gift of Seymour H. Knox, Jr, 1967
© R.B. Kitaj

Page 140* (cat.52)
Page 16: Ecology, Fire, Air, Water, Earth
1969–70
Joe Tilson
Screenprint and oil on canvas on wood
relief
1690 x 1690mm (66½ x 66½in)
The Artist, Courtesy of Waddington
Galleries, London
© Joe Tilson

Page 142* (cat.51)
Swingeing London 67 (a) 1968–9
Richard Hamilton
Oil on screenprint
669 x 851mm (26⅜ x 33½in)
Private Collection
© Richard Hamilton

Page 143* (cat.49)
Self-portrait 1967
Andy Warhol
Silkscreen ink on synthetic polymer paint
on canvas
1867 x 1867 x 52mm (73½ x 73½ x 2in)
Tate, London 2007
© Licensed by the Andy Warhol Foundation
for the Visual Arts, Inc./ARS, New York and
DACS, London 2007

Artist Biographies

Page 150
Peter Blake 1963
Tony Evans
© Tony Evans, Timelapse Library Ltd

Page 151
Derek Boshier 1963
Jorge Lewinski
© The Lewinski Archive at Chatsworth

Page 152
Pauline Boty 1964
Michael Ward
© Michael Ward/National Portrait Gallery,
London (NPG x125839)

Page 153
Patrick Caulfield 1965
Jorge Lewinski
© The Lewinski Archive at Chatsworth

Page 154
Allan D'Arcangelo 1969
Unknown photographer
© Art Gallery at the University of Buffalo,
New York

Page 155
Jim Dine 1959
Yale Joel
© Time & Life Pictures/Getty Images

Page 156
Richard Hamilton 1964
Jorge Lewinski
© The Lewinski Archive at Chatsworth
(NPG x13717)

Page 157
Nigel Henderson 1953 (detail; p.60)
Nigel Henderson
Courtesy of The Mayor Gallery, London
(NPG 1090)

Page 158
David Hockney 1963
Tony Evans
© Tony Evans, Timelapse Library Ltd

Page 159
Robert Indiana 1962
John Adroin
Courtesy of Los Angeles County Museum
of Art

Page 160
Jasper Johns 1955 (detail; p.68)
George Moffet
© George Moffet

Page 161
Ray Johnson 1960s
Unknown photographer
© The Estate of Ray Johnson, Courtesy
Richard L. Feigen & Co.

Page 162
Allen Jones 1962
Jorge Lewinski
© The Lewinski Archive at Chatsworth

Page 163
R.B. Kitaj 1963
Jorge Lewinski
© The Lewinski Archive at Chatsworth

Page 164
Gerald Laing 1966
Unknown photographer
Courtesy of Gerald Laing and Sims Reed
Gallery, London

Page 165
Roy Lichtenstein 1964
Ken Heyman
© Ken Heyman/Woodfin Camp

Page 166
Claes Oldenburg 1966
Jorge Lewinski
© The Lewinski Archive at Chatsworth

Page 167
Eduardo Paolozzi 1959
Lewis Morley
© Lewis Morley Archive/National Portrait
Gallery, London (NPG P512(18))

Page 168
Peter Phillips 1963
Jorge Lewinski
© The Lewinski Archive at Chatsworth

Page 169
Mel Ramos 1964
Leta Ramos
© Leta Ramos

Page 170
Robert Rauschenberg 1954
(detail; see p.41)
Rachel Rosenthal
© Rachel Rosenthal

Page 171
Larry Rivers 1960s
Shunk Kender
© Shunk Kender

Page 172
James Rosenquist 1965
Unknown photographer
© Getty Images/Hulton Archive

Page 173
Colin Self 1964
Jo Keys
© Jo Keys

Page 174
Richard Smith 1958
Ken Harding
© Getty Images/Hulton Archive

Page 175
Joe Tilson 1960
Roger Mayne
© Roger Mayne/National Portrait Gallery,
London (NPG x4066)

Page 176
Andy Warhol 1960
Weegee (Arthur Fellig)
© Getty Images/Hulton Archive

Page 177
Tom Wesselmann 1961
Jerry Goodman
© Jerry Goodman

The publisher would like to thank the
copyright holders for granting permission
to reproduce works illustrated in this book.
Every effort has been made to contact
the holders of copyright material, and
any omissions will be corrected in future
editions if the publisher is notified in writing.

SELECT BIBLIOGRAPHY

Books, journals and articles

General

Amaya, Mario, *Pop as Art: A Survey of the New Super Realism* (Studio Vista, London, 1965).

Benchley, Peter, 'The story of Pop, what it is and what it came to be', *Newsweek*, 25 April 1966, pp.56–61.

Brown, Emily, 'Sex, Lies, and History', *Modernism/Modernity*, vol.10, no.4, November 2003, pp.729–56.

Canaday, John, 'Pop Art Sells On and On – Why?', *New York Times* Magazine, 31 May 1964, sec.6, pp.7, 48, 52–53.

Cohen, R. H., 'Star Quality', *Portfolio* , vol.5, no.5, 1983, pp.80–7.

Compton, Michael, *Pop Art* (Hamlyn, London, 1970).

Coplans, John, 'The New Painting of Common Objects', *Artforum*, November 1962, pp.26–9.

Finch, Christopher, *Pop Art: Object and Image* (Studio Vista, London, 1968).

Hamilton, Richard, 'For the Finest Art try – Pop!', *Gazette* (London), no.1, 1961, p.3.

Leslie, Richard, *Pop Art: A New Generation of Style* (Todtri Productions, New York, 1977).

Lippard, Lucy R., *Pop Art* (Thames & Hudson, London, 1966).

Livingstone, Marco, *Pop Art: A Continuing History* (Thames & Hudson, London, 1990).

Madoff, Steven Henry (ed.), *Pop Art: A Critical History* (University of California, Berkeley, CA and London, 1997).

Mamiya, Christin J., *Pop Art and Consumer Culture: American Super Market* (University of Texas Press, Austin, 1992).

McCarthy, David, *Pop Art* (Tate Gallery Publishing, London, 2000).

Melly, George, *Revolt into Style: The Pop Arts in Britain* (Penguin, London, 1970).

Osterwold, Tilman, *Pop Art* (Taschen, Cologne, 1999).

Russell, John, and Suzi Gablik, *Pop Art Redefined* (Thames & Hudson, London, 1969).

Szücs, György, 'Bálvány és narkotikum [Idol and drug]', *Müvészet*, vol.28, no.6, June 1987, pp.44–7.

Varnedoe, Kirk, and Adam Gopnik, *Modern Art and Popular Culture: Readings in High and Low* (The Museum of Modern Art, New York, 1990).

Whiting, Cecile, *A Taste for Pop: Pop Art, Gender and Consumer Culture* (Cambridge University Press, Cambridge, 1997).

Individual Artists

Peter Blake

Rudd, Natalie, *P B* (Tate Gallery Publishing, London, 2003).

Patrick Caulfield

Livingstone, Marco, *Patrick Caulfield: Paintings* (Lund Humphries, Aldershot, 2005).

Jim Dine

Livingstone, Marco, *Jim Dine: The Alchemy of Images* (Monacelli Press, New York, 1998).

Richard Hamilton

Hamilton, Richard, *Polaroid Portraits* (Edition Hansjörg Mayer, Stuttgart, 1972).

David Hockney

Livingstone, Marco, *Hockney's Portraits and People* (Thames & Hudson, London, 2003).

Melia, Paul (ed.), *David Hockney* (Manchester University Press, Manchester, 1995).

Roy Lichtenstein

Lobel, Michael, *Image Duplicator: Roy Lichtenstein and the Emergence of Pop Art*, (Yale University Press, New Haven and London, 2002).

Waldman, Diane, *Roy Lichtenstein* (Abbeville Press, New York, 1983).

Jasper Johns

Berstein, Roberta, *Jasper Johns Paintings and Sculptures 1954–1974: The Changing Focus of the Eye* (UMI Press, Ann Arbor, Michigan, 1972).

Hopps, Walter, 'An interview with Jasper Johns', *Artforum*, 3 March 1965, pp.33–6.

Ray Johnson

Fesci, Sevim, 'An interview with Ray Johnson, 17 April 1968', *Archives of American Art Journal*, vol.40, no.3–4, 2000, pp.17–27.

Allen Jones

Livingstone, Marco, *Allen Jones: Sheer Magic* (Thames & Hudson, London, 1979).

Claes Oldenburg

Celant, Germano, Dieter Koepplin and Mark Rosenthal, *Claes Oldenburg: An Anthology* (National Gallery of Washington, DC, and Solomon R. Guggenehim Museum, New York, 1995).

Soutif, Daniel, *Claes Oldenburg ou l'autoportrait à l'objet* [Claes Oldenburg or the self-portrait with objects], *Artstudio*, no. 19, Winter 1990, pp.40–55.

Peter Phillips

Crispolti, Enrico, *Peter Phillips: Opere/Works 1960–1974* (Ideae, Milan, 1977).

Mel Ramos

Kuspit, Donald B., *Mel Ramos: Pop Art Fantasies: The Complete Paintings* (Watson-Guptil, New York, 2004).

Levy, Thomas (ed.), *Mel Ramos: Heroines, Goddesses, Beauty Queens* (Kerber Verlag, Bielefeld, 2002).

Rosenblum, Robert, *Mel Ramos: Pop Art Images* (Taschen, Cologne, 1994).

Larry Rivers

Hunter, Sam, *Larry Rivers* (Rizzoli, New York, 1989).

James Rosenquist

Narrett, Eugene, 'Rosenquist in retrospect: wrestling with the American goddess', *New Art Examiner*, vol.14, no.4, December 1986, pp.23–5.

Joe Tilson

Compton, Michael, and Marco Livingstone, *Tilson* (Thames & Hudson, London, 1992).

Andy Warhol

Flatley, **Jonathan**, 'Warhol gives good face: publicity and the politics of prosopopoeia', *Pop out: queer Warhol*, ed. Jennifer Doyle, Jonathan Flatley, José Estaban Muñoz (Duke University Press, Durham, 1996), pp.101–33.

Halpert, **Peter Hay**, 'Andy Warhol's polaroids: instant fame', *Photo Review*, vol.15, no.4, 1992, pp.2–6.

King, **Margery**, 'Starstruck: Andy Warhol's Marilyn and Elvis', *Carnegie Magazine*, vol.62, no.10, 1995, pp.10–14.

Nettleton, **Taro**, 'White-on-white: the overbearing whiteness of Warhol being', *Art Journal*, vol.62, pt.1, 2003, pp.14–23.

Smith, **Charles Saumarez**, 'I try to make everybody look great: Andy Warhol and the idea of the twentieth-century portrait', *Modern Painters*, vol.14, no.2, 2001, pp.54–7.

Tom Wesselmann

Gardner, **P.**, 'Tom Wesselmann: I Like To Think That My Work is About All Kinds of Pleasure' *Artnews*, vol.81, no.1, January 1982, pp.67–72.

Hunter, **Sam**, *Tom Wesselmann* (Academy Editions, London, 1994).

Stealingworth, **Slim**, *Tom Wesselmann* (Abbeville Press, New York, 1980).

Solo exhibition catalogues: UK artists

Peter Blake
Peter Blake (55 paintings, collages and drawings), Stedelijk Museum, Amsterdam, 1973; Gemeentemuseum, Arnhem, 1974; introduction by Rainer Crone.

Peter Blake (paintings and drawings), Kunstverein Hamburg, Hamburg, 1973–4; introduction by Uwe M. Schneede.

Peter Blake, Tate Gallery, London, 1983.

Pauline Boty
Pauline Boty (1938–1966): the only blonde in the world, Whitford Fine Art and Mayor Gallery, London, 1998; texts by Sue Watling and David Alan Mellor.

Patrick Caulfield
Patrick Caulfield Paintings: 1963–1971, Walker Art Gallery, Liverpool, 1981; Tate Gallery, London 1981; text by Marco Livingstone.

Richard Hamilton
Richard Hamilton: exteriors, interiors, objects, people, Kunstmuseum, Winterthur, 1990.

Richard Hamilton, Tate Gallery, London, 1992; ed. Richard Morphet.

David Hockney
David Hockney: Faces 1966–1984, Laband Art Gallery, Los Angeles, 1987; introduction and text by Marco Livingstone.

David Hockney Portraits, Museum of Fine Arts, Boston, 2006; Los Angeles County Museum of Art, California, 2006; National Portrait Gallery, London, 2006–7; texts by Sarah Howgate and Barbara Stern Shapiro.

Allen Jones
Allen Jones: Retrospective of Paintings 1957–1978, Walker Art Gallery, Liverpool, 1979; Serpentine Gallery, London, 1979; Sunderland Museum and Art Gallery, Sunderland, 1979; Staatliche Kunsthalle, Baden-Baden, 1979.

R.B. Kitaj
R.B. Kitaj: A Retrospective, Tate Gallery, London, 1994; Los Angeles County Museum of Art, California, 1995; Metropolitan Museum of Art, New York, 1995; ed. Richard Morphet.

Gerald Laing
Gerald Laing, 1963–1993: A Retrospective, Fruitmarket Gallery, Edinburgh, 1993.

Peter Phillips
Retrovision: Peter Phillips – Paintings 1960–1982, Walker Art Gallery, Liverpool, 1982; introduction by John McEwen, text by Marco Livingstone.

Joe Tilson
Joe Tilson: Pages – Recent Work, Marlborough Fine Art, London, 1970.

Solo exhibition catalogues: US artists

Allan D'Arcangelo
Allan D'Arcangelo: Retrospettiva, Palazzina dei Giardini, Modena, 2005; texts by Walter Guadagnini and Silvia Ferrari.

Jim Dine
Jim Dine: walking memory, 1959–1969, Solomon R. Guggenheim Museum, New York, 1999; Cincinnati Art Museum, Ohio, 1999–2000.

Robert Indiana
Robert Indiana, Retrospective 1958–98, Musée d'art Moderne et d'art Contemporain, Nice, France, 1998.

Jasper Johns
Jasper Johns, Whitney Museum of American Art, New York, 1977–8; text by Michael Crichton.

Jasper Johns: a retrospective, Museum of Modern Art, New York, 1996; texts by Kirk Varnedoe and Roberta Bernstein.

Ray Johnson
Ray Johnson 1927–1995: a memorial exhibition, Richard L. Feigen & Co., New York, 1995; texts by Richard L. Feigen and Frances Beatty.

Ray Johnson: correspondences, Whitney Museum of American Art, New York, 1999; Wexner Center for the Arts, Ohio State University, Columbus, 2000; eds. Donna De Salvo and Catherine Gudis.

Roy Lichtenstein
Roy Lichtenstein, Guggenheim Museum, New York, 1993; text by Diane Waldman.

Robert Rauschenberg
Robert Rauschenberg: Combines, Metropolitan Museum of Art, New York 2005–6; Museum of Contemporary Art, Los Angeles, 2006; Centre Georges Pompidou, Paris, 2006–7; Moderna Museet, Stockholm, 2007; texts by Paul Schimmel et al.

Larry Rivers
Larry Rivers: art and the artist, Corcoran Gallery of Art, Washington, DC, 2002; texts by Barbara Rose and Jacquelyn Days Serwer.

James Rosenquist

James Rosenquist, Denver Art Museum, Denver, Colorado, 1985 and tour; text by Judith Goldman.

James Rosenquist: A Retrospective, Museum of Fine Arts and the Menil Collection, Houston, 2003; Solomon G. Guggenheim Museum, New York, 2003–4; and Guggenheim Museum, Bilbao, 2004; texts by Walter Hopps and Sarah Bancroft.

Andy Warhol

Andy Warhol: Arbeiten = Works 1962–1986, Thasseus Ropac, Salzburg, 1987.

Andy Warhol: A Retrospective, The Museum of Modern Art, New York, 1989; text by Kynaston McShine.

About Face: Andy Warhol Portraits, Wadsworth Atheneum, Hartford, Connecticut, 1999–2000; Miami Art Museum, 2000; text by Nicholas Baume.

Andy Warhol: retrospective, Neue Nationalgalerie, Berlin, 2001; Tate Modern, London, 2002; Museum of Contemporary Art, Los Angeles, 2002; ed. Heiner Bastian.

Andy Warhol: Supernova, Stars, Deaths, and Disasters, 1962–1964, Walker Art Center, Minneapolis, 2005–6; Museum of Contemporary Art, Chicago, 2006; Art Gallery of Ontario, Toronto, 2006; text by Douglas Fogle.

Andy Warhol: Ten Portraits of Jews of the Twentieth-Century, National Portrait Gallery, London, 2006; text by Paul Moorhouse.

Group exhibition catalogues

This is Tomorrow, Whitechapel Art Gallery, London, 1956; text by Richard Hamilton *et al.*

The International Exhibition of New Realists, Sidney Janis Gallery, New York, 1962; texts by Sidney Janis, John Ashbery and Pierre Restany.

The Popular Image, Institute of Contemporary Arts, London, 1963; text by Alan Salomon.

Pop Art USA, Oakland Art Museum, California, 1963; text by John Coplands.

The New Generation: 1964, Whitechapel Art Gallery, London, 1964.

New American Realism, Worcester Art Museum, Worcester, Massachusetts, 1965; text by Martin Carey.

American Pop Art, Whitney Museum of American Art, 1974; text by Lawrence Alloway.

Pop Art in England: Beginnings of a New Figuration 1947–63, Kunstverein in Hamburg, Hamburg, 1976; Stadtische Galerie Im Lenbachhaus, Munich, 1976; City Art Gallery, York, 1976; text by Uwe M. Schneede.

Pop art, 1955–70, Art Gallery of New South Wales, Sydney, 1985; Queensland Art Gallery, Brisbane, 1985; National Gallery of Victoria, Melbourne, 1985; text by Henry Geldzahler.

Pop Art: U.S.A.–UK, Odakyu Grand Gallery, Tokyo, 1987; text by Lawrence Alloway and Marco Livingstone.

Pop Art: An International Perspective, Royal Academy of Arts, London, 1991 and tour; text by Marco Livingstone.

Hand-Painted Pop: American Art in Transition, 1955–62, Museum of Contemporary Art, Los Angeles, 1992–3; Museum of Contemporary Art, Chicago, 1993; Whitney Museum of American Art, New York, 1993; text by Donna M. De Salvo.

The sixties art scene in London, Barbican Art Gallery, London, 1993; text by David Mellor.

Europop: A Dialogue with the US: About 90 Pieces, Arken Museet for Moderne Kunst, Copenhagen, 1999.

Les années pop: 1956–1968, Centre Georges Pompidou, Paris, 2001; text by Mark Francis.

Pop Art: U.S./U.K. Connections, 1956–1966, Menil Collection, Houston, 2001 (in association with Hatje Cantz, Ostfildern-Ruit, 2001); texts David E. Brauer *et al.*

Pop Art UK: British Pop Art 1956–1972, Palazzo Santa Margherita, Palazzina dei Giardini, Modena, 2004; ed. Marco Livingstone.

British Pop, Museo de Bellas Artes, Bilbao, 2005–6; text by Marco Livingstone.

INDEX

Page numbers in *italics* refer to picture captions.

ACKNOWLEDGEMENTS

In mounting an exhibition that explores the relationship between Pop Art and portraiture it was imperative to advance an international perspective. The movement had its roots in Britain and America and the subsequent simultaneous and interconnected development of Pop Art portraiture in both countries is an essential part of the story. For that reason the exhibition has been conceived as a visual dialogue between British and American Pop Art. Securing the loan of key works by the leading Pop artists and maintaining a balance between exponents working on both sides of the Atlantic have been primary considerations. The final line-up comprises over fifty works by twenty-eight artists, a number of whom are represented by several portraits. The presence of these works is critical to the argument and I am profoundly grateful to all those lenders who have generously supported the exhibition.

Bringing the project to fruition has been complex and I owe a primary debt of gratitude to my Director, Sandy Nairne, who supported the endeavour from the outset and offered advice at key stages in its progress. The process of identifying and agreeing important loans benefited from the support of numerous individuals. In particular I would like to thank Michael Findlay, Mark Francis, James Mayor, Nicholas Serota and Paul Schimmel, all of whom gave me valuable help. Many others made important contributions. Claire Everitt provided first-rate support and managed the project with great efficiency. It was a great pleasure to work again with Paul Williams on the design of the exhibition. Following our earlier collaboration on the Bridget Riley retrospective at Tate in 2002, I had absolute confidence in his ability to respond to a difficult brief and, ably assisted by Juliet Phillips, he created a setting that was entirely sympathetic to the aims of

Pop Art Portraits. Grita Rose-Innes designed an elegant and imaginative catalogue, the production of which was skilfully controlled by Ruth Müller-Wirth. The project overall was expertly coordinated by Caroline Brooke Johnson. My sincere thanks also go to Denny Hemming for her highly skilled editing. The publication includes an authoritative essay on the social history of the period by Dominic Sandbrook, for whose insights I am very grateful. I was especially pleased to join forces with Sean Rainbird, ex-colleague at Tate and now Director of the Staatsgalerie Stuttgart, in showing the exhibition in Germany.

In addition, the following individuals all assisted in the development and organization of the book and exhibition in significant ways: Paloma Alarco, Thomas Ardill, Lucie Balance, Pim Baxter, Frances Beatty, Emma Black, Claudia Bloch, Susanna Brown, Greg Burchard, Krzystof Cieskowski, David Clarke, Naomi Conway, Andrea Easey, Denise Ellitson, Neil Evans, Richard L. Feigen, Ian Gardner, Sylvain Giraud, Daniel Hermann, Tim Holton, Chrissie Iles, Lynette Johnson, Celia Joicey, David Lambert, Barbara London, Tyler Lundquist, Alissa Minot, Richard Morphet, Tova Ossad, Eddie Otchere, Gabrielle Popp, Paul Pringle, Bridget Riley, Rachel Rosenthal, Jonathan Rowbotham, Kanoko Sasao, David Saywell, Jacob Simon, Sarah Tinsley, Eva White, Alexandra Willett and William S. Wilson. Special thanks go to my family: Rosemary, Sarah, Anne and Sam.

Paul Moorhouse
Curator of Twentieth-Century Portraits
National Portrait Gallery, London

'They always say that time changes things, but you actually have to change them yourself.' **Andy Warhol**